MASTERPIECES OF EIGHTEENTH-CENTURY VENETIAN DRAWING

Introduction by
Giandomenico Romanelli

Texts by
Alessandro Bettagno
Adriano Mariuz
Terisio Pignatti
Lionello Puppi
Ugo Ruggeri

Commentaries on the plates by
Ernst Goldschmidt

Thames and Hudson

This book was prepared under the direction of Ernst Goldschmidt
on the occasion of an exhibition held at the Palais des Beaux-Arts, Brussels,
15 April - 5 June 1983.

Translated from the French
Dessins vénitiens du dix-huitième siècle
by David Smith

Published in Great Britain by Thames and Hudson Ltd,
30 Bloomsbury Street, London WC1B 3QP

Published in the United States by Thames and Hudson Inc.,
500 Fifth Avenue, New York, New York 10110

Library of Congress Catalog Card Number 83-50526
ISBN 0-500-27319-7

Printed and bound in Belgium

Contents

Introductory Note

The drawings are arranged according to artist and theme, rather than in chronological order. Some coloured plates have been placed out of sequence for technical reasons. The illustration notes are in general based on books or catalogues listed for each work as references (Ref.). General bibliography and sources can usually be found in the works cited. A short reading-list with the abbreviations used in the captions follows this note.

If not otherwise indicated in the illustration notes, white paper was used in the original drawing. The measurements of each picture or sheet are given in millimetres, the height first, the width second.

Bibliographical References

cited in an abbreviated form under Ref. in the illustration notes

(a) Books and articles in alphabetical order according to the authors' names

Byam Shaw 1951	James Byam Shaw, *The Drawings of Francesco Guardi* (London 1951)
Byam Shaw 1962	James Byam Shaw, *The Drawings of Domenico Tiepolo* (London 1962)
Byam Shaw 1977	James Byam Shaw, 'Some Guardi Drawings Rediscovered', *Master Drawings*, Vol. 15, No. 1 (1977)
C./L.	W.G. Constable, J.G. Links, *Canaletto* (Oxford 1976)
Sabine Jacobs 1975	Sabine Jacobs, *Italienische Zeichnungen der Kunstbibliothek Berlin* (Berlin 1975)
Knox-Thiem 1970	George Knox and Christel Thiem, *Tiepolo*. Graphische Sammlung Staatsgalerie, Stuttgart (Stuttgart 1971)
Knox Quaderno	George Knox, *Un Quaderno di vedute di Giambattista e Domenico Tiepolo* (Milan 1974)
Knox 1975	George Knox, *Catalogue of the Tiepolo Drawings in the Victoria and Albert Museum* (London 1975)
Knox 1980	George Knox, *Giambattista and Domenico Tiepolo. Chalk Drawings*, 2 Vols (Oxford 1980)
Morassi	Antonio Morassi, *Guardi. Tutti i disegni* (Venice 1975)
Morassi 1973	Antonio Morassi, *I Guardi. L'Opera completa di Antonio e Francesco Guardi*, 2 Vols (Venice 1973)
Pallucchini 1943	R. Pallucchini, *I disegni del Guardi al Museo Correr* (Venice 1943)
Pallucchini 1956	R. Pallucchini, *Piazzetta* (Milan 1956)
R. Pallucchini	R. Pallucchini, *Arte Veneta* (1969-70)
Parker 1948	K.T. Parker, *The Drawings of Antonio Canaletto in the Collection of His Majesty the King at Windsor Castle* (Oxford and London 1948)
Parker 1956	K.T. Parker, *Catalogue of the Collection of Drawings in the Ashmolean Museum* (Oxford 1956, reprinted 1972)
Pignatti 1968	Terisio Pignatti, *Pietro Longhi* (Venice 1968)
Pignatti 1975	Terisio Pignatti, *Pietro Longhi dal disegno alla pittura* (Venice 1975)
Rieder 1975	W. Rieder, 'Piranesi at Gorhambury', *The Burlington Magazine* (1975) pp. 582-91
P.M. Sekler 1962	P.M. Sekler, 'Giovanni Battista Piranesi's "Carceri" Etchings and Related Drawings', *The Quarterly* (1962) pp. 330-63
H. Thomas 1954	H. Thomas, *The Drawings of Giovanni Battista Piranesi* (London 1954)
Vigni 1972	Giorgio Vigni, *Disegni del Tiepolo* (Trieste 1972)

(b) Exhibition catalogues

Art vénitien en Suisse	*Art vénitien en Suisse et au Liechtenstein* (Mauro Natale) (Pfäffikon and Geneva 1978)
Berlin 1967 (Winner)	*Zeichner sehen die Antike* (M. Winner) (Berlin 1967)
Cini 1956	*Disegni del Museo di Bassano* (L. Magagnato) (Fondazione Giorgio Cini, Venice 1956)
Cini 1964	*Disegni veneti del Settecento nel Museo Correr di Venezia* (T. Pignatti) (Fondazione Giorgio Cini, Venice 1964)
Cini 1972	*Venetian Drawings of the Eighteenth Century* (A. Bettagno) (Heim Gallery, London, Fondazione Giorgio Cini, Venice 1972)
Cini 1978	*Disegni di Giambattista Piranesi* (A. Bettagno) (Fondazione Giorgio Cini, Venice 1978)
Cini 1980	*Disegni veneti di collezioni inglesi* (Julian Stock) (Fondazione Giorgio Cini, Venice 1980)
La Strozzina 1963	*Disegni della Fondazione Horne in Firenze* (L. Ragghianti Collibi) (Florence 1963)
London 1980	*Canaletto Paintings and Drawings* (The Queen's Gallery, London 1980)
Paris 1971	*Venise au XVIIIe siècle* (R. Bacou) (Paris 1971)
Udine 1965	*Disegni del Tiepolo* (A. Rizzi) (Udine 1965)
Venice 1965	*Mostra dei Guardi* (P. Zampetti) (Venice 1965)
Venice 1982	*Canaletto, Disegni – Dipinti – Incisioni* (A. Bettagno) (Fondazione Giorgio Cini, Venice 1982)

Venice in the Eighteenth Century

Giandomenico Romanelli

It is hard for several reasons to discuss eighteenth-century Venice. The city and state were composed of many different and often conflicting elements during this richest and most fateful period of its history; and there were many changes of political leadership. In addition the Settecento in Venice, its literature, drama and art, are seen by us now through a historical distorting-glass. It is almost impossible to calculate to what extent the subject has been misrepresented, misconstrued, exalted or denigrated, trivialized, by the writers of the two succeeding centuries. All that we can say with certainty is that the eighteenth century in Venice has suffered more from such misinterpretation than any other period of the city's long history. Fortunately, we have an Ariadne's thread to help us through the labyrinth, in the great number of recent scholarly studies that have been devoted to the topic as a whole or to specific aspects of it.[1]

What strikes us at once is the great wealth of eighteenth-century Venetian cultural life. There were a multitude of outstanding individuals working there at that time in the fine arts, in the theatre and literature generally, in law, economics, journalism, political science and scholarship of all kinds. These figures point to the variety, and to the many contradictions of Venetian life of the period. The writers include, for example, Carlo Goldini (1707-93), Gasparo and Carlo Gozzi (1713-86 and 1720-1806 respectively), Giammaria Ortes (1713-90), Andrea Memmo (1729-93), Giacomo Casanova (1725-98) and Francesco Algarotti (1712-64). In the graphic arts, Giambattista Tiepolo, Antonio Canaletto, Gian Antonio Guardi and Pietro Longhi were born in 1696, 1697, 1699 and 1702 respectively and died in 1770, 1768, 1760 and 1785, and the careers of Francesco Guardi, Pietro Bellotto, Giandomenico Tiepolo and Alessandro Longhi also fit perfectly into the framework of our study (1712-93; 1720-80; 1727-1804; 1733-1815). In related spheres, the lives of the architect, historian and theoretician Tommaso Temanza (1705-89) and the artist Giambattista Piranesi (1720-88) also fall within the limits of the eighteenth century.

[1] A vast number of books and articles have been written about eighteenth-century Venice. In the following list, I mention only those studies that have appeared since 1945 and add something new to our knowledge of the cultural and general history of the city. Most of these books contain lengthy bibliographies. In order to avoid making this list almost endless, I have not included any monographs on individual eighteenth-century Venetian artists. For these, the reader should consult the titles mentioned in the articles and the notes that follow, as well as the general bibliography on p. 4. I would, however, make an exception in the case of the monumental catalogue of the exhibition held at Gorizia and Venice that was published just as the present volume was ready for press. It is *Da Carlevarijs ai Tiepolo. Incisori veneti e friulani del Settecento* (Venice 1983).

M. Petrocchi, *Il tramonto della Repubblica di Venezia e l'assolutismo illuminato* (Venice 1950); M. Berengo, *La società veneta alla fine del Settecento* (Florence 1956); G. Tabacco, *Andrea Tron 1712-1785 e la crisi dell'aristocrazia senatoria a Venezia* (Trieste 1957); *La civiltà Veneziana del Settecento* (Florence 1960, new edn 1979), with contributions by various authors; G. Torcellan, *Una figura della Venezia settecentesca: Andrea Memmo* (Rome 1963); *ibid., Settecento Veneto e altri scritti storici* (Turin 1969); F. Venturi, *Settecento riformatore. Da Muratori a Beccaria* (Turin 1969); J. Georgelin, *Venise au siècle des lumières* (Paris 1978); M. Brusatin, *Venezia nel Settecento: Stato, architettura, territorio* (Turin 1980); G. Cozzi, *Stato, Società e Giustizia nella Repubblica Veneta* (sec. XV-XVIII) (Rome 1980); G. Cozzi, *Repubblica di Venezia e stati italiani. Politica e giustizia dal secolo XVI al XVIII* (Turin 1982).

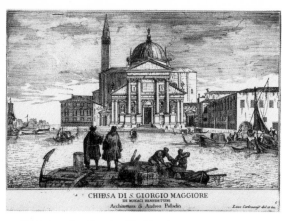

1 L. Carlevarijs, Church of S. Giorgio Maggiore, 1703

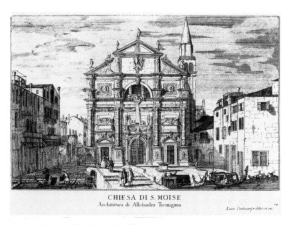

2 L. Carlevarijs, Church of S. Moisè, 1703

I have listed a few names only in order to indicate the vast range of talent in a century filled with men who played major parts in the cultural life of Europe. They were in fact so important that the history of the city and its influence (now decidedly cultural rather than political) can be traced in a series of foreign journeys undertaken by them: we think, for example, of the periods spent abroad by Tiepolo, Algarotti, Pellegrini, Rosalba Carriera and Giacomo Quarenghi. Above all, however, it is Casanova who comes to mind in this context. He travelled the length and breadth of Europe, returned to spend an unhappy period in Venice (1774-83), then set off again on his wanderings until he died in 1798 in Bohemia. The timing of his death was in a sense symbolic, since it occurred so soon after the end of the Republic of Venice in the course of the famous May of 1797.

The lives of individual Venetians and the political and institutional history of the city and state were inextricably interwoven; one event followed so closely on another in those last years of the Republic that they are almost impossible to disentangle – a confusion which is in itself evidence of the serious tensions and contradictions that existed within the political structure, and which even those Venetians who were most receptive to new ideas, and to the profound changes that were taking place in the social fabric of Europe, were ultimately unwilling or unable to resolve.

Rather than a brusque and unexpected reshuffling of the historical cards, the fall of Venice should therefore be seen as the falling into place of a pattern of causes, portents and premonitions: like a vast network of clues, apparent only to the penetrating eye of the detective. 'The principal part that Venice had to play in the eighteenth century was to monitor the diplomatic and military manoeuvres that were taking place in the rest of Europe', Berengo has insisted. He then goes on to say that 'although the Republic was kept by force of circumstances, and by its own choice, away from the centre of affairs, it remained ever vigilant for signs of any threat to its territories and its peace. International negotiations no longer took place in Venice in the eighteenth century, as they had two hundred years before, but the city was still a great clearinghouse of political information, a forum, where all the warning signals that came from Germany, the East, from semi-legendary Muscovy, and from the other Italian states, could be heard. Venetian ambassadors and residents abroad were as busy as ever; but their task was now that of listening, evaluating and passing on information. They had no longer to intervene in the flux of events and try to impose their own pattern. From negotiators they had changed into observers.'

At the beginning of the century, during the years that preceded and followed the Peace of Passarowitz (1718), Venice had lost its position at the centre of political decision-making in Europe – a loss which was rationalized and made acceptable by the formulation of a theory of neutrality. This change resulted in a gradual, almost imperceptible, shift in the quality of Venetian life. The members of the ruling class in

particular tended to become cynically disillusioned, to flirt with the idea of reform, to despair of the future, and to make ineffectual efforts to keep themselves afloat at the expense of others' weakness. All this within a context of unstable political equilibrium in which the state of the economy gave constant anxiety.

This situation finally hardened when the thousand-year-old Republic came up against the great-power politics of the heady and turbulent years when Napoleon was strengthening his power. His armies took Venice in May 1797, and the last Doge abdicated. Venice was a democracy from May to October, and this proved to be a radical and irreversible break with the past (despite the 'little restoration' attempted during the first period of Austrian domination, 1797-1805). The moment of this break, when there seemed every prospect of a new order emerging, had been viewed by some Venetians with fear, and welcomed by others in a spirit of reform and liberty.

More tears must have been shed by authors over the end of the Republic than over the fall of Byzantium, with which it has often been compared; but this should not cloud our view of the eighteenth century in Venice. It was not, after all, a century of death, but one of life. We have only to think of the city's cultural achievements, its literature, art and architecture. Another creation was the great myth of Venice itself, which was born in the eighteenth century and became in the ninteenth century one of the great repositories of the European imagination.

The first edition of Luca Carlevarijs' set of *vedute* or views of Venice, *Le fabriche, e vedute di Venetia disegnate, poste in prospettiva et intagliate da Luca Carlevarijs*, appeared at the very beginning of the eighteenth century, in 1703. Domenico Lovisa published his collection of *vedute, Il gran teatro di Venezia,* a little later, in 1717. Coronelli had published his more questionable, and partly plagiarized, work, the *Singolarità di Venezia,* in 1708-9. These volumes of engravings provide us with our first comprehensive anthology of the Venetian scene, depicted with the characteristically documentary approach of the *vedutisti,* and published commercially. The use of engraved plates made it possible to mass-produce and to offer them at a very reasonable price. The volumes were easy to handle, and the illustrations realistic, although with a considerable element of idealization and stylization. Collections of this kind carried the image of Venice far beyond its shores, and were followed by similar collections of engravings by Canaletto, Marieschi, Giampiccoli, Visentini and other artists. It was not long before there were countless volumes of *vedute,* often of the same places seen from different points of view. The *vedutisti* may on the whole be taken as reliable guides to eighteenth-century Venice, including the architectural and environmental changes that they recorded in every corner of the city.

Almost all the buildings designed by Baldassare Longhena, the greatest of Venetian Baroque architects, that were commenced during his life-

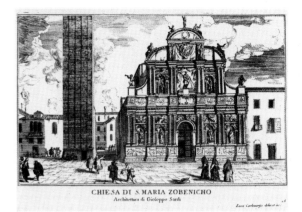

3 L. Carlevarijs, Church of S. Maria Zobenigo, 1703

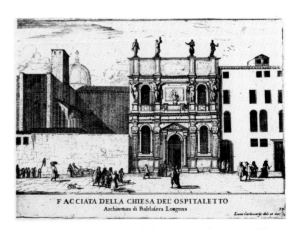

4 L. Carlevarijs, Façade of the Church of the Ospitaletto, 1703

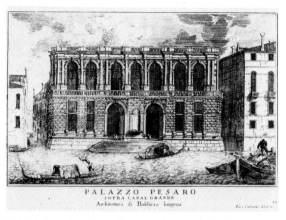

5 L. Carlevarijs, Palazzo Pesaro on the Grand Canal, 1703

time, were complete by the end of the seventeenth century. These included the church of S. Maria della Salute and other religious buildings, and the many *scuole,* libraries, palaces and great monuments that he designed in Venice. Work on his Cà Pesaro and Cà Rezzonico went on for many years, and the strikingly misshapen appearance of these unfinished buildings attracted painters and engravers, who studied and drew them.

Both Cà Pesaro, which was completed by Gaspari in 1710, and Cà Rezzonico, finished even later by Massari, can be regarded as symbols of a period of transition in which architecture and town-planning based on the quality of perspective in Baroque design (visible in the way they are represented) gives way to a new aesthetic consciousness. This fresh feeling involved a determination to limit the exuberance of seventeenth-century designers, and a search for a different form of classicism – one more sober, more ideologically self-contained and more in accordance with the eighteenth-century spirit. Giorgio Massari, with his enormous productivity, boundless versatility and 'eclectic' form of classicism, was almost ideally adapted to fulfil the demands imposed by the urban context, by his specific commissions, and by contemporary fashion. In fact, he was above all able to give architectural form to the most characteristic and instantly recognizable image of eighteenth-century Venice. Although some of his work seems merely a laborious repetition with a minimum of articulation (such as his completion of the Cà Rezzonico), and while, in other cases, the ponderous and almost totally uninventive workmanship points to the need to build in order to survive, some of his buildings, such as the churches of the Pietà, the Fava and the Gesuati, are masterpieces.

If, however, we want to see real innovation and a proof that the concepts and language of architecture were being renewed in the eighteenth century, we have to look at the work of other Venetians. The church of S. Vidal (or Vitale), based on a plan by Andrea Tirali, was begun in 1700. Thirty years later, work began on one of the most important religious, anti-Baroque buildings in Venice : the church of S. Simeone Piccolo, situated at the end of the Grand Canal. The architect responsible for it, Giovanni Scalfarotto, intended in a sense a more 'correct' version of the Salute at the other end of the Grand Canal. But it was Tommaso Temanza who designed the church that is most original, most consciously emancipated in its eighteenth-century conception and yet most rich in ideas far beyond the culture of that century. This is the Maddalena, planned in 1760 and built in the two following decades. Neo-classical architects both in and outside Venice were repeatedly to return to this church as a model and as a practical demonstration of the principles of good architectural design.

S. Vidal was the first indication of a conscious, deliberate return to Palladio, beyond the unthinking respect paid to the master in the seventeenth century. From it the tradition of Palladian classicism developed, both in its strict form and its freer espression during the neo-classical period.

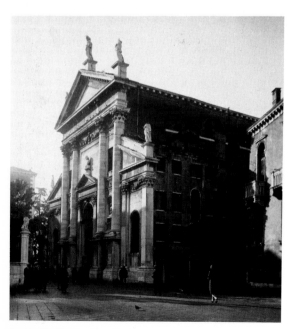

6 Andrea Tirali, Church of S. Vidal

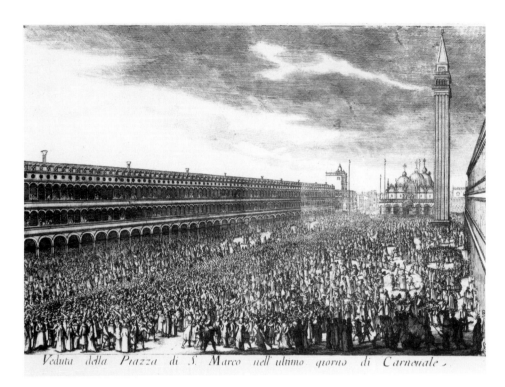

7 D. Lovisa, Piazza S. Marco on the last day of the carnival, 1720

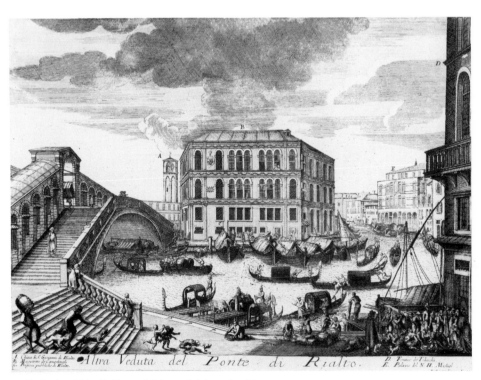

8 D. Lovisa, Rialto Bridge and Palazzo dei Camerlenghi, 1720

9 D. Lovisa, Balancing act near the Pescheria di Rialto, 1720

The *vedutisti* recognized quite clearly their task of reproducing and revealing the renewed image of the city, both in showing parts of buildings betraying signs of change, and the result of large-scale architectural transformations. A special type of *veduta* isolated fragments of existing architecture or buildings and projected them onto another landscape in a way that is detached, liberated and slightly 'perverse', showing just how freely artists could interpret the new unwritten laws governing architecture. This also points to a desire to intervene critically in the urban environment, and shows the artists working midway between the *capriccio* and the *veduta* in the strict sense of the term. The most famous examples are a Palladian composition by Canaletto (and another by Guardi) of a Rialto Bridge that was never built, and another by Canaletto showing the horses of St Mark's Basilica mounted on high pedestals in the Piazzetta.

Luca Carlevarijs, the first of a whole generation of *vedutisti,* dedicated his *Fabbriche e vedute* to the Doge Alvise Mocenigo, defining the limits of the *veduta* and justifying it as an art form. He had, he claimed, 'undertaken a considerable task' in drawing and engraving more than a hundred plates for the collection, and aimed to 'make a knowledge of the magnificient treasures of Venice more widespread in foreign countries'. His task had not only been to collect documentary evidence, but also to glorify the appearance, form and artistic wealth of the city. Many modern buildings erected throughout the seventeenth century are included in Carlevarijs' engravings, and he seems to have paid special attention to those built by such Baroque architects as Longhena, Sardi and Tremignon. Other, such as Palladio, Scamozzi, Sansovino and Sanmicheli, are of course well represented in his engravings, but more, it would seem, as points of historical reference than as masters in their own right. Architecture as such is symbolized by Longhena's famous façade for Cà Pesaro, built only up to the balustrades over the *piano nobile*.

The impression one gains of Venice from most of Carlevarijs' *vedute* is that of a city built entirely of marble and densely packed with palaces. The artist was proud to be able to claim that he had made extensive use of mathematics in achieving his artistic aims: 'that is, arithmetic, geometry, perspective and civil architecture'.

Carlevarijs always carefully documented in his pictures the form of building that claimed his attention; he rarely looked at the context within which it was situated. That was for him of secondary importance, and worth only suggesting. He represents principally the Venice of monumental architecture in his engravings; all that testifies around St Mark's, along the Grand Canal and in the less central parts of the city, to the many-sided yet homogeneous magnificence of this most anti-natural of capitals. But there is no doubt that he was attracted above all to massive, extensive buildings, and he fills his views with palaces, churches, *scuole* and hospitals richly adorned with volutes, pilasters, capitals, columns, arches and tympana. His urge to emphasize the effect of an unbroken array of monumental structures often made

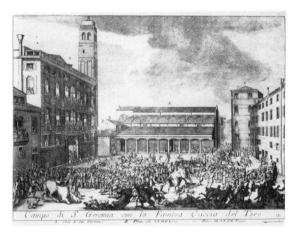

10 D. Lovisa, Bull-baiting in the Campo S. Geremia. On the left, the Palazzo Labia, 1720

him indifferent to the correct proportional relationships between buildings and the other elements in his engravings, notably the human figures, animals and boats.

His *Fabbriche e vedute* do, however, contain a repertoire of the elements that help us form a picture of eighteenth-century Venice: the figures in cloaks and three-cornered hats, gondoliers and porters. (His fine *veduta* of S. Giorgio Maggiore shows us two male figures seen from the rear and standing on the pier of the Dogana – an engraving that Giandomenico Tiepolo was to remember.) He also gives us glimpses of life in the streets: festivals and processions, gondolas, the poor, games, quarrels, Eastern dress, wigs and puppet shows. He shows us a world both elegant and monstrous, tragic and vain, middle-class and fantastic – the world of Goldoni and Carlo Gozzi or of Canaletto and Pietro Longhi.

All these artists convey, whether through boundless energy, scientific enquiry or mockery and satire, an urge to express an idea of Venice. Carlevarijs gave careful form to that idea in his engravings, while Giandomenico Tiepolo expressed it in the Punchinello drawings of his old age with a caustic sarcasm that contradicted the consecrated view of the city's culture. The image of Venice was – as has often been pointed out before – above all a theatrical and scenic one. Domenico Lovisa was second only to Carlevarijs as an engraver of Venetian scenes, and it was certainly not by chance that his major work, dedicated to Venice, and the '*vedute* and paintings that are to be found there', was called a 'theatre': *Il gran teatro di Venezia*.

Comparing Lovisa with Carlevarijs, we are struck mostly by his incorporation of architectural objects within a view of the whole. He also insists on the 'theatrical' elements in each scene. His engravings always contain a human narrative element, or even a series of narratives. There are, for example, quarrels, processions, courtly encounters, carnival scenes, balancing acts, regattas in the canals and various sports and entertainments. Architectural monuments, palaces and churches hardly ever appear in isolation in Lovisa's work, but are almost always associated either with scenes of everyday life, or with special occasions in the streets, squares and canals of Venice. This involves a change in the documentary emphasis: buildings are closely related to the people and dogs who fill the bridges and public squares; he was especially concerned with the environment of the city as a composite and pulsating reality and with the commercial, religious and political activities that took place within its great and beautiful buildings.

Many engraved plans, prospects and bird's-eye views of Venice were produced at this time, and these elaborated upon the *vedute,* in a sense completing their work. The most important of these cartographic engravings of the eighteenth century were undoubtedly the *Nuova planimetria* of Ludovico Ughi (1729) and the unusual perspective view by Giorgio Fossati (1743).

Ughi's *Planimetria* is an extremely important record of early eighteenth-century Venice, carefully surveyed and engraved, and show-

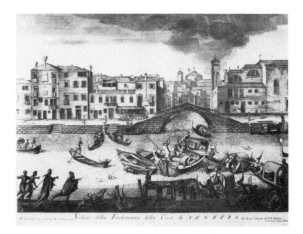

11 D. Lovisa, Fondamenta della Croce, 1720

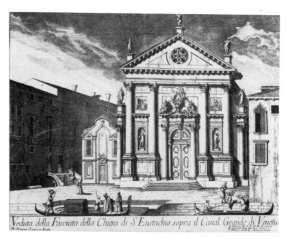

12 D. Lovisa, View of the Church of S. Stae, 1720

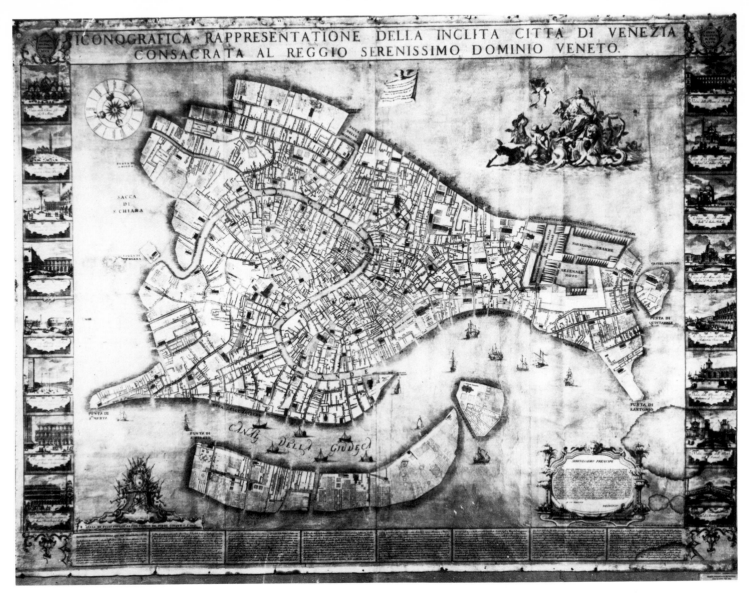

ICONOGRAFICA·RAPPRESENTATIONE DELLA INCLITA CITTA DI VENEZIA
CONSACRATA AL REGGIO SERENISSIMO DOMINIO VENETO.

13 L. Ughi, Plan of Venice, 1729

ing the physiognomy of the city in great detail. All the streets and waterways are clearly indicated, in this first representation of the whole city from a purely structural viewpoint; it owes nothing to the skill of the *vedutisti,* not does it strive to reproduce the atmosphere of Venice or a sense of architectural perspective.

These cartographic works reflect the eighteenth-century impulse to study Venice as an entity, which inevitably led to an increasingly careful analysis of the many different forms of its art and architecture and the context within which they were situated. This in turn initiated reflection about the city and its appearance, and established the conviction that the buildings that had shaped and changed Venice should be listed and classified. Venetians reacted differently to this need. Some wanted to investigate the past by rediscovering ancient myths or researching into sources. Others preferred to concentrate on conserva-

12

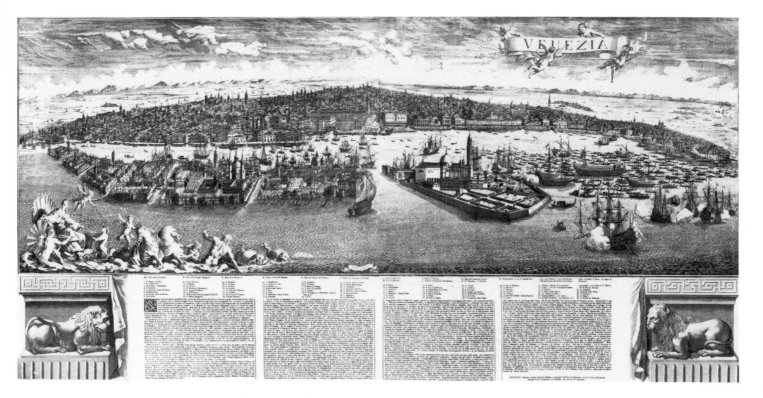

tion and preserving the city's special features and historical treasures. Venice was, after all, the result of factors coming together in an unprecedented and dynamic way. Conservation was not simply a question of continuing to apply the protective measures that had for long been a major concern of the public administration. On the contrary, it consisted on the one hand of producing works of art that were increasingly modern, grandiose and occasionally gigantic, and on the other of using the greatest and most glorious creations of the past as models for new works. The shores, or *lidi,* of Venice were protected by huge marble walls – the *murazzi* – made of Istrian stone. These reinforced the thin strips of land separating the lagoon from the open sea, from the Lido to Pellestrina. The office of the *Savi alle Acque* was responsible for several similarly audacious, technically highly developed and often very large-scale plans. Long before the eighteenth century the lagoon had required the constant attention of hydraulic engineers and mathematicians. It depended for survival on the perfect equilibrium of the sea itself, the rivers and canals flowing into it, the tides, the alluvial deposits, and the salt marshes used for rearing fish. The balance had to be maintained at the cost of constant vigilance, endless resourcefulness, the frequent application of new methods and the ruthless suppression of abuses.

This system of *murazzi* was designed by Bernardino Zendrini, the *Proto alle Acque,* or Controller of Waters. He was succeeded by Tommaso Temanza, who, not content simply to continue the work already initiated, sought to give the whole undertaking a cultural value, and to offer it to future generations as 'one of the wonders of the *Dominante*',

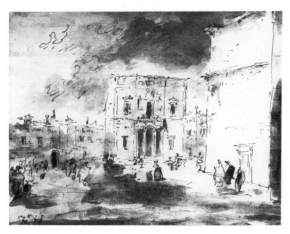

15 F. Guardi, Campo S. Fantin and Fenice Theatre, Venice,
Museo Correr

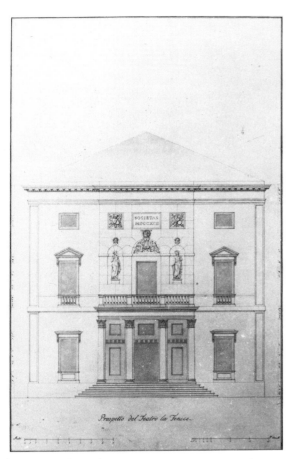

16 G.A. Selva, Fenice Theatre, façade, 1790-2
('Le Fabbriche di Venezia')

thus explicitly comparing it with the ancient Roman model. Temanza ordered a plaque commemorating this great work to be placed on the *murazzi* in 1751, stating that it was a 'truly victorious work of man, the sea and time' based on 'the example of the grandeur of ancient Rome'. The very air that one breathed in the office of the *Savi alle Acque* had a classical and historical dimension. It was not by chance that a youthful employee of the offices, Giambattista Piranesi, was led to Rome by the myth of its grandeur. He had, after all, been brought up to study passionately and systematically the documents of the past. Temanza was able to deal with concrete practical matters, to solve problems of pure theory and to throw himself wholeheartedly into historical research. He discovered, for example, one of the original documents of Venetian cartography – Fra Paolino's fourteenth-century plan of Venice, preserved in the library of S. Marco. Temanza had this engraved and published, together with an extremely clear and scholarly study.

Temanza occupied a central position in architecture, town-planning and civil engineering in the eighteenth century. With the ancient and respected tradition of the *Savi alle Acque* and the *Ingegneri ai Lidi* behind him, he was active in initiating the new forms of architecture that were later to be known as neo-classical. This was a new tradition so vital and so resolutely modern that it soon travelled far beyond the borders of Italy and became established as a totally fresh cultural expression. Temanza's ability to approach texts and documents with the passion of a historical researcher makes him a very modern figure. His achievements single him out as one of the great historiographers of the Enlightenment in Venice, and as a key figure in the cultural life of the city. His influence is also clearly recognizable in the last great architectural monument of eighteenth-century Venice, the theatre of La Fenice, based on a design by Giannantonio Selva, and built, after a great deal of controversy, between 1790 and 1792. From that time onwards the language of architecture became that of European neo-classicism. After his training under Temanza, Selva travelled in France, England and the Low Countries. His work was original and distinctive, precisely because he worked within the new European neo-classical tradition, yet his architecture has all the refinement of eighteenth-century Venice. He sets up a subtle, ironic dialogue with the urban context: his building fits into its historic setting while firmly making an individual statement of its own. Canaletto gave great prominence in his *vedute* to perspective, viewing the objects that he wished to portray from well above the surface of the ground or the water. He also frequently extended the line of the horizon in a highly individual way, putting more air and sky into his works than any other painter or *vedutista* had done before him. His perspectives go far beyond an isolated palace or a single group of façades, to embrace a prospect which contains by implication a vast universe beyond. There are many examples of this technique in his work: his extraordinary *veduta* of the *Harbour of St Mark's*, in Boston, is possibly the most accomplished of his great paintings, but there are others that display similar effects. These include his *Campo Santa Maria*

Formosa at Woburn Abbey, the Vienna *Riva degli Schiavoni towards St Mark's*, the *Grand Canal* in the Galleria Nazionale in Rome, the *Church of Santi Giovanni e Paolo* in the Gemäldegalerie in Dresden, and his nocturnal *Festival of the Arzere di S. Marta* in Berlin. He treated not only Venice but also London in this way, and the great breadth of space in his pictures is perhaps their most striking characteristic. His *vedute* are executed with great precision and attention to detail, and this, combined with the sense of space, makes his depiction of life in his native city so memorable, be it images of official receptions, celebrations and festivals of the Doge and his court, or glimpses of the more hidden aspects of the city's life, expressing in the cracks and broken plaster its antiquity, the long history and the wretchedness of so many of its people in their daily struggle to survive. All these aspects are present in Canaletto's pictures. He shows us the triumphant city of the Ducal Palace and the *Bucentaur,* and the many splendid and ostentatious visits of imperial ambassadors and foreign royalty. But he also reveals the Venice of poverty, deprivation and disease, the city of healers and fortune-tellers, informers and beggars, peddlars and vagrants – the Venice of those whose function in the scheme of things was lowly and despised, those who belonged to no recognized guild or organization, and the many outsiders who where not integrated into the structure of Venetian society. These Venetians are to be found not only among Canaletto's *macchiette*, but also, for example, in Zompini's *Arti che vanno per via* or 'Street trades', in Grevembroch's watercolours and in Volpato's tavern scenes.

Both aspects of eighteenth-century Venetian life, its splendour and its squalor, were also depicted by Giandomenico Tiepolo in his secular and in many ways almost blasphemous *Via Crucis,* or 'Stations of the Cross', of Punchinello, and in the later set of drawings of his *Divertimento per li regazzi,* in which he looks quizzically at the upper stratum of urbane, official and secure Venetian society, with the eye of a bitter old man leaving a legacy to the new post-aristocratic Venice that he saw emerging.

When his father Giambattista died, Domenico inherited the burden of a great reputation; with surprising lucidity and independence of mind, he recognized both the strengths and the weaknesses of what had been passed on to him, and exposed the mechanism and the workings of the great rhetorical machine that Giambattista had set in motion and which constituted, as it were, the heroic level of Venetian Settecento civilization, whose capacity for fantasy and transfiguration of reality it harnessed in a kind of epic sublimation of the present: all this can be seen in the allegorical and celebratory scenes that he painted for the Rezzonico family.

Domenico learned his skills in his father's studio and applied them with great mastery and intuition, but he radically subverted what he learned. Steering a course between cynicism and despair, he almost imperceptibly became an artistic revolutionary, expressing a negative and destructive from of sarcasm in his work. He was almost entirely

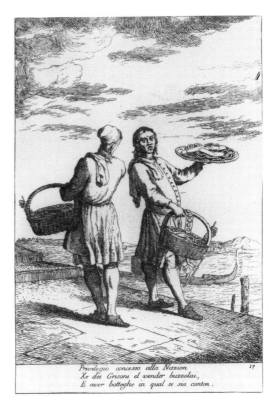

17 G. Zompini, Biscuit sellers, 1785

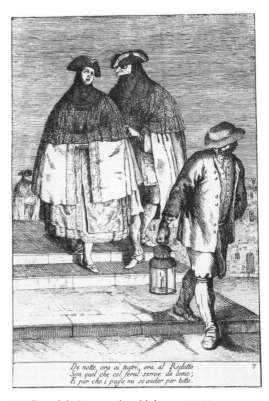

18 Zompini, Accompanier with lantern, 1785

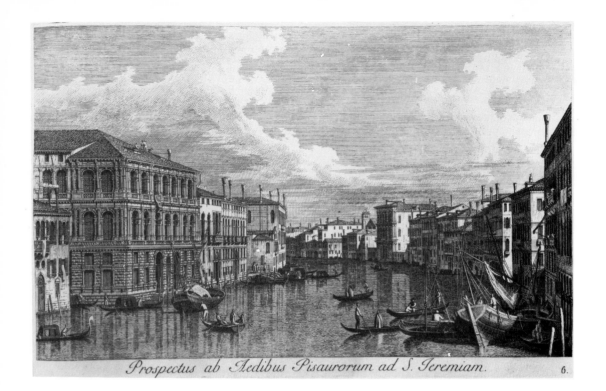

Prospectus ab Aedibus Pisaurorum ad S. Ieremiam. 6.

19 Canaletto-Visentini, The Grand Canal at S. Geremia with the Cà Pesaro, 1742

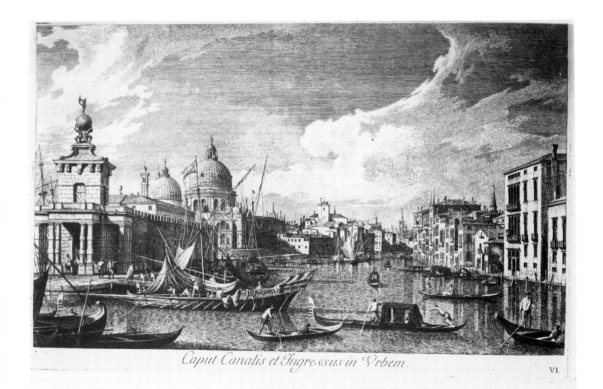

Caput Canalis et Ingressus in Urbem. VI.

20 Canaletto-Visentini, The Salute and the Punta della Dogana at the entrance to the Grand Canal, 1742

preoccupied with what went on behind the scenes, the other side of the Venetian coin.

In a sense, his work reflects a change in social behaviour. The Venetians of his time are people who have lost interest in politics and left the political arena to return to private and domestic bliss. They want to escape the frustrations of public life and administrative duties, and are strongly drawn to study, intellectual pursuits and the search for a new dimension and quality in life. This tendency continued, and its fruits can be seen in the collections of works of art and archaeological objects of the time and in the increasing interest in libraries, academies of various kinds and literary salons.

In the sixteenth century it had been Cardinal Grimani's marbles which became the focus of attention in the Venetian temple of culture, the Library of St Mark. Now tastes had changed: individuals in the city gained prestige through the private collections of historical objects of every kind that filled their own houses and palaces. There was a thriving trade in antiquities, and no lack of work for experts, middlemen and dealers. Filippo Farsetti, Ascanio Molin, Teodoro Correr and the Querini and Gradenigo families all had notable holdings.

The value of these private collections, museums and libraries to the community as a whole was less direct in the eighteenth than in other centuries. For the collectors, involvement in civic, cultural and political life frequently gave rise to difficulties, disappointments and setbacks; Scipione Maffei in Verona, Andrea Tron, Andrea Memmo, Marco Foscarini and Gianmaria Ortes are cases in point. Some families, including the Morosinis, the Trons and the Mocenigos, concentrated on the management of their lands and were bold enough to introduce untried methods of agriculture, often to great advantage, in their estates. Countless treatises were written about new farming techniques and management, and they were debated at length in the academies of agriculture.

Pietro Longhi was undoubtedly the greatest and most gifted artistic representative of this withdrawal into domestic life, which represents a partial disruption of a social structure which in many respects was still highly cohesive and based on attitudes and values held in common. The public Venice of Canaletto's *vedute,* then, was matched by the other and no less brilliant indoor Venice of Longhi. This other city was one of tapestry-hung salons and chamber music, partly veiled ladies, servants, masked gentlemen, chaplains, discreet lovers, lapdogs, powder and perfume. Longhi's pictures of domestic Venice point to an ability on the part of the artist, and the people he portrayed, to understand, analyse and express themselves to an extent that disarms any attempt to moralize. Longhi rejected rhetoric and the epic style, while avoiding caustic irreverence or sarcasm, and without following too intimate an approach. His Venetians are aware of their dignity and high culture, and belong to a society able to survive almost any political blow that might fall. But a blow too great for them was in fact about to fall. The final collapse of Venice was imminent and the warning signs were not difficult to perceive towards the end of the century.

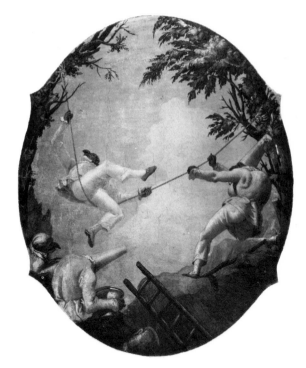

21 Domenico Tiepolo, The punchinello's swing, Venice, Cà Rezzonico

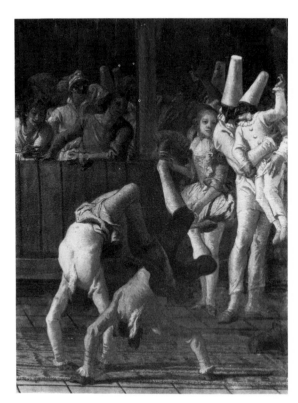

22 Domenico Tiepolo, The travelling showmen, Venice, Cà Rezzonico

Ludovico Manin, the last doge, abdicated on 12 May 1797 and the old régime was replaced by a provisional municipal government. This continued until Napoleon handed over Venice and part of its territory to Austria under the terms of the treaty of Campo Formio.

Those hectic and confused months were in no sense lost time. They forced Venetians to see their city in a different light and to re-evaluate its history, its political structures and its administration, and above all to reflect on its future. The Venice to which they looked forward was still a triumphant city; but triumphant in the name of equality and fraternity, law and education. In the city squares there were public shows stressing the moral values of the republican ideal, and presenting exemplary historical episodes. The new theatre that had just been built, the famous Fenice, echoed to the sound of patriotic songs and festivals glorifying democracy. Many artists used their art to propagate new ideas. The Austrians at first imposed a very conservative form of government on Venice, and it was not long before the old *Dominante* was in a state of political, administrative and economic crisis which deeply disturbed both the ruling class and the bourgeoisie, although the latter, where it existed, was too weak to be effective.

Despite this, however, Venice at the beginning of the nineteenth century was still a vital force, especially in the sphere of art. It should not be forgotten that it was a Venetian sculptor, Canova, who established the norms for the whole of Europe at the time. The great and varied artistic life of Venice during the eighteenth century would continue to bear fruit well into the century that followed.

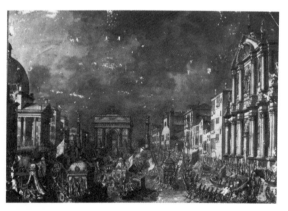

23 G. Borsato, The festival on the Grand Canal for the arrival of Napoleon I, 1807, Venice, Museo Correr

The Artists and their Drawings

Reference is made to the following books and articles in this chapter: J. Byam Shaw, 'Tiepolo Celebrations: Three Catalogues', *Master Drawings* (Autumn, 1971); M.H. von Freeden and C. Lamb, *Das Meisterwerk des Giovanni Battista Tiepolo: Die Fresken der Würzburger Residenz* (Munich 1956); D. von Hadeln, *Handzeichnungen von G.B. Tiepolo* (Munich 1927); T. Hertzer, *Die Fresken Tiepolos in der Würzburger Residenz* (Frankfurt 1943); G. Knox, *Catalogue of the Tiepolo Drawings in the Victoria and Albert Museum* (London 1960, 2nd. edn. 1975); *id., Tiepolo. A Bicentenary Exhibition, Fogg Art Museum,* Harvard University (1970); *id., Giambattista and Domenico Tiepolo. A Study and Catalogue Raisonné of the Chalk Drawings* (Oxford 1980); *id., Un Quaderno di vedute di Giambattista e Domenico Tiepolo* (Milan 1974); M. Kozloff, 'The Caricatures of Giambattista Tiepolo', *Marsyas* X (1961); A. Morassi, *Disegni veneti del Settecento nella collezione Paul Wallraff. Catalogo della Mostra* (Venice 1959); *id.,* 'Sui disegni del Tiepolo nelle recenti mostre di Cambridge Mass., e di Stoccarda', *Arte Veneta* (1970); *id.,* 'A "Scuola del Nudo" by Tiepolo', *Master Drawings* (Spring, 1971); T. Pignatti, 'I disegni su carta blu dei Tiepolo', *Arte in Europa. Scritto di storia dell'arte in onore di Edoardo Arslan* (Pavia 1966); *id., Tiepolo: Disegni* (Florence 1974); A. Rizzi, *Disegni del Tiepolo, con un saggio introduttivo di A. Morassi. Catalogo della Mostra* (Udine 1965); A. Seilern, *Italian Paintings and Drawings at 56 Princes Gate* (London 1959); G. Vigni, *Disegni del Tiepolo* (Padua 1942, 2nd. edn., Trieste 1972).

The Drawings of Giambattista Tiepolo

Adriano Mariuz

Many of the faces in Giambattista Tiepolo's drawings are shown with the eyes half-closed. We see no more than a slit beneath the heavy eyelids, as though the light were too intense for them to open their eyes fully. It is this sun-filled quality that first strikes us when we look at his work; together with the unerring line that yet retains a hint of an improvisatory quiver. The result is one of fleeting, lyrical beauty.

It was not long before Tiepolo's contemporaries came to recognize and admire these aspects of his work, as well as his great inventiveness and originality. As early as 1732, Vincenzo Da Canal, the Venetian biographer of Gregorio Lazzarini, Tiepolo's first master, wrote that the young artist was 'extremely fertile in imagination. That is why copyists and engravers try to reproduce his works, which are full of inventions and whimsical ideas. His drawings are already so highly valued that he has sent collections of them to the most distant parts of the world.'

While Da Canal was clearly anxious to emphasize the artist's unlimited creativity, he was also implicitly acknowledging the intrinsic artistic value of Tiepolo's drawings, which he obviously regarded as self-sufficient works of art. It is probable that he was thinking of a particular type of pen and wash composition, executed in great detail and offered for sale as a little monochrome picture or passed on to an engraver to be used as a model. Several fine examples of such drawings have been preserved. Tiepolo later produced many drawings of this kind to fig. 24 satisfy the demands of patrons and collectors – Francesco Algarotti, for example, had 116 in his collection. But although Tiepolo disposed of many of his drawings in this way, he undoubtedly kept the majority in his studio, where they were later classified, probably by his son Giandomenico. They found their way into various albums with such titles as *Vari studi e pensieri, Sole figure vestite, Sole figure per soffitti* and *Tomo terzo de Caricature* ('Different studies and ideas', 'Individual costumed figures', 'Individual figures for ceilings', 'Third volume of Caricatures' and so on).

Tiepolo originally drew mainly for himself, but this does not prevent his drawings from being aesthetically completely autonomous. Far from constituting mere preparatory exercises for paintings, they can be seen as independent and distinctive works of art in their own right which exist in many cases alongside his paintings as a vast and exceptional body of work. Going through them page by page is like reading an extraordinary adventure of the imagination. They can in fact be compared only with the drawings of one other man – Rembrandt – several of whose works Tiepolo had seen; they moved him to even greater boldness in his own drawing.

He drew not only in order to have a permanent record on paper of his first thoughts or basic design, or in order to study a detail that he intended to use later in a finished work, but mainly

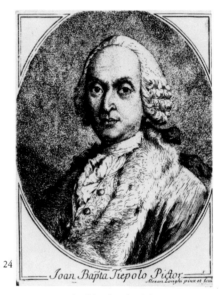

24 Giambattista Tiepolo
Venice 1696 - Madrid 1770
Portrait engraved by Alessandro Longhi

21

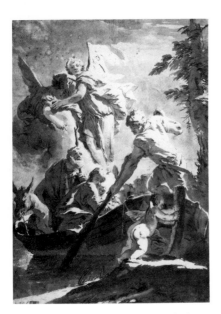

25 The crossing of the Holy Family during the flight into Egypt
Bassano del Grappa, Museo Civico

because he wanted to express his inner vision as freely and as completely as possible. For him, drawing was a sensitive instrument which he used to penetrate the secret depths of his own inspiration. In a drawing he could give form to the most fleeting and fantastic images by capturing them in the light, or he could turn those aspects of reality that filled his fertile mind into bright images on paper. Drawing was also a way of expressing the essence of ideas, themes and human beings that could not be so vividly expressed in painting. It was in his drawings rather than on canvas that the two poles of his creative and essentially poetic imagination appear so clearly: one was revealed in the *capriccio*, so free of all traditional meanings that it took on a strongly enigmatic flavour; the other was expressed in his many caricatures. In these, Tiepolo was able to express his reaction to the reality of the individuals he met and his artistic vision of them in the isolation of their ridiculous bodies.

Quite apart from these obvious contrasts, however, there was an inner development in his graphic art that we must consider if we are to understand the drawings in this book. In 1734 he made several in connection with the frescoes in the Villa Loschi at Biron near Vicenza. From these it is not difficult to distinguish the most striking personal aspects of his drawing. Before 1734 his drawings were mainly experimental, displaying a great diversity of styles and techniques, such as pen and wash on pencil sketches, a technique that he came later to prefer to most others, and sanguine heightened with white lead or sanguine and reddish wash. These materials were always used on white paper. His drawings and paintings of this period show him moving quite clearly from a plastic notion of form, set off by a strongly marked *chiaroscuro*, to a more airy vision in which light already has the effect of sunlight.

Like other artists of his generation, Tiepolo at the beginning of his career was powerfully influenced by Giambattista Piazzetta and Federico Bencovich, whose works were marked by strong contrasts between light and shade, giving human figures an entirely new emphasis and a hitherto unknown psychological depth. Their art was starkly lacking in decorative distractions, and had a dramatic quality that, together with the other features, made it very avant-garde in Venetian artistic circles. The young Tiepolo who, according to Morassi (1971), may well have attended Piazzetta's school of life drawing, was inevitably drawn to this new art. A striking example of the older man's influence is Tiepolo's *A seated male nude,* in the Graphische Sammlung, Stuttgart, dated about 1720. In it, great stress is laid on the human figure, which is almost grotesquely deformed, in part because of the intensive and overemphatic application of *chiaroscuro* in the shading of the body. The human figures in all Tiepolo's youthful drawings are almost excessively accentuated in this way and give the impression of great inner tension.

The *Three nude men in a landscape,* in the Museo Civico of Udine, are bathed in light, giving a sense of space. There is also a hint of sensuality in the artist's lingering over the shading of their young bodies. Even in this early drawing, however, it is possible to catch a glimpse of Tiepolo's preoccupation with the arcane and mysterious, for these three youths seem to have come together for the incantation of some obscure magic spell. What emerges from this drawing is a feeling for the *capriccio,* possibly after the artist had seen some of the work of Giulio Carpioni, a seventeenth-century Venetian painter who was greatly admired for his 'fantastic inventions, including dreams, sacrifices and bacchanals... and his beautiful *capricci'* (Orlandi, 1704). Tiepolo's interest in an earlier artist should cause no surprise. He was a man of considerable culture and learning, especially in the sphere of art, and his familiarity with the old masters dates back at least to the time when he was drawing after Tintoretto, Giuseppe Salviati or Francesco Bassano, for the plates in the *Gran teatro delle pitture e prospettive de Venezia,* published by Lovisa in 1720. The drawing of *The expulsion of Hagar,* also in the Stuttgart collection, points to the artist's interest in modern painters, since it may have been freely copied from Luca Giordano or from one of Sebastiano Ricci's youthful compositions (Byam Shaw, 1971).

As we have seen, Tiepolo was asked in 1734 to decorate Count Nicolò Loschi's villa near Vicenza with frescoes. He had by that time achieved considerable fame for his drawings and paintings executed in Venice, Udine, Milan and Bergamo. The year before, a publication

pl. 1

pl. 2

pl. 3

known as the *Discrizione di tutte le pubbliche pitture della città di Venezia* had been brought up to date by Anton Maria Zanetti and reprinted. It is interesting for its perceptive description of Tiepolo's special qualities: 'What makes him such an outstanding and excellent artist is his prompt inventiveness and his ability to distinguish and at the same time to depict so many figures with a very fresh and novel approach... This is combined with a precise application of *chiaroscuro* coupled with luminous indeterminacy of form... *[lucidissima vaghezza].'*

It is above all this luminosity that strikes us in the frescoes of the Villa Loschi and Tiepolo's many preparatory drawings for them. Count Loschi wanted his walls painted with a complex set of moral and didactic allegorical illustrations. The artist therefore had the task of visualizing the work as a whole and its individual parts as dramatically personifying abstract concepts of different virtues and vices. At the same time, he had to bear firmly in mind the teachings in Cesare Ripa's *Iconologia,* a book that artists had been consulting for more than a century to help with this kind of work.

The commission gave Tiepolo the opportunity to consider anew the art of that master of allegorical painting, Paolo Veronese. It would seem that he spent time studying the *Allegories* that Veronese painted for the Sala del Collegio in the Ducal Palace in Venice. Tiepolo singled out from these paintings not only several original features – his figure of Humility, for example, is clearly based on Veronese's Meekness – but also the hint of limpid classicism that bathes the composition in a crystalline light. When the Count of Tessin came to Venice in 1736 and saw Tiepolo's work, he recognized this influence and described the artist as a 'member of the Veronese sect' (literally *un sectaire de Paul Véronèse*), declaring that he painted with 'infinite ardour' and that his 'colouring was brilliant' *(un feu infini, un coloris éclatant).* The count was so impressed that he apparently wished him to decorate the Royal Palace at Stockholm.

Even in his preparatory drawings for the Villa Loschi frescoes, Tiepolo had to apply his naturally wayward powers of imagination to the serious problem of going beyond the norms traditionally imposed by the *Iconografia* and transforming the allegory into a sophisticated comedy. The moral theme of *Humility disregarding Pride,* for example, became for him an opportunity to dramatize an encounter between two elegant and eccentric ladies, one of whom moves like a showy peacock, a symbol of pride. This drawing, and all the drawings in the series to be found in the Trieste Civici Musei de Storica ed Arte, The Victoria and Albert Museum, and Yale University (New Haven), have a dazzling luminosity reinforced by translucent shading made by spots of wash applied in varying degrees of intensity. This luminosity, coupled with Tiepolo's extremely fluid use of lines inked over light pencil markings, is one of the most conspicuous features of his later pen-and-ink drawings. Like Canaletto he discovered that light could be both objectively present and a creation of the artist's imagination, and that, filling a boundless space, it provided the point of departure for any conceivable artistic vision.

Tiepolo also made a number of *chiaroscuro* drawings of allegorical statues, probably in order to help Count Loschi select which ones he wanted for his home. The count in fact chose only two for his frescoes (Rizzi, 1965). This may be the first example of those 'variations on a theme' which were an essential aspect of Tiepolo's graphic works. The theme in this case was, of course, the illusionistic or 'fictive' statue. The idea of a theme and variations was common in the eighteenth century, not only in the visual arts, but also in music – we have only to think of Bach's *Musical offering.* It gave the artist or musician the freedom to use the imagination boldly and to express creative gifts with great virtuosity – and Tiepolo certainly gave full scope to his imagination in many of his creations. His *Teste di fantasia* or 'Fantasy heads' are the first examples that come to mind. These belong to a picturesque artistic genre greatly appreciated by his contemporaries – Francesco Algarotti, for instance, described it as the visual analogy to the sonnet or to the madrigal in poetry. They are basically imaginary portraits, usually heads of pages or bearded Orientals with strange hairstyles, and half-way between theatre and haute couture. Tiepolo executed these drawings with quick, confident strokes of the pen and shaded them lightly with wash. He drew 'fantastic heads' of individuals in the flower of youth, and of old men with frowning faces who seem to conceal a deep and incommunicable wisdom. In a

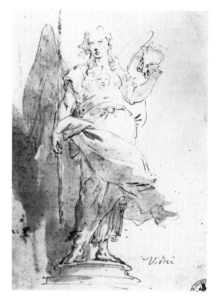

26 Allegorical statue representing Virtue
Trieste, Civici Musei di Storia ed Arte

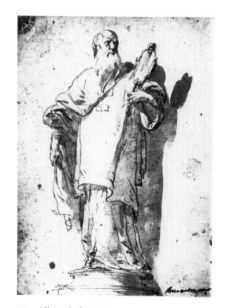

27 Allegorical statue
Trieste, Civici Musei di Storia ed Arte

figs. 26-7

pl. 33

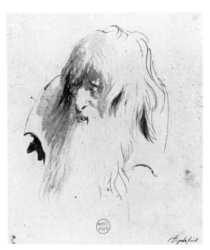

28 Old man's head
Montpellier, Musée Atger

pl. 37 later set of *Single costumed figures* in the Victoria and Albert Museum, both the figures themselves and their costume are imaginary and seem to belong to some unlikely Eastern country, like those in Carlo Gozzi's play *Turandot, fiaba chinese teatrale tragicomica.* Tiepolo was no less imaginative in his landscape series *Great trees,* now in the Civici Musei di Storia ed Arte in Trieste, in which nature is transformed into a highly decorative theme. These drawings have been dated about 1740 (Vigni, 1972).

Tiepolo's style clearly developed while working on the drawings for the fresco entitled *The course of the chariot of the sun,* commissioned by Marquis Giorgio Clerici, marshal to the empress of Austria, Maria Theresa, for the ceiling of the salon of his palace in Milan in 1740. This was Tiepolo's largest composition so far. The ceiling and its surround had to be filled with a great number of figures in isolation and in groups, taken from the vast allegorical repertoire of the Baroque period with its strongly theatrical flavour. Tiepolo recreated the familiar deities of air, earth, water, satyrs, nymphs, winged cupids and personifications of the arts, sciences and continents. The characters of the *grand teatro* of the Baroque, recreated with a new delight in the exotic and picturesque, make their appearance in an immense pictorial *divertimento.* Intended to glorify the benevolent power of the enlightened sovereign, this became in fact an apotheosis of the imaginative and creative power of the artist himself, and his immense ability to charm and delight. It was not long before both he and his work were highly praised in a collection of poems.

The very theme of the *Chariot of the sun* implied a glorification of light, and that is one of the most remarkable aspects of the drawings connected either directly or indirectly with this commission. Most of the drawings are now preserved in the Fondazione Horne in Florence, and the Metropolitan Museum and the Pierpont Morgan Library in New York, and they are certainly among the masterpieces of European art. The white paper provides a luminous background from which the artist's line emerges, outlining the images and figures, suspending them before us untouchably at the furthest limits of our space. It is only certain painters of the Far East who have been able to give the whiteness of their paper this luminous quality, with such a brilliant sense of immediacy. It is these qualities above all that characterize Tiepolo's

fig. 29 drawings of the 1740s – possibly his most creative period in this sphere of art.

Tiepolo, then, created a mysterious world of sunlight filled with images floating in space and not bounded by the law of gravity. Significantly, it was also in about 1740 that a further very distinctive set of drawings appeared, most of them now in the Victoria and Albert Museum, and closely related in theme to the two series of etchings known as the *Capricci* and the *Scherzi di Fantasia.* Their titles – *capriccio* and *scherzo* – are taken from musical terminology where they referred to instrumental pieces without a clearly defined form, but with a lively rhythm and original structure, and full of unexpected passages. In the language of eighteenth-century visual aesthetics, the same words indicate a fantastic or extravagant artistic inspiration and generally refer to compositions without an easily recognizable subject, resulting from a whim of the imagination and intended to please a new kind of collector or connoisseur (such as the Venetians Anton Maria Zanetti the Elder and Francesco Algarotti). According to Knox (1960), such men 'cultivated something of an "art for art's sake" attitude' and 'valued the individuality of a painter and defended his right to the free use of imagination'.

Although the sources of some of the motifs used in these artistic fantasies have been traced – above all to the engravings of Benedetto Castiglione – no one has been able to decipher or account in any way for the thematic content of Tiepolo's *Capricci* and *Scherzi.* The most common view is that they were a kind of game, produced by the artist as a playful distraction from his great religious and profane works. More recently, however, they have become accepted as the products of periods of intense artistic concentration in which not only the imagination played a leading part (Kozloff, 1961), but scepticism and irony have been forcefully expressed. This is undoubtedly true in the case of Tiepolo's *Scherzi,* which reach mysterious depths. Soothsayers in Oriental robes, warriors with ancient weapons, and naked shepherds and youths, all have walk-on parts in the historical scenes depicted by Tiepolo. In his *Scherzi,* however, the same figures are seen in remote places strewn with classical remains such as obe-

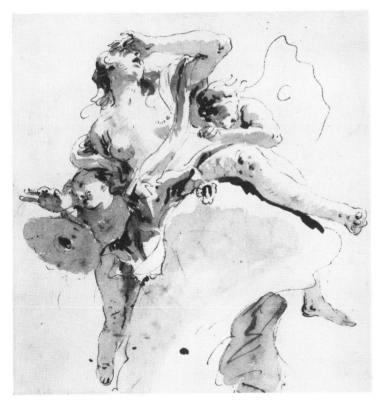

29 Psyche taken up to Olympus
New York, Private collection

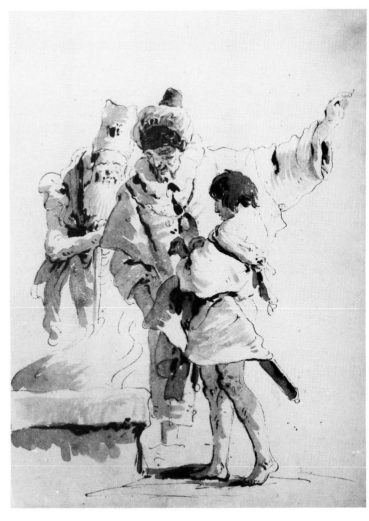

30 Scherzo di Fantasia
New York, Metropolitan Museum of Art

lisks, sarcophagi and altars, but also with the emblems and tools of the magician's trade. They seem to thrust themselves forward to take part in exorcisms and acts of necromancy, or to examine with feverish curiosity something hidden in the ashes of powdered bones. Under the cloak of a seemingly relaxed form of art, the artist is using these images, with their antitheses of youth and old age, life and death, primitive instinct and ancient wisdom, to ask searching questions about the human condition which transcend the generally accepted framework of sense. All possible answers are quickly exposed as vain. All is presented as an insoluble enigma, in an atmosphere of endless suspense.

Into this imaginary space, where everything appears both mysterious and vain, solemn and gratuitous, Tiepolo introduces Pulcinella or Punchinello, the most popular character in the Commedia dell'Arte, who had already been used by such artists as Alessandro Magnasco and Pier Leone Ghezzi. By introducing Punchinello into his private world of fantasy, Tiepolo extended his art to the theatre of the common people with its improvised drama, its potential for mockery and ridicule, and the theme of illusion implied in the use of the mask. Tiepolo's Punchinello has a long hooked nose, a hunchbacked dwarfish body and a tall cylindrical hat which points to an essentially phallic significance. Masked characters in Italian comedy of the period generally play a stereotyped and rigidly determined rôle. Punchinello, however, was not limited in this way, and could reproduce himself by a kind of parthenogenesis, playing several different parts at the same time. His costume never changed, but his rôle was infinitely

pl. 38

31 Study for the figure of Antonio Bossi
Venice, Museo Correr

pls 21-5

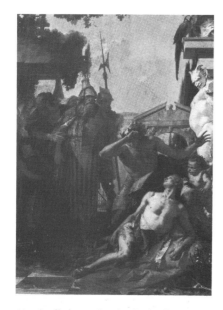

32 Apollo lamenting the death of
Hyacinthus
Castagnola, Thyssen-Bornemisza Collection

variable, with the result that he can be seen simultaneously as one and as many. His real self remained essentially elusive. He appears alone in the *Scherzi di fantasia,* but in the drawings in which Tiepolo developed the Punchinello theme between about 1735 and 1760 (Morassi, 1959), he is usually surrounded by other Punchinellos, so that we have the impression that this whole race has been excluded from the great history paintings and that their presence here reveals those works as fundamentally false.

Ghezzi's Punchinellos are simply buffoons; but Giambattista Tiepolo's Punchinello scenes do not make us laugh. They are utterly serious and even tragic. His Punchinellos are physically deformed, and the artist shows them shamelessly satisfying nature. All the while, their masks hide their real identity and keep them at a distance from the viewer. The viewer, in turn, is drawn into Punch's twisted visual world, where he joins in the game in the guise of a caricature. Complementary to the masked Punchinello, caricature unmasks the individual. His physical defects are revealed; he is seen as simply external, put on show as a figure of fun. Through Punchinello, that anti-hero of the popular theatre, Tiepolo was able to employ his imagination in the caustic observation of society fundamental to caricature.

Two other Venetians, Marco Ricci and Anton Maria Zanetti, drew caricatures that were really no more than a regression to the scribblings of childhood. Tiepolo's caricatures, executed in as 'noble' a style as his other drawings, have a value and a meaning which go far deeper than a mere relaxation of the creative imagination (as Max Kozloff pointed out in his penetrating essay on the subject, 1961). They reflect a fundamental aspect of Tiepolo's artistic vision: his interest in revealing the comic 'truth' of individual humanity, the antithesis and complement to the sublime 'invention' of fables, allegories and other narrative and pictorial forms. It was this aspect of Giambattista Tiepolo's work that played a decisive part in the artistic development of his son Giandomenico, which began in earnest in about 1740 when he was working as an apprentice in his father's studio.

Giambattista's first drawings in charcoal and red chalk (sanguine) can be dated to this time. They are often heightened with white chalk, and most of them are on bluish paper. Together with the drawings of his sons Giandomenico and Lorenzo using the same technique, they form a most impressive body of work. They are, unlike his pen-and-wash drawings, detailed preparatory studies for paintings and frescoes, including isolated figures and parts of the human body such as heads and hands, often drawn from life. Giandomenico, Lorenzo, and other assistants, must have copied these drawings, thus acquiring his style and the skill they needed to collaborate with him (Knox, 1980).

There is, in fact, little agreement between art historians as to whether most of these drawings should be attributed to Giambattista or not. Doubt persists in particular in the case of those relating to the magnificent frescoes painted between 1750 and 1753 with the help of his son Giandomenico in the Kaisersaal, and on the ceiling of the great staircase of the Residence of the Prince-Bishop of Würzburg. The most creative of these drawings, especially those showing isolated figures, are generally attributed to Giambattista. They give the impression, because they are in certain respects different from the same figures in the finished painting or fresco, that they are preparatory studies or 'first ideas'. There is also continued controversy over a set of minutely detailed drawings, most of which are now preserved in the Graphische Sammlung of the Staatsgalerie, Stuttgart. The debate can be reduced to two basic standpoints. According to the first view, held by Hadeln and Knox, these drawings are accurate studies made by Giambattista for use as cartoons. Other experts, including Hertzer, von Freeden and Lamb, Seilern, Byam Shaw, Morassi, Pignatti and Vigni, have suggested that they are copies made by Giandomenico, and in certain cases by Lorenzo or other artists, to preserve a record of the frescoes. This is the hypothesis I personally favour, but to go into it further would call for a minute commentary on each drawing concerned.

Among the comparatively rare pen-and-wash drawings executed by Giambattista Tiepolo at more or less the same time as he was decorating the Würzburg Residence, is a remarkable set of preparatory studies for the picture *Apollo and Hyacinthus.* This painting is now in the Thyssen-Bornemisza Collection at Lugano. The series contains many different experimental

compositions, in which the lines are interlaced and even entangled, and the wash-shading gives a dramatic effect. Tiepolo's imagination was clearly stirred by the theme of the god of light mourning his dearest friend whose death he· had caused. Tiepolo had already painted Apollo in triumph in an immense sky, and he now had the task of depicting the sorrow of this most Olympian of gods, stricken by the revenge of Dionysus, god of passion and tragic destiny, whom the artist shows in his picture as a pale, satyr-headed herm-figure dominating the scene with his derisive laughter.

A drawing now in the Victoria and Albert Museum, intended for the composition of a fresco in the Villa Valmarana near Vicenza, shows *Angelica and Medoro,* and is based on these studies. There is an interesting contrast between the strikingly emblematic composition of his *Apollo and Hyacinthus* and the emergence here of an emotional emphasis in his work, bordering almost on the sentimental. Tiepolo is undoubtedly responding to the requirements of his patrons, whose modern tastes inclined to a form of art that appealed to the heart rather than one that was either grandiloquent or hedonistic. He tried to satisfy this need in his frescoes for the Villa Valmarana, with their elegiac mood and their intimate atmosphere. On other sheets in the same series he sketched the gods of classical antiquity. They appear as fleeting figures surrounded by light, captured by the artist just as they are about to vanish. His rapid shorthand line gives these creations their ephemeral quality.

His son Giandomenico also worked in the Villa Valmarana, showing his originality as an artist in his attempt to depict contemporary attitudes and practices. His approach was empirical, but at the same time humorous, providing a touch of comedy complementary to the mythic drama staged by his father. Goethe, when he visited the villa in 1786, much admired Giandomenico's 'natural style' (in contrast to the sublime). Nor was Giambattista's own style entirely alien to this quality of naturalness: two of his extraordinary landscapes, drawn after nature and revealing powers of observation entirely free of all preconceived ideas, date from the time when he was decorating the Villa Valmarana. It is as if he surveyed the country in the immediate vicinity of the villa from a point far above it in the sky, and fastened upon one or two details of no importance in themselves; his almost exclusive concern was to reproduce the effects of light. Very little of the architecture of the villa itself is included in these drawings – the upper part of the entrance above a wall made dazzling by the sunlight, for example, or the stable roof. In other drawings, as Knox has pointed out, the theme is a rustic portal, a farmyard with a well, or the pilasters of a gate. These architectural themes usually appear above an area of light provided by the white paper, so they give a similar impression tó that made by Tiepolo's allegorical and mythological figures floating on white clouds.

He continued to paint huge frescoes on the ceilings of palaces for as long as he could. This was his public work, done for the glory of rich patrons. At the same time, however, he expressed his inner life with increasing frequency, revealing his personal moods and his states of mind, in his drawings. The bent figure of an aged Punchinello, the drawing showing Punchinello alone on his deathbed, and a number of caricatures in which physical deformity is mercilessly exposed yet rendered grandiose in its effect, may all date from these later years.

Much of the intimate and personal art produced by Giambattista Tiepolo towards the end of his career has to do with domestic life and affection. Perhaps the most perfect expression of this is to be found in the wonderful series of variations on the theme of the *Holy Family.* He drew about seventy of these while suffering from gout that severely restricted his activities as a painter (Knox, 1970). They are diverse in composition and treatment, but together express almost every possible aspect of family love and emotion. His pen traces the bonds of affection uniting the Virgin, the infant Jesus and the elderly Joseph, with the spontaneity and the pure beauty of an arabesque.

In 1762 the artist left for Spain. He was never to return to his native Venice. Before his departure, he gave the album containing his drawings of the Holy Family to his son Giuseppe Maria, a canon regular in the Somasco convent of S. Maria della Salute in Venice. Handing them over for safe keeping to a son in holy orders would seem to indicate that he regarded these drawings as especially important – that they were his spiritual will and testament.

fig. 32

33 Punchinello
Formerly in Rome, Apolloni Collection

pls 11-13, 32

fig. 33 34 Caricature
fig. 34 Trieste, Civici Musei di Storia ed Arte

fig. 35 pls 42-3

35 Punchinello on his deathbed
New York, Private collection

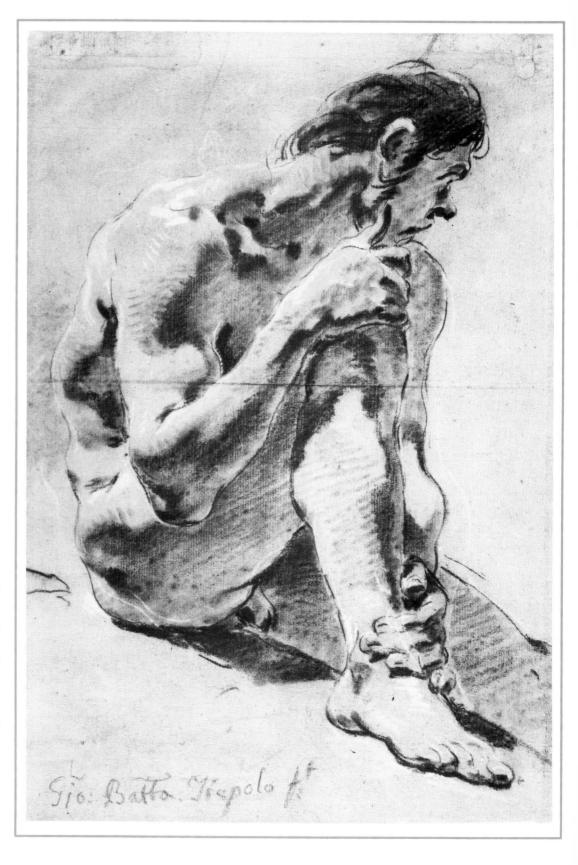

1 A seated male nude

Black chalk and sanguine on buff-
coloured paper
350 × 240
Inscription in red: *Gio: Batta. Tiepolo
ft.*

Stuttgart, Graphische Sammlung
Staatsgalerie (1439)

This impressive drawing is usually
dated between 1720 and 1725 and
is one of an important group of
youthful drawings. It is difficult to
be sure whether the inscription is
an authentic signature, since
Giambattista rarely signed his
drawings.

Ref.: Knox-Thiem 1970 No. 1; Knox
1980 M. 336

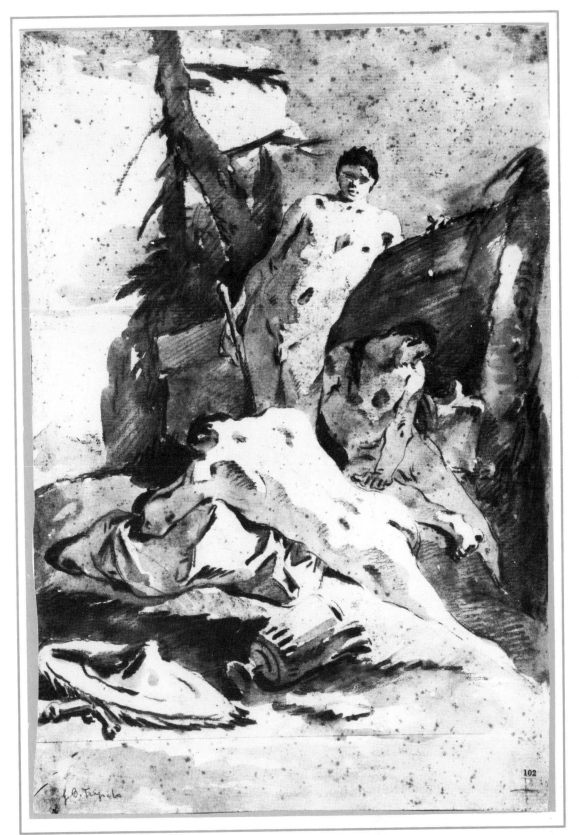

2 Three nude men in a landscape

Sanguine and reddish wash on pencil
sketch
390 × 265

Udine, Civici Musei e Gallerie di
Storia ed Arte (Cat. 102)

Pignatti, who was the first to draw
attention to this drawing, regards
it as the 'exemplary basis' for
several of the drawings preserved
in the Victoria and Albert Museum
and suggests that it should be
dated between 1720 and 1725.

Ref.: Udine 1965 No. 4

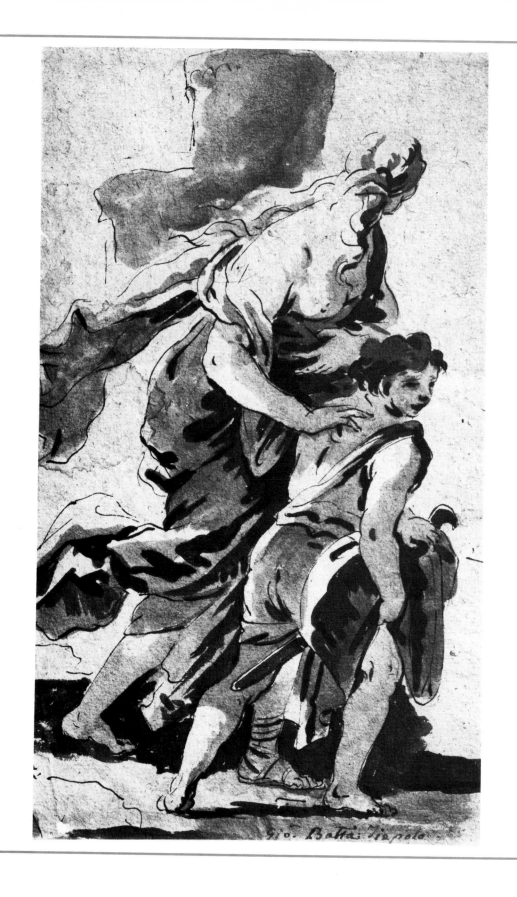

3 The expulsion of Hagar

Pen and wash on grey-brown paper
300 × 170
Inscription: *Gio. Batt. Tiepolo.*

Stuttgart, Graphische Sammlung
Staatsgalerie (1424)

Knox, who dates this drawing
'about 1725', compares it with a
study preserved in the Victoria and
Albert Museum and carried out in
connection with the decorations of
the Palazzo Sandi-Porto in Venice
that were completed in 1725.

Ref.: Knox-Thiem 1970 No. 2

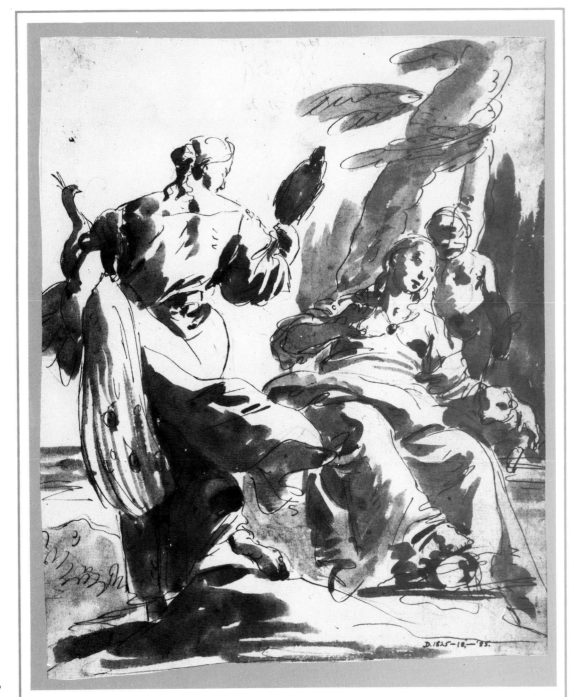

4 Humility disregarding Pride

Pen and wash on pencil sketch
220 × 179
Inscription in red: *Gio: Batta. Tiepolo ft.*

London, Victoria and Albert Museum (D.1825.18 - 1885)

This page is part of an important group of studies made for the frescoes of the Villa Loschi at Birone near Vicenza, dated 1734.

Ref.: Knox 1975 No. 11

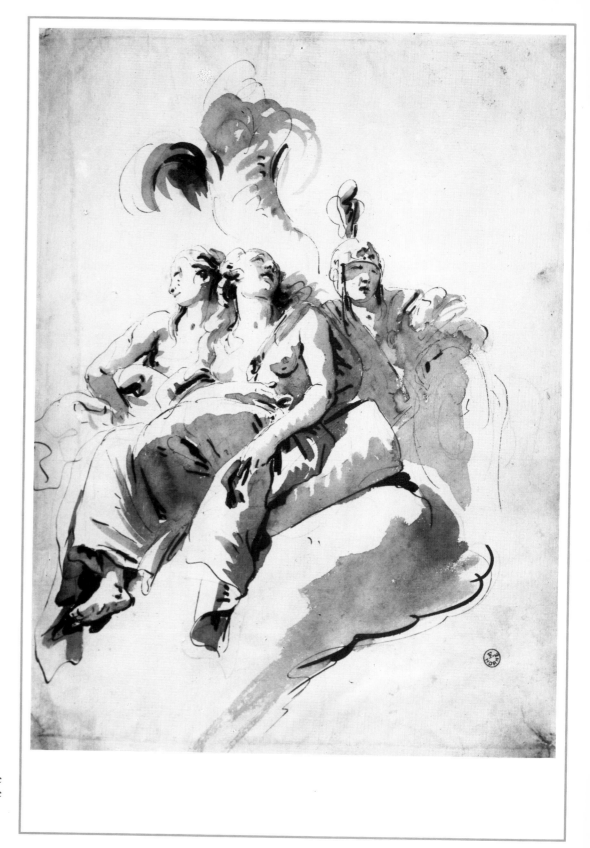

5 Three women on clouds

Pen and wash
380 × 290

Florence, Gabinetto Disegni e Stampe degli Uffizi (Fondazione Horne) (6318)

Ref.: La Strozzina 1963 No. 131

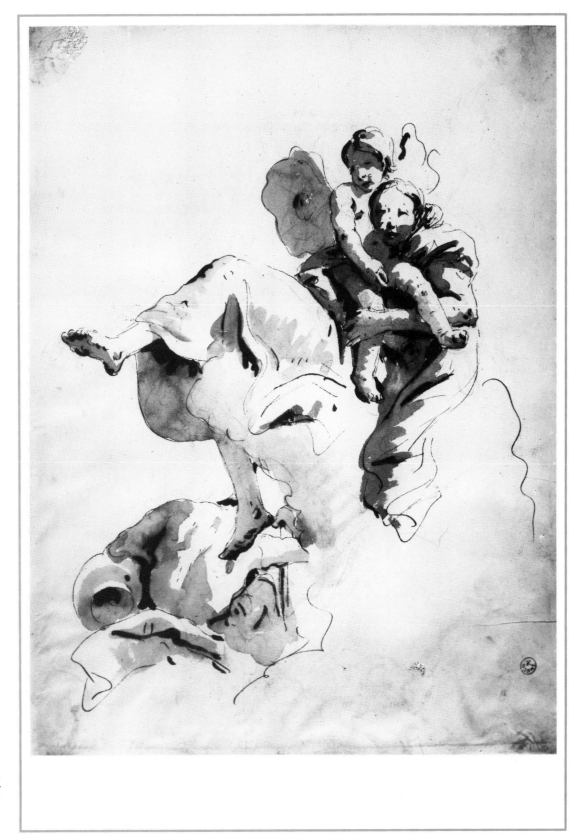

6 Psyche and a cupid

Pen and wash
350 × 275

Florence, Gabinetto Disegni e Stampe degli Uffizi (Fondazione Horne) (6327)

Study for the picture *The Triumph of the Arts* kept at the Museum of Vicenza and dated 1744.

Ref.: La Strozzina 1963 No. 139

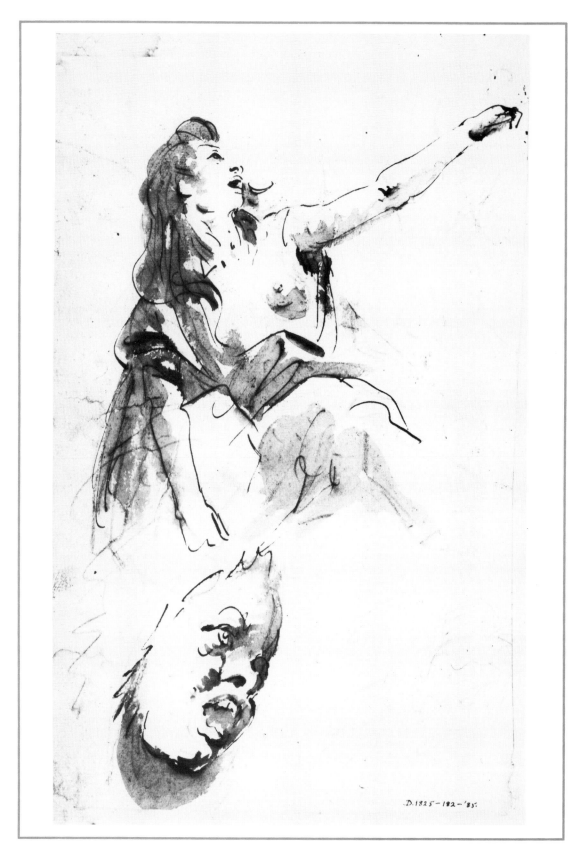

7 A seated woman, and the face of an African child

Pen and wash on pencil
305 × 197

London, Victoria and Albert Museum (D.1825.182 - 1885)

This study, executed with great verve, cannot be directly linked with any of Tiepolo's paintings.

Ref.: Knox 1975 No. 33

Giambattista Tiepolo

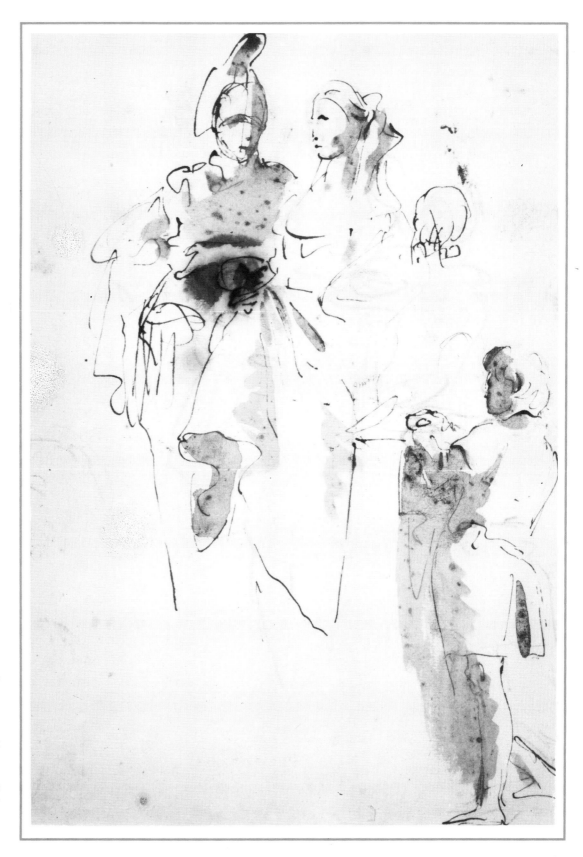

8 A Roman soldier and a lady,
waited upon by a page

Pen and wash on black chalk
302 × 212

London, Victoria and Albert
Museum (D.1825.186 - 1885)

According to Knox, this drawing is
based on an ancient marble repre-
senting Telamon and Hesione.

Ref.: Knox 1975 No. 69

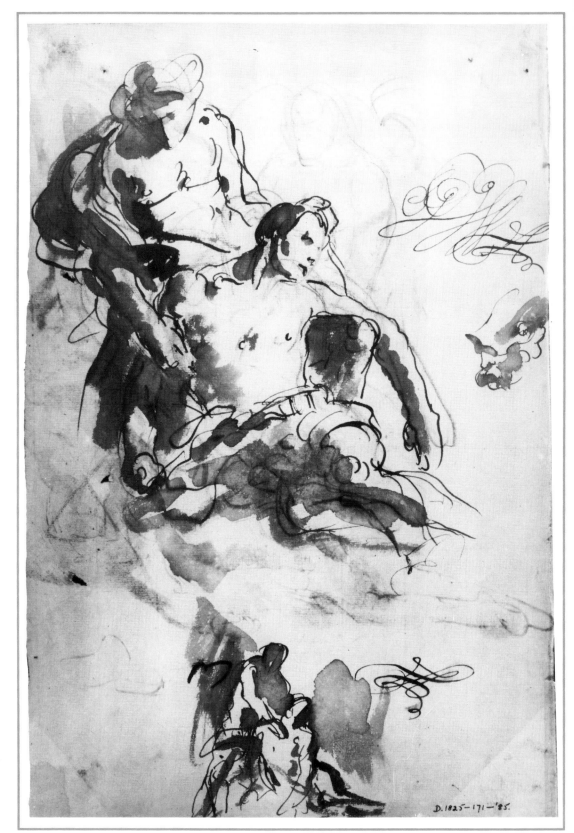

9 Apollo and Hyacinthus

Pen and bistre wash on sanguine
324 × 222
On the verso: another study for the
same subject

London, Victoria and Albert
Museum (D.1825.171 - 1885)

·Two preparatory studies for the
picture *Apollo and Hyacinthus*
preserved in the Thyssen-
Bornemisza Collection at Casta-
gnola Lugano.

Ref.: Knox 1975 No. 186

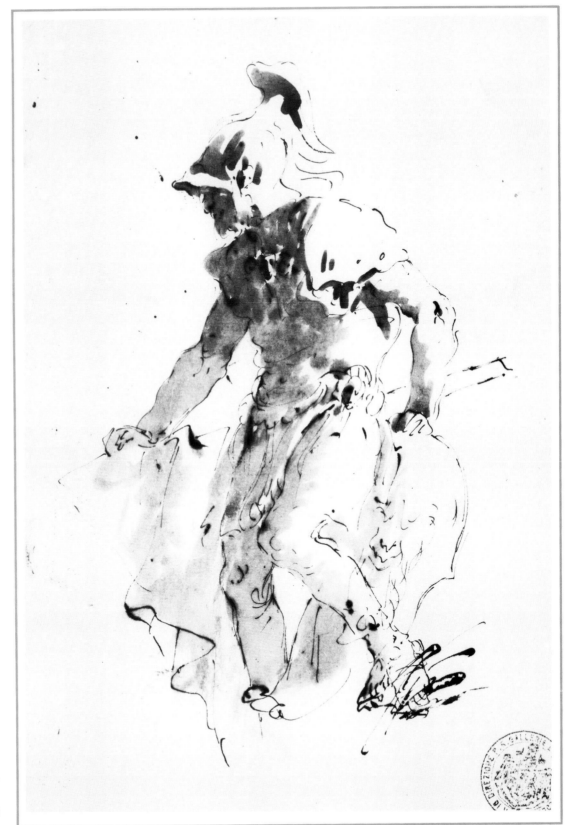

10 Figure of a warrior

Pen and wash
267 × 189

Trieste, Civici Musei di Storia ed
Arte (1894)

This drawing, made with very free
strokes of the pen and brush, is
one of a group of drawings, several
others of which are also preserved
at Trieste. Vigni has connected
them with two paintings - *Alexan-
der and Diogenes* (Bologna,
Modiano Collection) and *Alexan-
der and Campaspe in Apelles' stu-
dio* (Paris, Louvre) - and has sug-
gested a date 'between 1735 and
1740'.

Ref.: Vigni 1972 No. 76 (1942
No. 32)

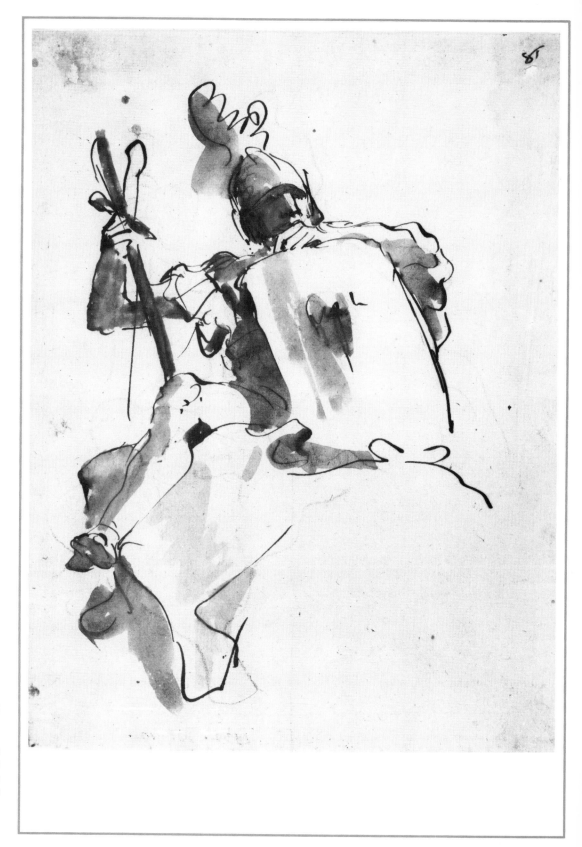

11 Mars

Pen and wash
232 × 172
Marked *81* in top right-hand corner

Stuttgart, Graphische Sammlung
Staatsgalerie (1435)

Specialists' opinions about this
drawing, which is very similar to
the following one, are divided as
to its connection with the frescoes
in the Villa Valmarana.

Ref.: Knox-Thiem 1970 No. 19

Giambattista Tiepolo

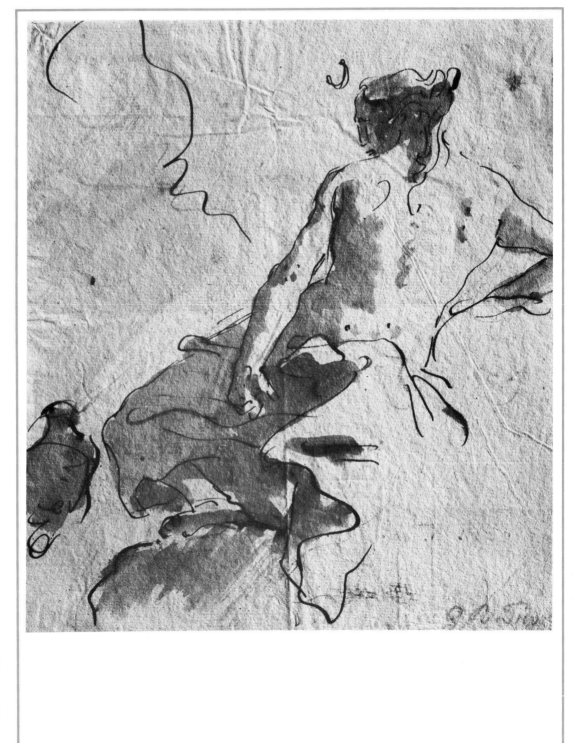

12 Diana

Pen and wash on black chalk
188 × 172
Pencil inscription: *G.B. Tiepolo*

Stuttgart, Graphische Sammlung
Staatsgalerie (1434)

Knox believes that this drawing is
a study for one of the frescoes in
the Villa Valmarana near Vicenza.
The opinion is confirmed by four
drawings made for the same room
and preserved in the Victoria and
Albert Museum, to which the fol-
lowing drawing also belongs.

Ref.: Knox-Thiem 1970 No. 18

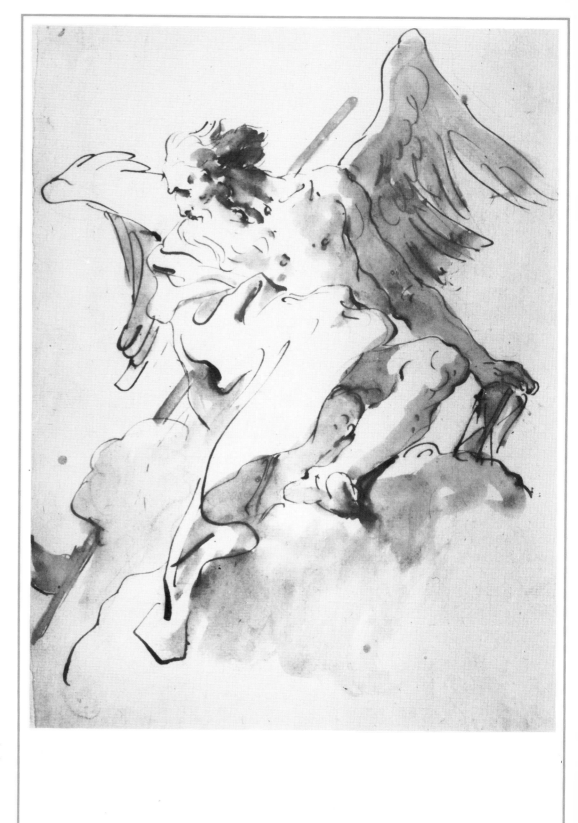

13 Chronos

Pen and wash on black chalk sketch
222 × 172

London, Victoria and Albert
Museum (D.1825.18 - 1885)

This spectacular drawing is one of
a group made for the frescoes of
the Stanza dell'Olimpo in the Fos-
teria of the Villa Valmarana near
Vicenza.

Ref.: Knox 1975 No. 255

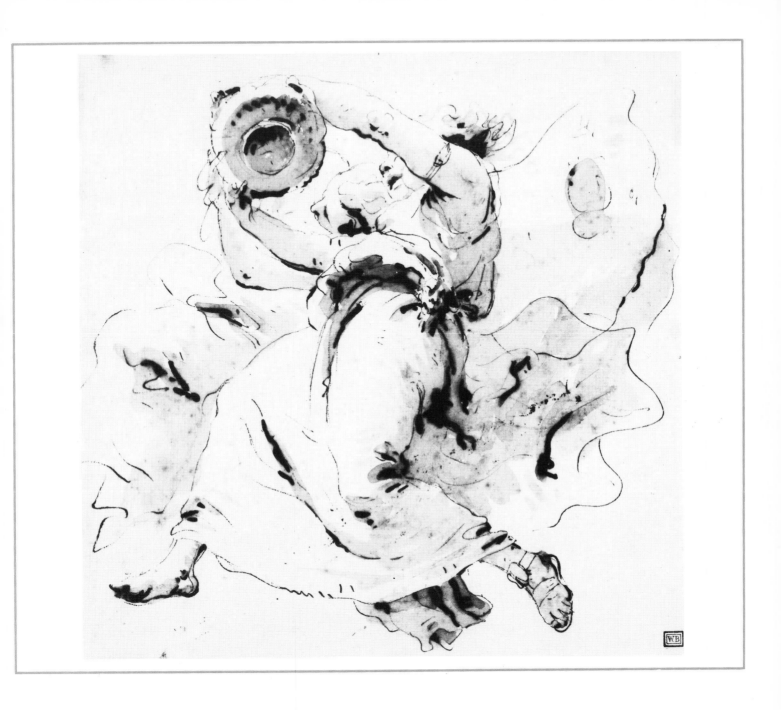

14 Two winged bacchantes holding an urn

Pen and wash 232 × 237

England, private collection

This very lively drawing is apparently not connected with any particular work by the master.
Knox dates it to the 1740s.

Ref.: Cini 1980 No. 74

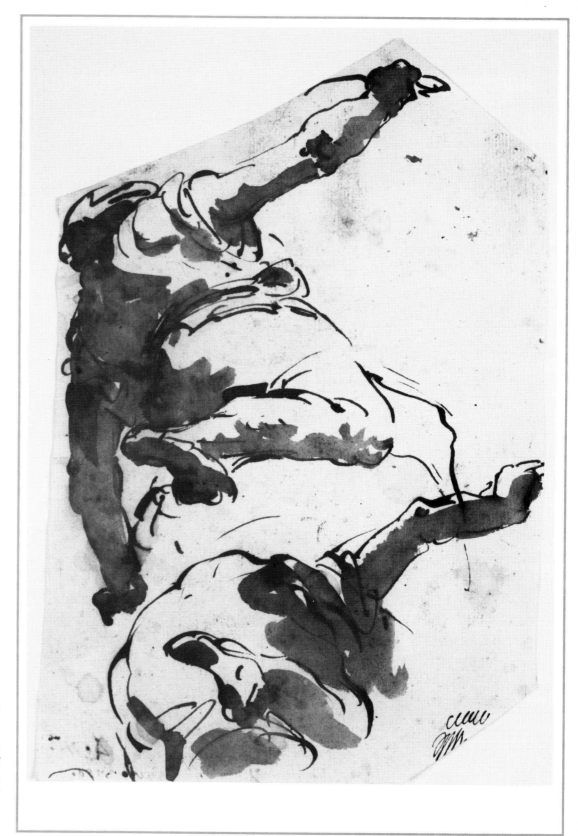

15 Two figures seen from below

Pen and wash
218 × 150 (unevenly trimmed)

Stuttgart, Graphische Sammlung
Staatsgalerie (1431)

Knox thinks that this group of stu-
dies may belong with a number of
important studies preserved at the
Pierpont Morgan Library in New
York.

Ref.: Knox-Thiem 1978 No. 12

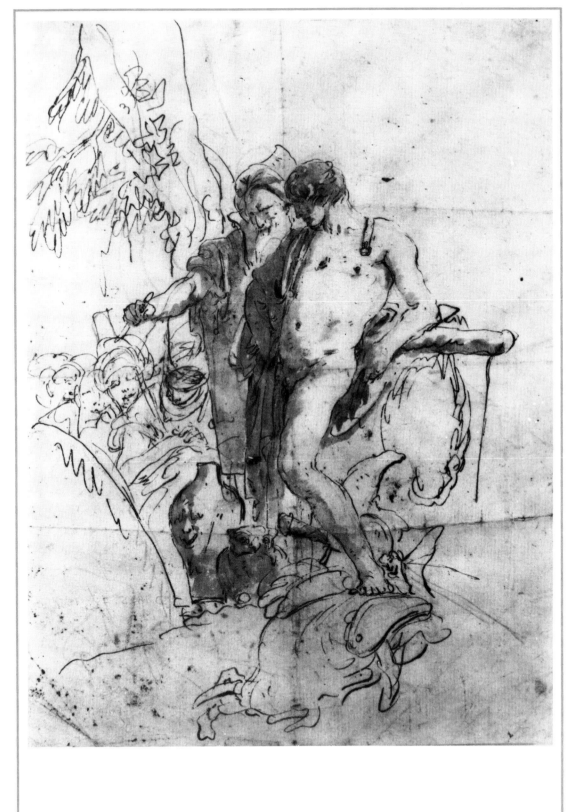

16 A young man and a magician leaning on an altar

Pen and wash
207 × 153

London, Victoria and Albert Museum (D.1825.41 - 1885)

In the second edition of his catalogue of Tiepolo's drawings in the Victoria and Albert Museum (1975), Knox has concluded that this drawing should be included among the studies made by the artist for his famous series of etchings of the *Scherzi,* which, together with the *Capricci,* have been dated about 1749.

Ref.: Knox 1975 No. 45

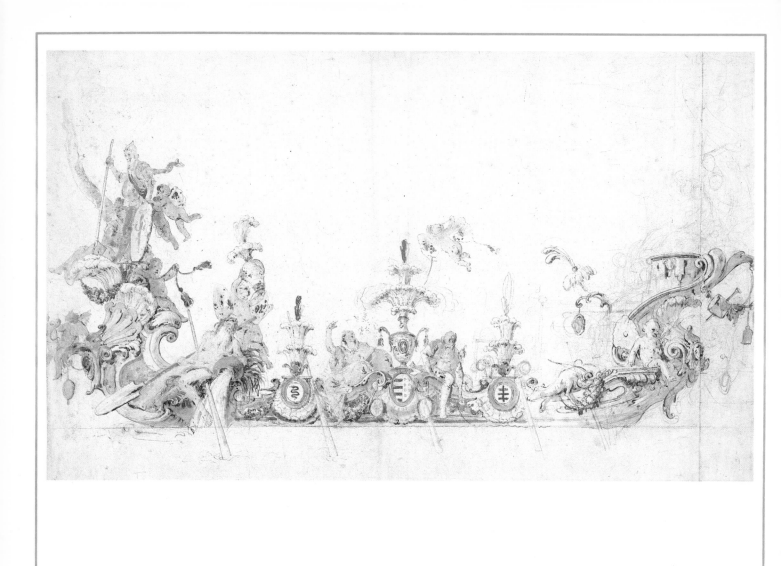

17-18 Design for a *bissona*

Pen and watercolour on black chalk on two joined pieces of paper 469 × 789

England, private collection

This is one of the most magnificient of all the Venetian designs for richly decorated boats. It can be
compared with the *bissone* of Francesco Guardi (Nos 126-7).
The three coats of arms on the side of this fantastic vessel have so far not been identified.

Ref.: Cini 1980 No. 80

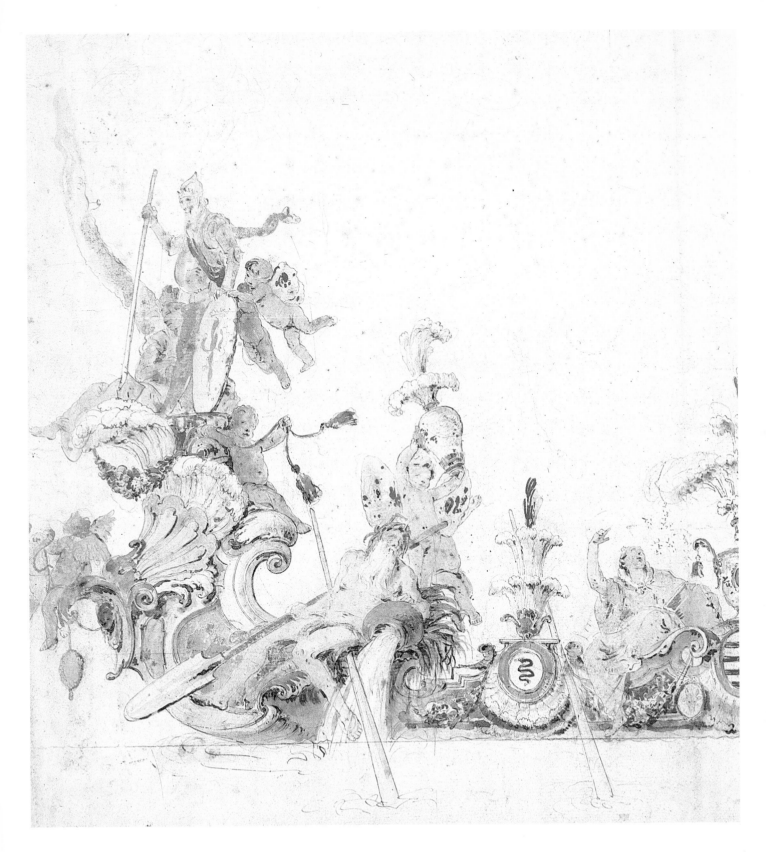

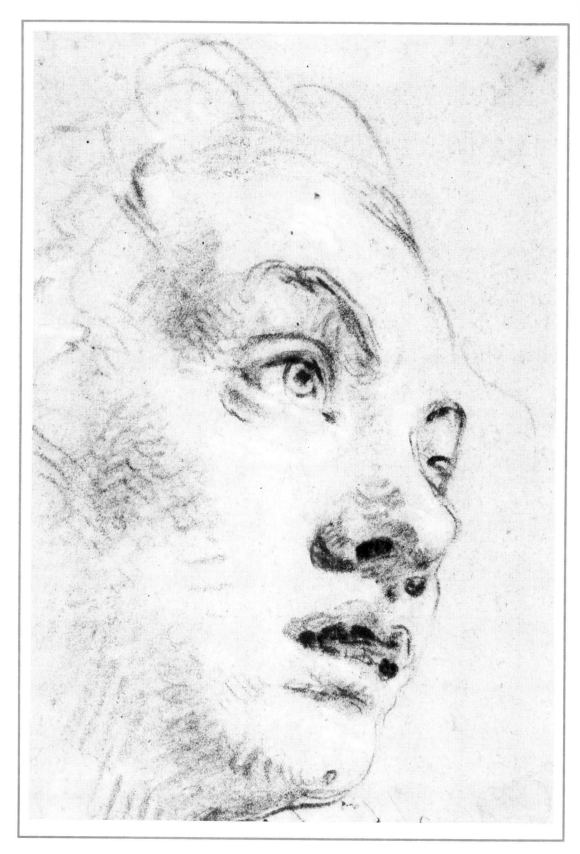

19 Woman's head facing right

Red and white chalk on blue paper
197 × 133

England, private collection

Angela Krahe was the first to rec-
ognize that this fine drawing was a
study for the head of Abigail in
the picture *David and Abigail*,
preserved in the Fürth Museum,
which Morassi dated about 1751-3.

Ref.: Cini 1980 No. 76

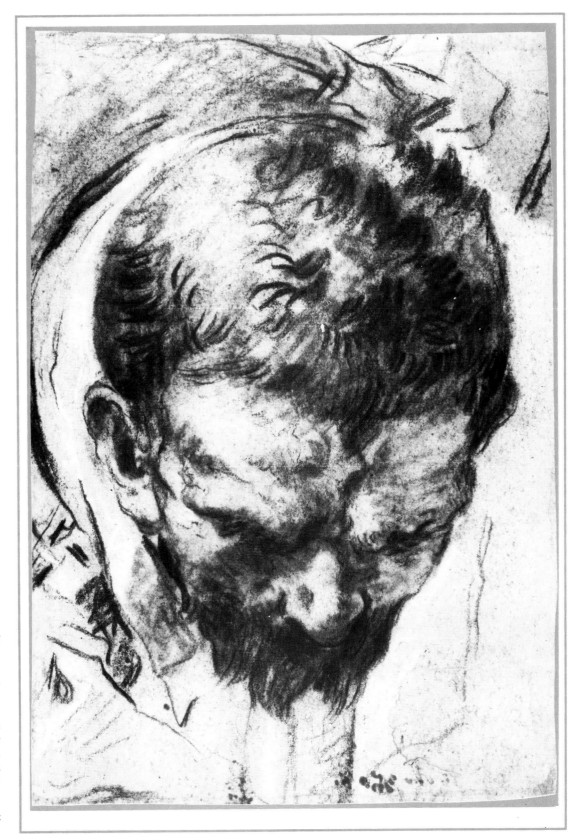

20 Foreshortened man's head

Black and white chalk on blue-grey paper
260 × 182

Oxford, The Visitors of the Ashmolean Museum (1080)

Study for the soldier in the bottom left-hand corner of the fresco made in 1749 at the Villa Cordellina in Montecchio Maggiore near Vicenza and illustrating *The magnanimity of Scipio* .

Ref.: Parker 1956 No. 1080; Knox 1980 M. 662

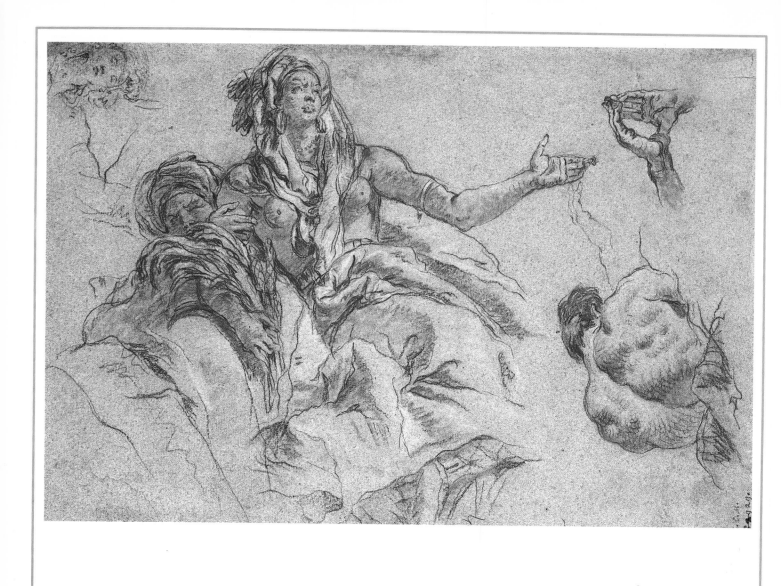

21 Africa

Red and white chalk on blue paper 257 × 393
On the verso: *America.*

Stuttgart, Graphische Sammlung Staatsgalerie (1477)

Study for the figure personifying Africa in the fresco of the great staircase of the Würzburg Residence.
The sketches on the right of this splendid page are connected with the Asia group in the same fresco.

Ref.: Knox-Thiem 1970 No. 90; Knox 1980 M. 363

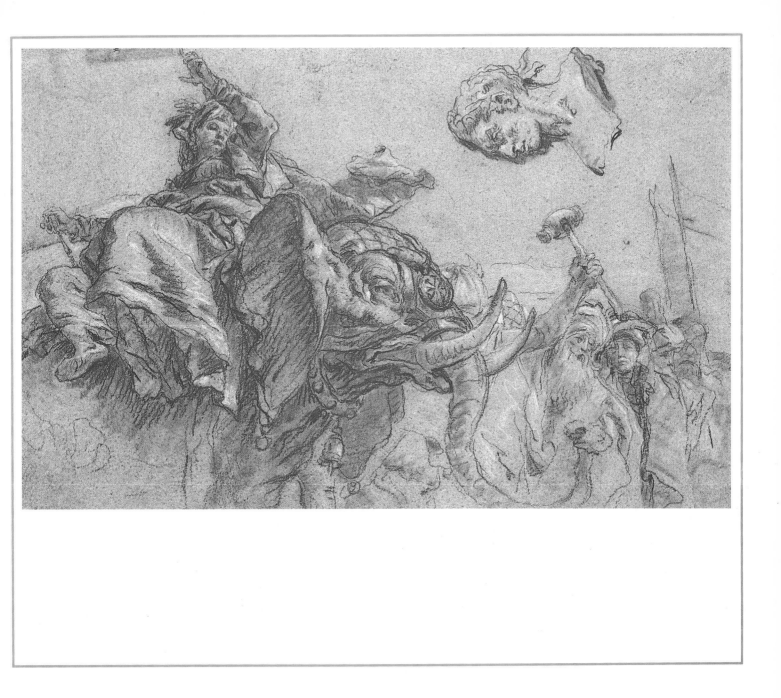

22 Asia

Red and white chalk on blue paper 262 × 402
On the verso: sketch for the Nile in the Africa group of the same fresco

Stuttgart, Graphische Sammlung Staatsgalerie (1478)

Study for the figure representing Asia in the fresco on the ceiling of the great staircase of the Bishop's
Residence at Würzburg.

Ref.: Knox-Thiem 1970 No. 93; Knox 1980 M. 366

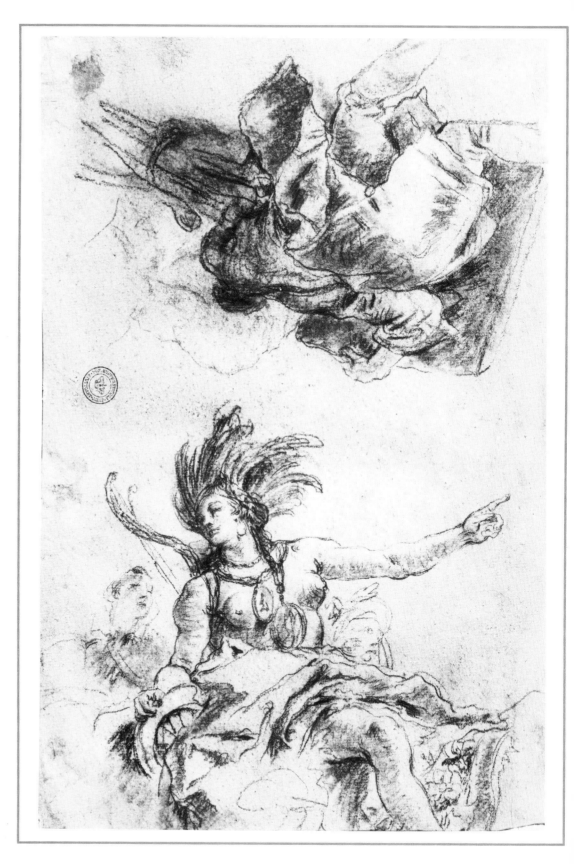

23 (21 verso) Studies for two
figures in the *America* group

See No. 21 (recto).

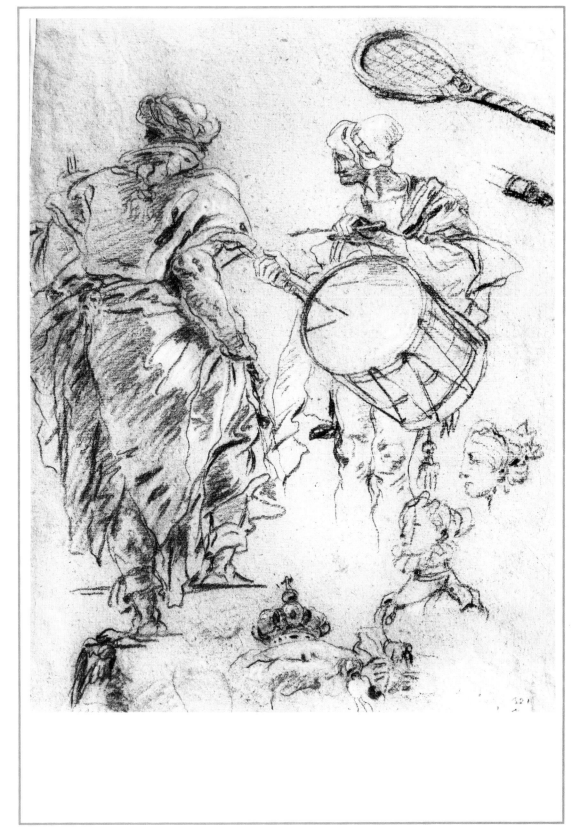

24 Details for the frescoes in the Kaisersaal of the Würzburg Residence

Black and white chalk on blue paper
970 × 280
On the verso: a right hand (in sanguine) by Domenico Tiepolo

Stuttgart, Graphische Sammlung Staatsgalerie (1486)

The figure of the man on the left can also be found in the part of the fresco devoted to the *Investiture*, and the drum is on the left in that group. With the exception of the racket, which is found in the picture *The death of Hyacinthus*, at present in the Thyssen-Bornemisza Collection at Castagnola Lugano (see figure 32), the other details refer to the *Marriage* part of the fresco.

Ref.: Knox-Thiem 1970 No. 82; Knox 1980 M. 355

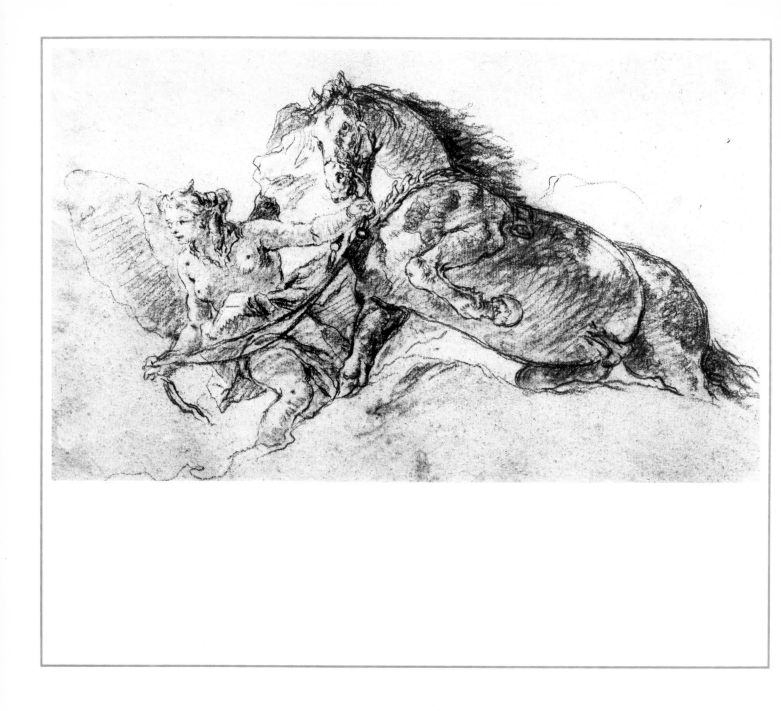

25 Aurora leading a sun-horse by the bridle

Sanguine and white chalk on blue paper 216 × 365
On the verso: two studies of a forearm (in black and white chalk)

Stuttgart, Graphische Sammlung Staatsgalerie (1476)

Study for a detail above the *Africa* group in the fresco on the ceiling of the staircase in the Würzburg
Residence.

Ref.: Knox-Thiem 1970 No. 95; Knox 1980 M. 368

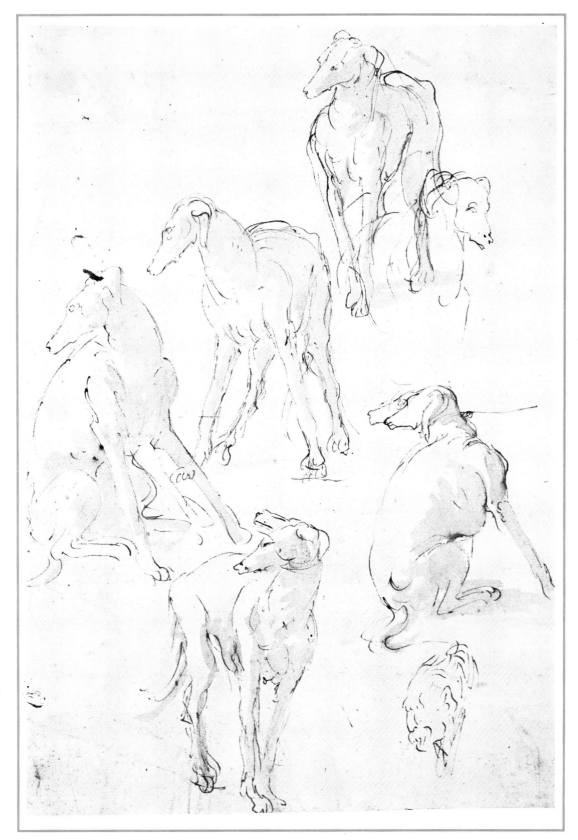

26 Dogs

Pen and wash
254 × 180

Trieste, Civici Musei di Storia ed Arte (2048)

There are four pages of studies of dogs in the Trieste Museum. Vigni has noted a stylistic connection between these and the drawing in the same collection of three nude men, precisely dated - which is very rare in the case of Tiepolo - to 17 February 1744.

Ref.: Vigni 1972 No. 120 (1942 No. 189)

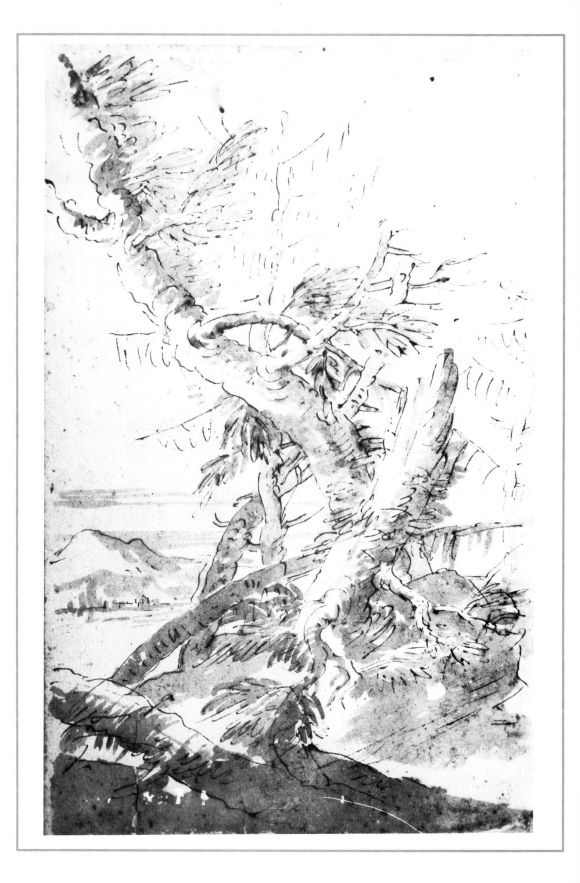

27 Landscape

Pen and wash
500 × 320

Trieste, Civici Musei di Storia ed
Arte (2040)

There is a series of eleven 'land-
scapes' in the Trieste Museum
(Vigni 1975 Nos 60-70) of a very
different kind from the drawings
illustrated here in Nos 29 to 32. In
the second edition of his catalogue
Vigni has dated these between
1735 and 1740, and regards them
as 'fantastic' studies made in con-
nection with certain paintings
done for Verolanuova.

Ref.: Vigni 1972 No. 62 (1942
No. 181)

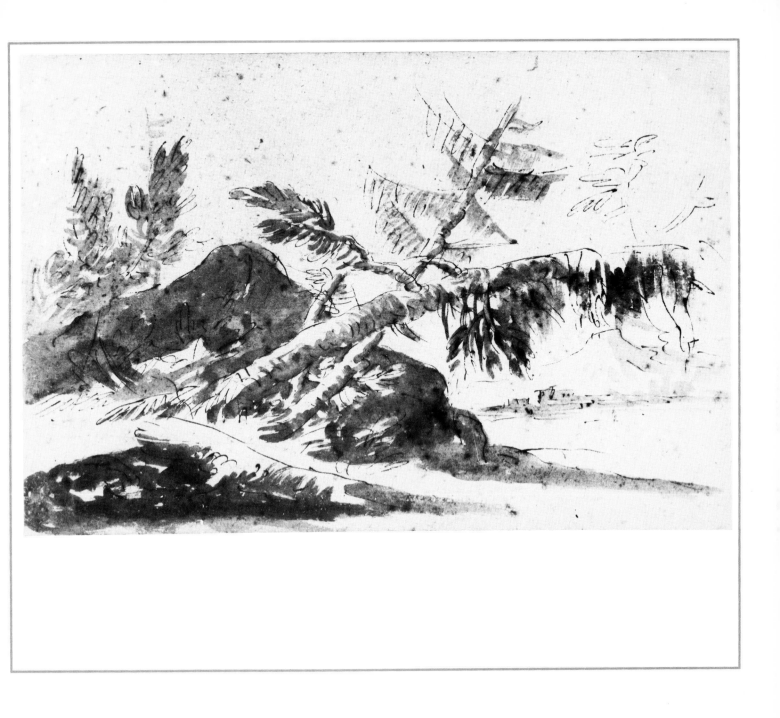

28 Landscape

Pen and wash 323 × 499

Trieste, Civici Musei di Storia ed Arte (2044)

See the previous number.

Ref.: Vigni 1972 No. 70 (1942 No. 185)

29 Udine Cathedral

Pen and wash 117× 200

Cambridge, Fitzwilliam Museum (PD 29 - 1959)

This drawing and the three that follow form part of *Un quaderno di vedute di Giambattista e Domenico Tiepolo,* in other words, a sketchbook of small drawings which are now scattered.
Knox has tried to reconstitute this sketchbook in his publication of 1974. His conclusion is that these pages provide a rare and fleeting image of Giambattista 'at work', in Cézanne's words, 'on the theme'.
This view shows the southern aspect of the cathedral.

Ref.: Knox, *Quaderno* No. 50

30 A church and other buildings

Pen and wash 155 × 280
On the verso: a little pen sketch
Inscription: *Tiepolo G.*

Rotterdam, Museum Boymans-van Beuningen (I.127)

Although the inscription may be reminiscent of Domenico Tiepolo's signature and the little sketch on
the back has also to be attributed to him, this fine drawing is undoubtedly the work of his father.

Ref.: Knox, *Quaderno* No. 43.

31 Portal of a villa

Pen and wash 142 × 252

Cambridge, Fitzwilliam Museum (PD 30 - 1959)

See No. 29

Ref.: Knox, *Quaderno* No. 51

32 Atrium of the Villa Valmarana

Pen and wash 126 × 238

Berlin, Kupferstichkabinett (KdZ 4580)

The place was identified by Vigni. The drawing can be dated to the summer of 1757.

Ref.: Knox, *Quaderno* No. 37; Udine 1965 No. 103

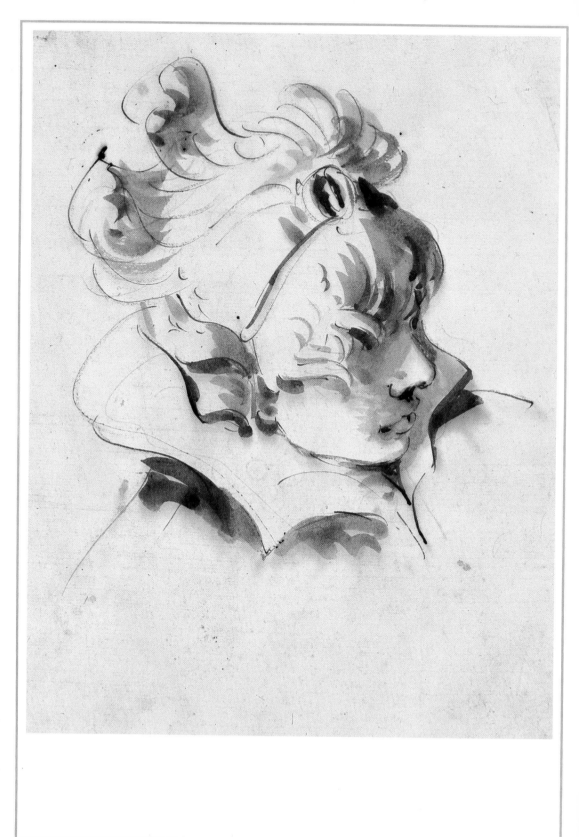

33 Head of a page

Pen and bistre wash on pencil sketch
242 × 194

Trieste, Civici Musei di Storia ed
Arte (1981)

This is undoubtedly one of the
most attractive of all the studies of
heads that Tiepolo made at differ-
ent times during his career.

Ref.: Vigni 1972 No. 51 (1942
No. 122); Udine 1965 No. 64

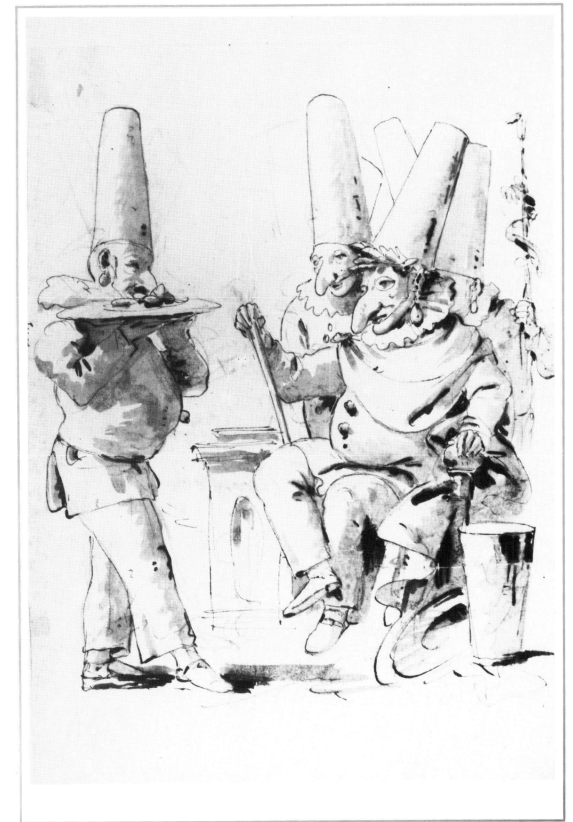

34 Scene with punchinellos

Pen and wash on pencil outline
280 × 208

Trieste, Civici Musei di Storia ed Arte

Tiepolo's many scenes featuring punchinellos must have been very popular at the period. In his catalogue of the Trieste drawings, Vigni quotes a letter from Algarotti, who boasts to the well-known collector Mariette that he 'possessed the finest punchinellos in the world done by our famous Tiepoletto'. The punchinello theme also fascinated Giambattista's son Domenico, who developed it in his series of drawings devoted to the life of Punchinello (see Nos 54-5).

Ref.: Vigni 1972 No. 220 (1942 No. 223)

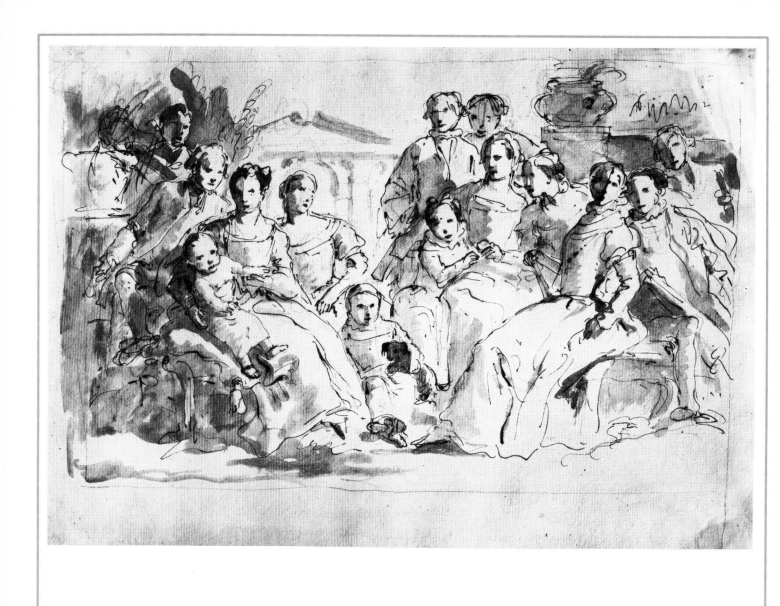

35 Family group

Pen and wash 303 × 438

Florence, Gabinetto Disegni e Stampe degli Uffizi (Fondazione Horne) (6317)

A particularly charming study for the fresco in the Villa Pisani at Stra, dating to 1761. The sketch for this
drawing is preserved in the Museum of Angers.

Ref.: La Strozzina 1963 No. 129

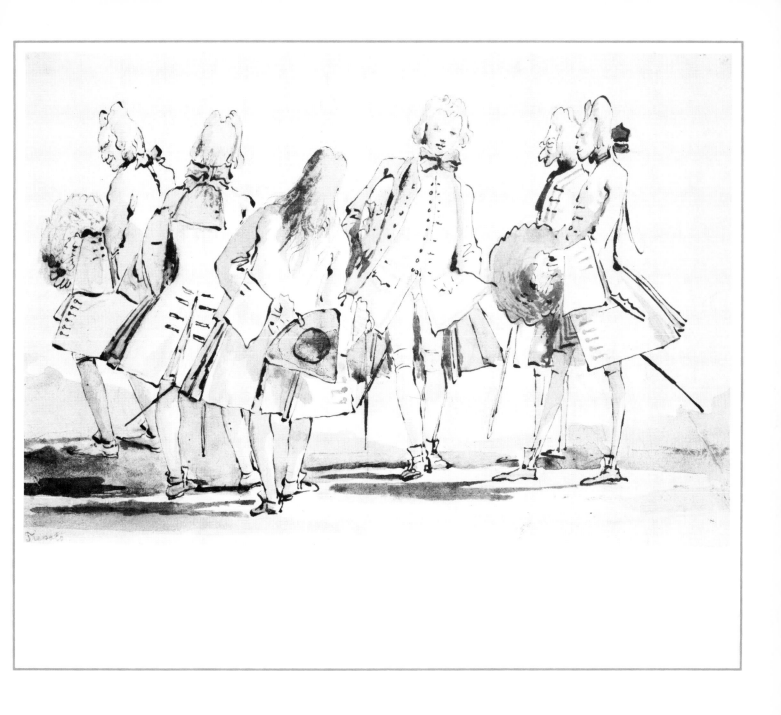

36 Parade of Venetian fops

Pen and wash on pencil sketch 237 × 352

Amsterdam, Rijksprentenkabinet, Rijksmuseum (1981 : 68)

Tiepolo did a great number of caricatures of individual persons, but this kind of parody, wittily
illustrating several figures, is extremely unusual in the master's work.

Ref. : Italiaanse tekeningen 1962 No. 182, Paris-Rotterdam

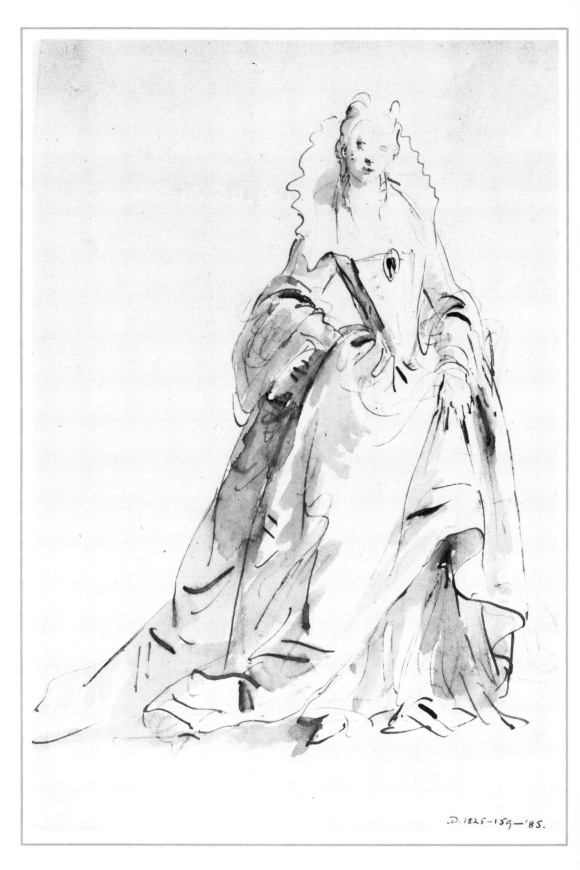

37 Lady wearing a gown with
high collar and pointed bodice

Pen and wash
226 × 158

London, Victoria and Albert
Museum (D.1825 - 159 - 1885)

Ref.: Knox 1975 No. 177

Giambattista Tiepolo

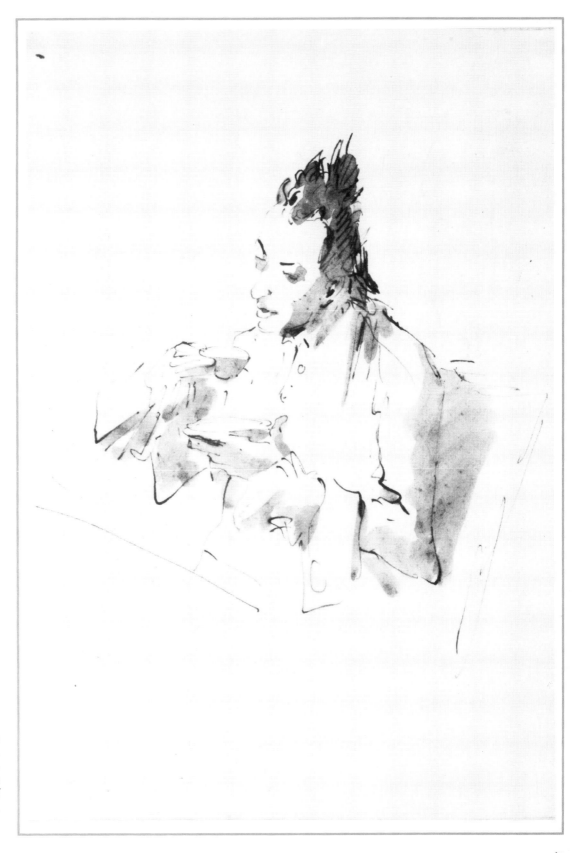

38 Coffee drinker

Pen and bistre ink and grey wash
194 × 140

England, Private collection

This little drawing comes from an
album containing 107 caricatures,
which was broken up after 1943. J.
Byam Shaw has shown that the
album was in the possession of
Domenico after his father's death.

Ref.: Cini 1980 No. 73

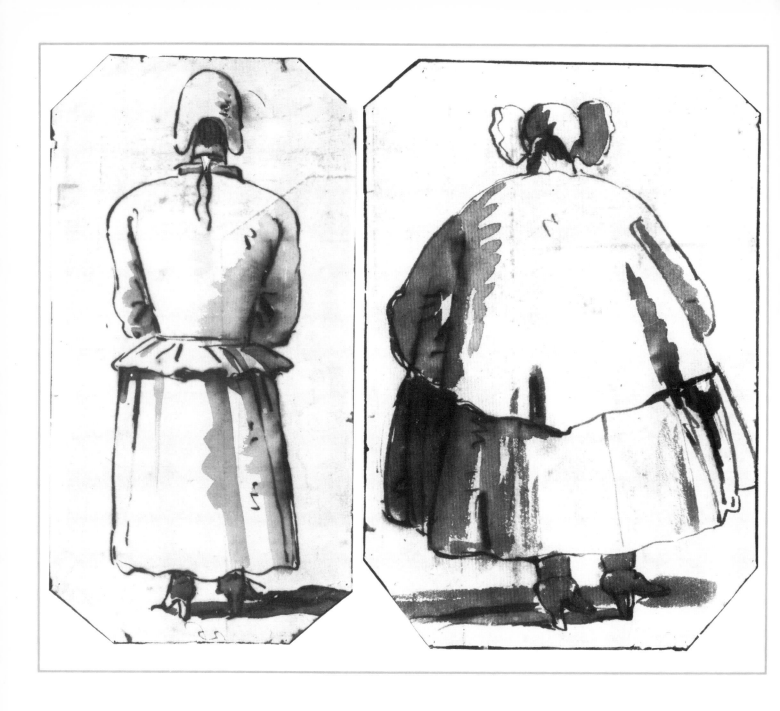

39 Caricature of a woman seen from behind

Pen and wash 193 × 103

Venice, Fondazione Giorgio Cini (30075)

Ref.: London 1972 No. 79

40 Caricature of a woman seen from behind

Pen and wash 170 × 175

Venice, Fondazione Giorgio Cini (30076)

Ref.: London 1972 No. 80

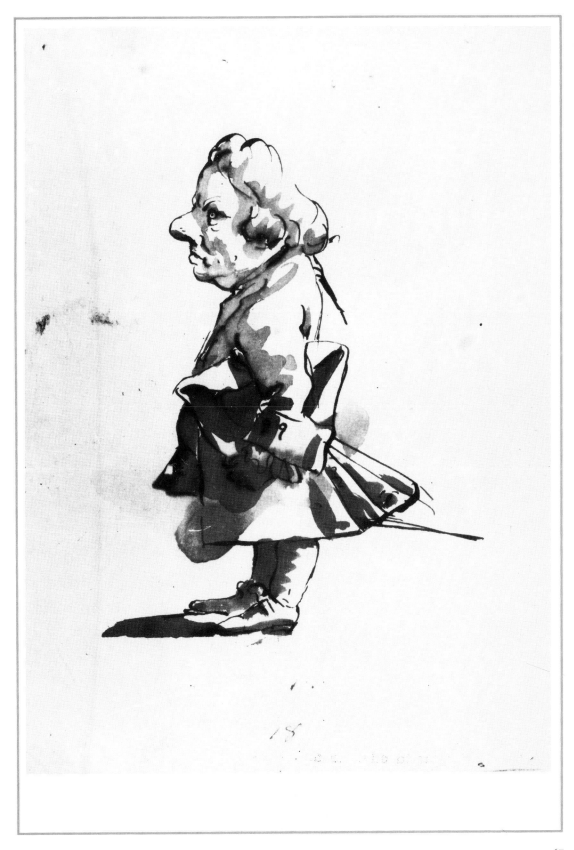

41 Caricature

Pen and wash
239 × 172

Trieste, Civici Musei di Storia ed
Arte (2101)

Ref.: Vigni 1972 No. 271 (1942
No. 250).

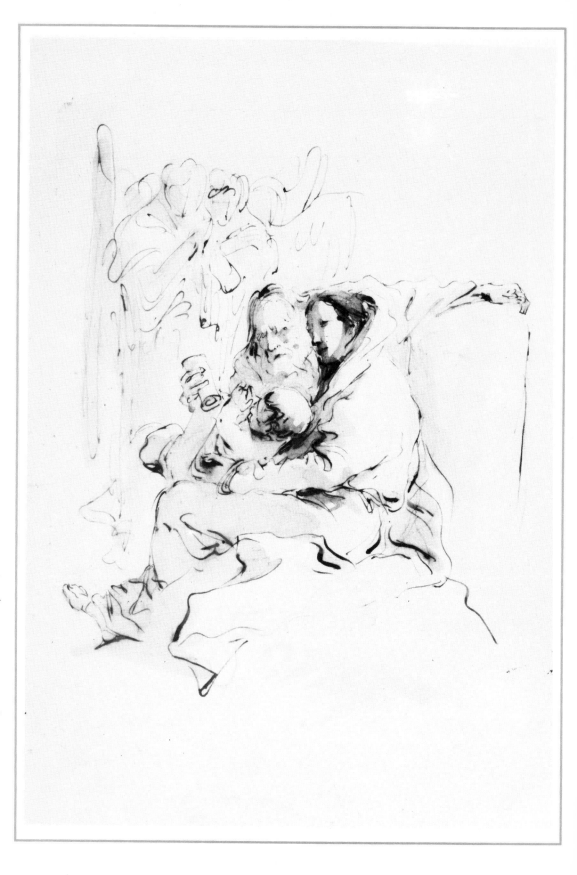

42 Holy Family with angels

Pen and wash
277 × 196 / 274 × 208

London, Private collection

This drawing and the following
one are part of a series of some
seventy variations on the theme of
the Holy Family, originally con-
tained in a volume placed in the
Somasco Convent in Venice when
Tiepolo left for Madrid. They were
dispersed after their sale by
Sotheby's as part of the Cheney
collection in 1885. Knox, in his
introduction to the catalogue of
Tiepolo drawings in the Victoria
and Albert Museum, studied the
origin of this series. They are be-
lieved to be self-contained draw-
ings and not studies for later paint-
ings. Knox dated them to about
1760.

Ref.: Cini 1980 Nos 83-92; No. 84

43 Holy Family with other persons

Pen and wash
274 × 206

London, Private collection

See the previous number.

Ref.: Cini 1980 No. 88

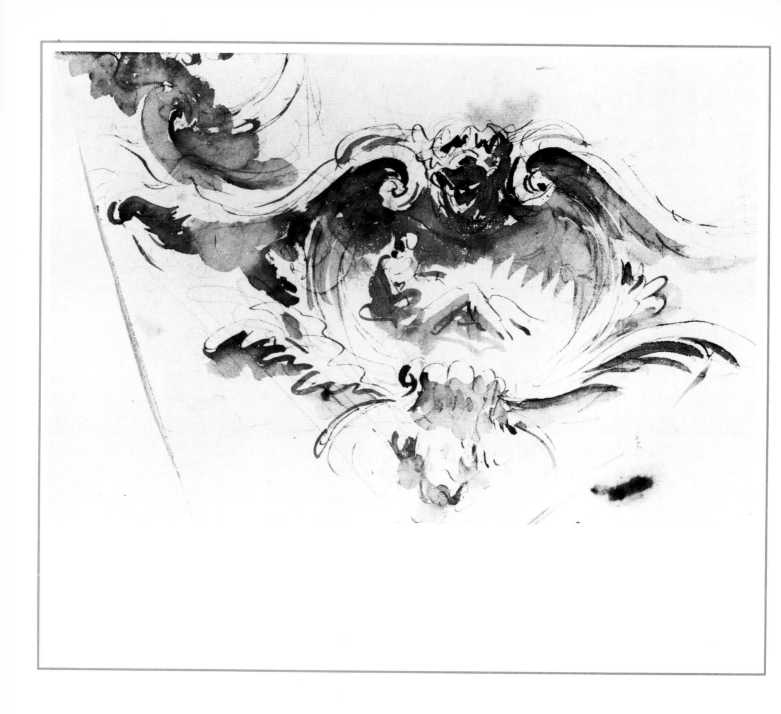

44 Decorative theme

Pen and wash on pencil sketch 177 × 270

Trieste, Civici Musei di Storia ed Arte (1918)

Ref.: Vigni 1972 No. 106 (1942 No. 56)

The Drawings of Giandomenico Tiepolo

Adriano Mariuz

Giambattista Tiepolo included a portrait of himself – a man in late middle age with thin, rather worn features – among the people surrounding the throne of Europa, on the fresco of the great staircase in the Würzburg Residence (1750-3). Next to him is a young man with a calm, intelligent face, looking sympathetically at the viewer as though he wished to establish a relationship of trust and understanding. This is a self-portrait of Giandomenico Tiepolo, who worked with his father on this enormous project.

Giandomenico's contemporaries thought of him mainly as a careful imitator of his father's work, but even at the beginning of his career, his originality was evident, for example in the fourteen pictures of the *Via Crucis* or 'Stations of the Cross' that he painted in 1747 for the Oratorio del Crocefisso, next to the church of S. Polo, in Venice. He portrays the suffering and death of Christ on these canvases with great narrative skill, and conveys a feeling of personal involvement. The crowd figures are particularly interesting, for he painted them in contemporary or exotic dress and in a rapid and flowing style. His manner had already become less exalted and more realistic than his father's.

An affection for dense, picturesque crowds remained with Giandomenico for the rest of his life. It is quite obvious, from a set of pen drawings of groups of strange and excited figures nervously overlapping each other, that this predilection had its origin in his father's *Capricci* and *Scherzi di fantasia*. The drawings are youthful exercises, clearly based on his father's engravings, and, as is unusual for this early stage of his development, he made no paintings from them. He also prepared a great number of detailed preparatory studies at about this time, in sanguine or charcoal often heightened with white chalk. It has been established that this was normal practice in the Tiepolo studio while Giandomenico was serving his apprenticeship there, and that he continued to use this technique until about 1780 when he attempted to classify the enormous accumulation of drawings, mounting them in new albums according to categories (Knox, 1979, 1980).

Like his father he generally worked in pen when putting his ideas on paper for the first time. The rapid sketches he made for a set of twenty-four etchings entitled *Picturesque ideas for the Flight into Egypt* show this clearly. The extraordinary drawings, dating to the years when he was working in Würzburg, were models for etchings that show different aspects of the Holy Family's flight from Bethlehem and arrival in an Egyptian town. In some respects the theme is similar to that of the *Via Crucis,* but it is treated here more interestingly as the account of a series of events observed step by step by a witness following the movements of those taking part. The result is a family chronicle that arouses our sympathies and involves us emotionally in the experiences of people not unlike ourselves. The artist includes a variety of details, some

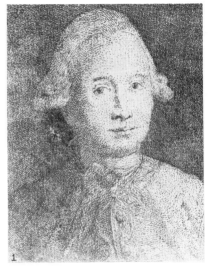

36 Giandomenico Tiepolo
Venice 1727 - Venice 1804
Self-portrait
Etching

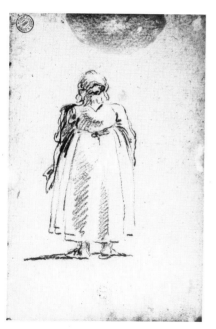

37 Figure study for *The Flight into Egypt*
Venice, Museo Correr

fantastic and others quite ordinary, that make the drawings charming, picturesque and entertaining. Giandomenico's work retained these qualities throughout his life, with similar features to be found in a much more developed form in the later drawings.

His sensibility can be called down-to-earth; it is far removed from the noble and exalted. Hardly surprisingly, then, he experimented with *genre* themes and depicted a society trying to forget its responsibilities in feasting, and in the confusion of street revelries during the masked carnival when the city became a theatre. On returning from Würzburg to Venice, he may have been led to choose this kind of subject by the prevailing cultural climate, dominated as it was by Goldoni's attempt to supplant the *Commedia dell'Arte* with his own scripted social comedy, the *Commedia Riformata*. Giandomenico was influenced by Pietro Longhi's glimpses of Venetian life, a new and attractive form of art which stimulated Francesco Guardi, who was Giandomenico's uncle on his mother's side, to try it himself. Examples of such paintings by Guardi are *The playhouse* and *The nuns' parlour,* at present in the Museo di Cà Rezzonico in Venice, and a *Ball in the playhouse* in the Seilern Collection, which Byam Shaw (1962, No. 62) dated to about 1755, and which points clearly, both in style and subject, to the young Tiepolo's interest in the way Guardi interpreted Longhi's themes. His *Conversation piece* in the Uffizi in Florence, on the other hand, contains a vibrant light and watercoloured shadows that are so translucent that the influence of some of his father's drawings is indisputable.

Giandomenico and his brother worked with their father in Madrid for almost eight years in the service of the king of Spain; so, on Giambattista's death in 1770 there was a sudden break not only in his life, but also in his artistic activity. He returned to Venice with the weight of his inheritance bearing down on him. His name was associated with the grandiloquent in art, and patrons went to him only when they wanted that kind of work. He continued to paint frescoes on the ceilings of churches and palaces in Venice and elsewhere until the end of his life, according to the grandiose iconography that was demanded of him, but in an increasingly impoverished pictorial language. He very likely realized that this form of art, already condemned by avant-garde theorists who favoured neo-classicism, had in fact died with his father who had created it. If he was to remain original he had to be his own patron. He therefore painted the extraordinary frescoes for his own country house at Zianigo, now in the Museo di Cà Rezzonico, and devoted his time and energy above all to drawing, recognizing that this was for him the medium most suited to his intimate manner as an artist. Following his return from Spain and until he was a very old man, he drew with almost feverish intensity, producing hundreds of drawings, more for himself than to please collectors, and signing each sheet as though impelled by a neurotic urge to assert his own identity.

Nearly all these drawings are in pen and wash over rapid pencilling, and the great majority form homogeneous sets. They are, in other words, variations on themes, like the youthful *Flight into Egypt,* for which his father Giambattista had provided him with an excellent model in his *Holy Family* series. In some cases, Giandomenico created more than a hundred variations on a single theme – as is clear from his numbering of the sheets in each set.

Byam Shaw's indispensable book on the subject lists the following religious themes, in addition to many biblical ones: God the Father borne by angels on the clouds; Christ received into heaven by the Father and the Holy Spirit; the Assumption or the Coronation of the Virgin; the Baptism of Christ; and St Anthony carrying the Infant Jesus. The many profane themes with variations include Hercules and Antaeus; cupids and cherubs disporting themselves; fictive statues of mythological figures; Oriental knights and their steeds in a landscape; satyrs and centaurs; and animals. Finally, two further series represent the peak of his achievement as a graphic artist. These are a series of contemporary scenes and another of the life of Punchinello.

Most of these themes and variations are not merely working-models for paintings, but are sequels to finished works by Giandomenico or his father, or unforeseen developments of them. In the drawings the artist's image loses the perfection and permanence that it has in the painting, and dissolves into a series of retakes, as if glimpsed amid the flux and change. The spots of wash, scattered as if at random, and the nervous, quivering line, seem to indicate that

the artist is catching at fleeting moments. Giambattista Tiepolo gave each of his drawings an absolute value; in Giandomenico's case, however, each drawing needs to be seen in relation to the others in the same series if its real charm is to be revealed. Seen within the context of the whole theme the individual variations have the fascination of Giandomenico's imagination, which a fellow-Venetian called *fecondissima di concetti,* 'abundant in concepts'.

The most remarkable of all Giandomenico's religious drawings are to be found in the set illustrating episodes from the Old and New Testaments and the Apocryphal Gospels. There are at least 250 of these sheets, all quite large. The sources are certain well-known works by Titian, Castiglione, Rembrandt and, of course, the artist's own father; but he transformed them completely. Drawn with his usual nervous and digressive hand, they are entirely lacking in solemnity and flow easily with the energetic narrative of the sacred themes; they are intermingled with an astonishing wealth of images drawn from genre paintings. One must conclude that the artist imbued them with the Romantic spirit that was so popular in the literature of the second half of the eighteenth century: their complex texture, unexpected turns, intermingling of comedy and pathos, and element of historical improbability are all characteristic of the Romantic approach.

fig. 38

He dealt with mythological themes in the same humorous, occasionally comic way, introducing aspects of ordinary and empirical experience into the traditional repertory and mixing events and figures from the realm of fable with day-to-day realism. In decorating one room of his house at Zianigo in 1771, he chose a mythological theme featuring satyrs, which he obviously took from engravings of his father's *Scherzi di fantasia,* and centaurs. The first volume of the *Antichità di Ercolano esposte* had appeared in Naples in 1757, containing reproductions of early paintings of centaurs and satyresses discovered in the excavations at Herculaneum. Giandomenico's somewhat ironical attitude towards the neo-classical movement in art, which was then so rapidly gaining ground, is reflected in his treatment of the life of satyrs as a literary or fabulous travesty of the peasant way of life. His rendering of their behaviour in his drawings was based on his observation of the naked urchins who tumbled and cut capers in the open air at grape-harvest festivities. The incongruous detail of an Italian village with its pointed bell-tower appears in the background of certain drawings. This exceptionally fine set of drawings on a theme, most of which he produced during the years following his painting of the first Zianigo frescoes, reveal the same general attitude (Cailleux, 1974). These constitute, as it were, a series of related reports on an Arcadia that had severed its connections with the noble style. This new Arcadia portrays, within a mythological framework, the reality of Venice and its rural hinterland. Every aspect of village life is there: an old satyr limping on his crutch, or a family of satyrs eating a meal of *polenta* in the kitchen of a cottage (Paris, Ecole Nationale Supérieure des Beaux-Arts).

Giandomenico's practice of introducing everyday realities into, for example, religious or mythological themes, and thus of confusing and contrasting different genres in the same drawing, directly undermines contemporary theories of art that aspired to universality – which includes both the established Baroque tradition and the emerging avant-garde neo-classical tendency. He deliberately 'regresses' to a personal idiom which may be defined, in relation to the dominant forms of art at this period, as a dialect, a demotic style that is spontaneously repetitive and ungrammatical, a private and very personal language, with all its tics, its approximations and its caustic tone. Through this unmistakable personal idiom, Giandomenico was able to expose, from an independent viewpoint, the harmless follies of contemporary society. In his later drawings especially, with their disturbing multitudes of Punchinellos, he revived the spirit of parody of the outmoded and derided *Commedia dell'Arte.*

His last great period of creativity, the greatest in his life, began in 1791 with his fresco representing the *New World* in one of the rooms at Zianigo. He developed the theme from a small scene included in the frescoes of the Villa Valmarana thirty-four years previously, and transformed it into an impressive vision of contemporary society. He painted it as a village community with aristocratic, middle-class and peasant people, together with a single Punchinello, pressing forward to see the magic lantern images presented by a talkative charlatan.

38 Mary informs Joseph of her pregnancy
New York, Private collection

39 Group of satyrs in the country
Paris, Ecole Nationale Supérieure des
Beaux-Arts

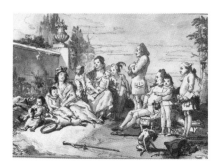

40 Family party in a villa garden
London, Sotheby's sale 1967

The same date, 1791, appears on no less than twenty drawings representing *Scenes of contemporary life*. Others in the same series are later. It is possible to subdivide this theme into three groups (Byam Shaw, 1962): scenes of peasant and gypsy life in the Venetian hinterland, of day-to-day Venetian life, and of aristocratic and upper-middle-class mores in Venice or the villas of the *terraferma*. Some of the people in these drawings are virtually copies of Giambattista's caricatures; again, as with his previous adaptation of other prototypes provided by his father, he places them in a context so that the target of his satire is not the individual or debased human nature, but society in its decadence. The contrast between the son's vision, which is critical, and his father's, which is sublime, can be seen by comparing the latter's fig. 40 *Family group* (pl. 35) with Giandomenico's treatment of the same theme, from which every trace of approbation seems to be excluded.

In these drawings of the theme of contemporary life, Giandomenico's powers of observation and humour are much in evidence, although the latter often borders on melancholy. He shows adults behaving like children, while the aristocracy and the bourgeoisie go through their little figs 41-2 secular rites in an ungainly dance, spending their time in frivolous and empty diversions in the gardens of their villas. He presents the comedy of a society in flight from the void; he puts on paper people's urge to escape, their feverish transformation of life into entertainment.

Either Pietro Longhi or Pier Antonio Novelli, the artist who drew the illustrations for the Zatta edition of the *Works* of Carlo Goldoni, might equally well have dealt with these themes, but neither would have captured the subtle but caustic sense of amusement and the hint of complicity with which only Giandomenico was able to represent the decadent and shadowy side of humanity. It is likely that he was acquainted with the engravings of Hogarth, whose caricatures were pointed out as outstanding examples of the genre by Francesco Milizia, a neo-classical theoretician well known in artistic circles in Venice, in his *Dizionario delle belle arte del disegno* of 1797. It is certain that he possessed Goya's *Caprichos*. He lacked, however, Hogarth's satirical spirit and Goya's violent pessimism. Nor could he make use of caricature, as could Rowlandson and Gillray, to face a reality in man that reason was unable to bear, or to point to the untamed bestial element that lies behind his civilized exterior. The Venetian artist was not the subject of a despotic sovereign; nor did he have behind him have the moral weight of an emerging middle class. He was simply the disillusioned witness of a society that did not know it was in its death-throes. His drawings, with their pale light and their groups of vulnerable and slightly comic little figures outlined against a faded background, give the tender impression of a farewell.

Towards the end of his career, Giandomenico was haunted by the figure of Pulcinella or Punchinello, who, as we have seen, appears in the set of frescoes painted in 1797 in a little room at Zianigo. The artist probably also began work during that year on the series of 104 drawings entitled *Divertimento per li regazzi,* illustrating the birth, loves, adventures, professional skills, sufferings, amusements, death, and finally the skeletal resurrection, of Punchinello, who is always accompanied by a chorus of his own doubles.

These drawings are among the supreme achievements of eighteenth-century European art. They are the creation of an artist with a quick and ever-changing imagination who delighted in combining different and contrasting ideas and confronting them with the ambiguity of a masked and impenetrable personality. The Punchinello drawings succeed in being limpid and elusive. They have the immediate appeal of a popular story, but also produce a disturbing, labyrinthine effect due to the countless identical figures on each sheet. Punchinello wears the same white costume and tall cylindrical hat as in Giambattista Tiepolo's drawings, but his mask is black, and he is slightly taller. Now of normal height, he is still deformed, pot-bellied and hunchbacked. In the *Divertimento* he is above all a social being. With his band of companions he mixes with other men, lives like everyone else, follows every profession and plays fig. 43 every part. He is the executioner and his victim – Punchinello in the firing squad shoots Punchinello the accused, or else is the hangman putting his own double to death. He is both the master and the servant; he is the landowner who tyrannizes his tenant-farmer, who is yet an-

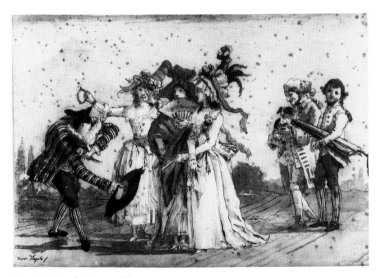

41 Meeting during a walk
London, Sotheby's sale 1967

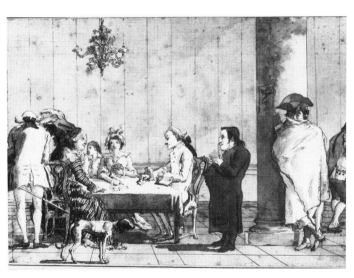

42 Game of cards
Private collection

other Punchinello. Physically slight and frail, he can mime every condition of man. Giandomenico consequently uses him in contemporary as well as in traditional scenes, and in both his own themes and those of his father. Everyone can be changed into Punchinello. Perhaps the best example of this metamorphosis is the composition of *Punchinello as a portrait painter*, fig. 44 which is a parody of Giandomenico's youthful drawing *Apelles painting Campaspe's portrait* fig. 45 *in the presence of Alexander*.

 The artist apparently wanted to prove unfounded the charge, brought against the masked characters of the *Commedia dell'Arte* by those who championed the new form of comedy, that they were stereotyped and rigid. If we accept the hypothesis that Giandomenico began his *Divertimento* series in 1797, then it becomes apparent that the choice of Punchinello as the protagonist in this spiritual testament is related to that controversy. The *Commedia dell'Arte* was repeatedly condemned by francophile intellectuals who supported the provisional democratic government set up after the fall of the thousand-year-old Venetian Republic. In the words of the dramatist Antonio Piazza, in the *Gazetta urbana veneta* of 28 June 1797, 'These insipid and wretched improvised comedies, which stupefy the ignorant audience without enlightening or correcting them, should be outlawed.'

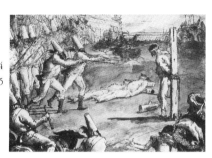

43 Punchinello's execution
Private collection

Giandomenico would thus have been championing the cause of the 'ignorant' people when he put the epic of Punchinello in the foreground of his drawings, as is confirmed by the title of the series, since this *Divertimento* was an entertainment for the *regazzi* or 'children'. What is more, eighteenth-century scholars believed Punchinello to be descended from the ancient Oscan masque of Macchus, and claimed that he had survived among the country people during the barbarian invasions. Because of this, Giandomenico's Punchinello drawings were implicitly polemical (in the opinion of Marcia E. Vetrocq, 1979), and were intended to show that native Italians were more imaginative than the barbarian invaders – who, in this case, were the French. Might not the crowd of identically dressed Punchinellos be a parody of the democratic ideals of *Egalité* and *Fraternité*?

 Values that were publicly stressed at that time were the dignity of the individual, ethical commitment, and, in the arts, the language of reason based on the classical model. The old Venetian artist nevertheless made use of the masquerade form, preferring its enigmatic and grotesque qualities, its playfulness, its openness to improvisation and parody, and its mocking attitude towards the claim that history should be taken seriously.

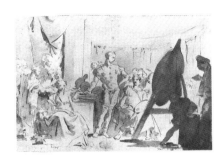

44 Apelles painting Campaspe's portrait in the presence of Alexander
Private collection

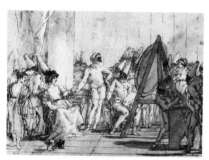

45 Punchinello as a portrait painter
Private collection

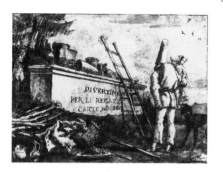

46 Frontispiece for the *Divertimento per li regazzi*
Kansas City, Nelson Gallery - Atkins Museum

Punchinellos formed no part of the rational world and belonged to an older culture. Giandomenico revived them for the only people who could still understand and love them – children and, since *regazzi* is ambiguous, servants as well (Bonicatti, 1970). Punchinello represented the human condition: constantly exposed to risk, playing many different and often contradictory parts, alternating between tragedy and farce in the never-ending adventure of a society inevitably based on falsehood and sham.

One of the finest drawings in the series is the frontispiece. A solitary Punchinello is seen standing with a doll over his arm in a pale landscape, contemplating a sarcophagus. The title of the series is inscribed on this tomb which is later to become Punchinello's own, and is the same one from which he emerges to play his part in the *Divertimento*. This whole 'entertainment for children' is like an exorcism that takes place within the framework of death. Byam Shaw pointed out in 1962 that this frontispiece is similar to the one Giandomenico used for his youthful etchings of the *Via Crucis,* reproducing his paintings in the Oratorio del Crocefisso of fig. 46 S. Polo. In both frontispieces the most important element is a sarcophagus. In the later drawing, however, Punchinello's symbols take the place of those of Christ's passion, so that the *Divertimento per li regazzi* and the mask of Punchinello are closely related to and contrasted with the Stations of the Cross and the face of Christ: just as the people of Venice led their lives in the rhythmic alternation of Carnival and Lent.

By the end of Giandomenico's career, the concept of the individual, and that of progression in historical time, were emerging as dominant themes. Giandomenico rejected – or failed to comprehend – this new reality. Conscious that all gods were now dead, he became an interpreter of the state of mind of those Venetians who filled the streets in February 1797, on the eve of the fall of the Republic, behaving, as the aristocrat Gaspare Lippomano said to the last representative of the Most Serene Republic in Paris, 'as though no misfortune had occurred and everything was proceeding most happily'. The artist made time stand still at that last Carnival and celebrated the comic invasion of Punchinello. His final message is also that of eighteenth-century Venice itself – that of the profound truth contained in the symbol of the mask.

Reference is made to the following books and articles in the text: M. Bonicatti, 'Il problema dei rapporti fra Domenico e Giovan Battista Tiepolo', *Atti del Congresso internazionale di studi sul Tiepolo* (Milan 1970); J. Byam Shaw, *The Drawings of Domenico Tiepolo* (London 1962); A.M. Gealt and M.E. Vetrocq, *Domenico Tiepolo's Punchinello Drawings. Catalogue of the Exhibition, Indiana University Art Museum* (1979); G. Knox, *Giambattista and Domenico Tiepolo. A study and Catalogue Raisonné of the Chalk Drawings* (Oxford 1980); id., *Tiepolo, tecnica e immaginazione. Catalogo della Mostra* (Venice 1979).

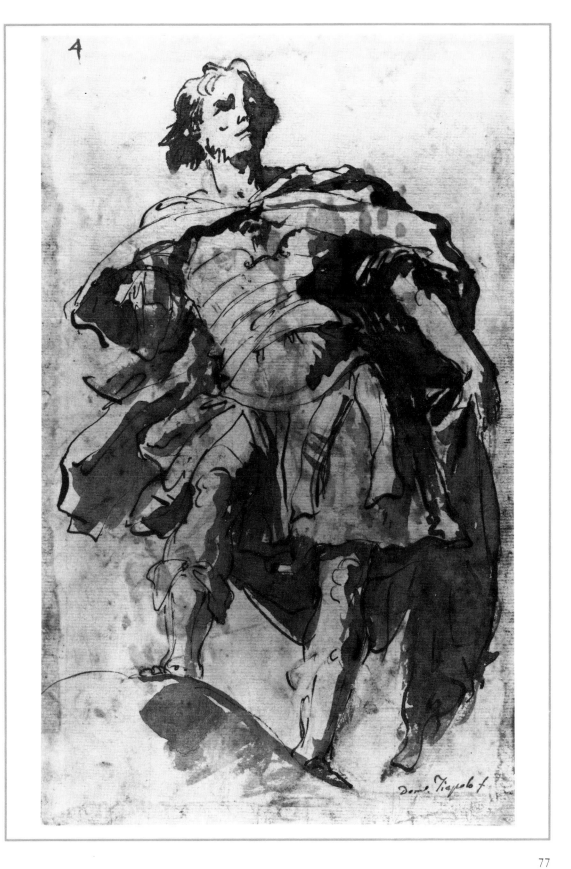

45 A standing man in Roman uniform

Pen and bistre wash
252 × 152
Signed: *Domo Tiepolo f.*

Stuttgart, Graphische Sammlung
Staatsgalerie (new acquisition)

Ref.: Knox-Thiem 1970 No. 63a

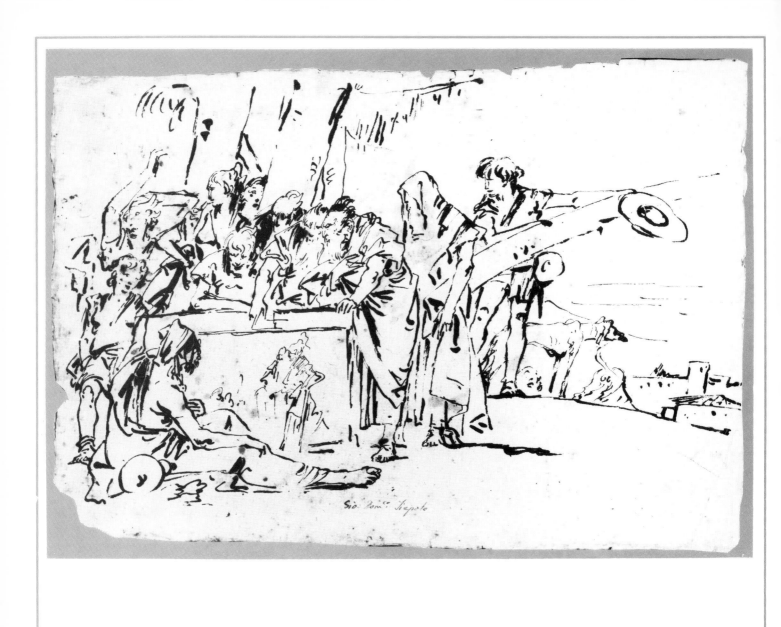

46 Composition in the manner of the Capricci

Pen (duck's quill) 300 × 453
Inscription: *Gio Dom co Tiepolo.*

Trieste, Civici Musei di Storia ed Arte (1859)

The problems raised by this rather unusual drawing - the inscription added at a later date, possibly by the artist; the style; the relationship between Giambattista and Domenico Tiepolo and so on - have been studied in detail by Vigni in his catalogue *Disegni del Tiepolo* (1942 edition and, in the 1972 edition, pp. 106 and 109ff.).

Ref.: Vigni 1972 No. 249

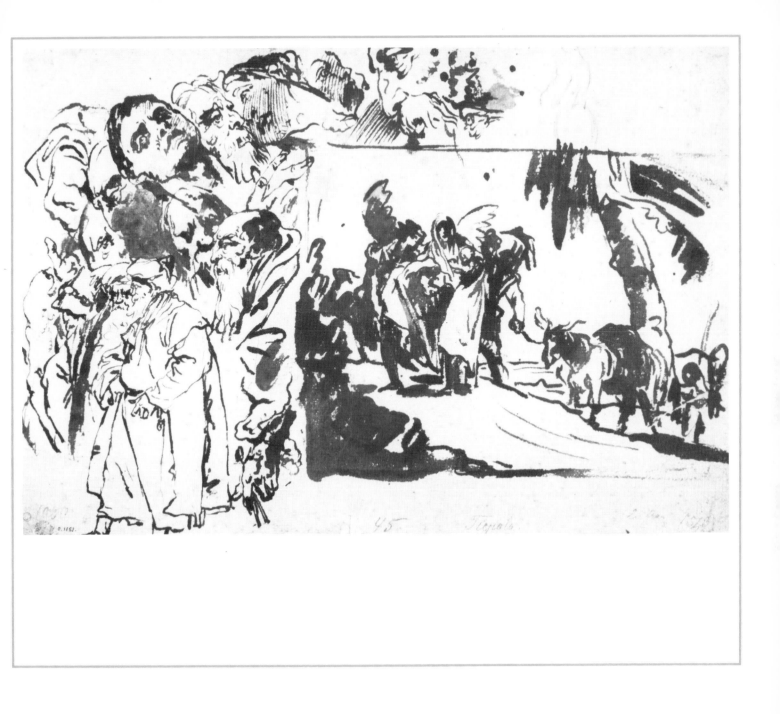

47 Sheet of sketches

Brush with brown ink on a sketch in black chalk 299 × 446

Besançon, Musée des Beaux-Arts (D.1658)

This 'exceptionally important' page (R. Bacou), showing a number of persons on the left and, on the
right, an 'idea' for a Flight into Egypt, may come, according to Byam Shaw, from a volume of sketches
containing 'variations' on this theme.

Ref.: J. Byam Shaw 1949 No. 7; Paris 1971 No. 7

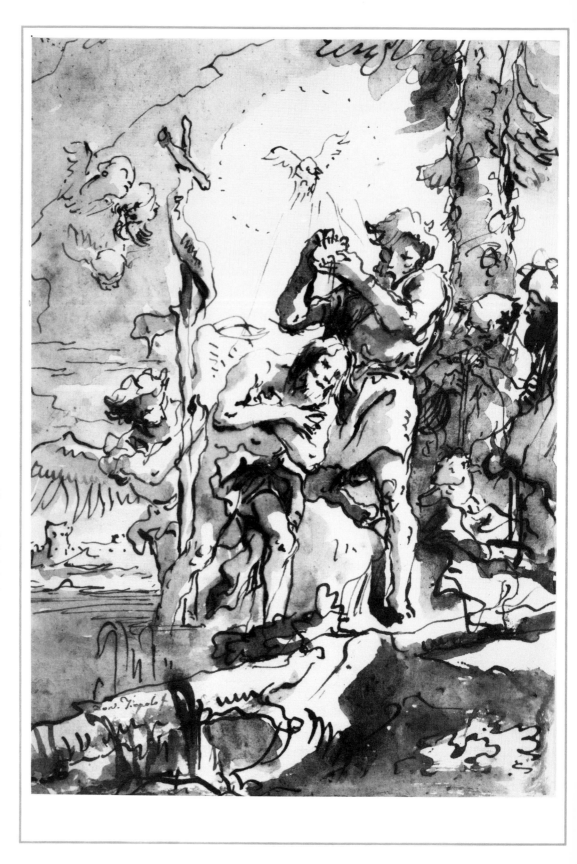

48 The baptism of Christ

Pen and bistre wash
260 × 186
Signed: *Dom. Tiepolo f.*

Stuttgart, Graphische Sammlung
Staatsgalerie (1516)

There are thirteen drawings of this
subject in the Stuttgart Graphische
Sammlung alone and very many
others are now scattered among
public and private collections. *The
baptism of Christ* is similar to the
Flight into Egypt (see the previous
number) in that the artist did
many 'variations' on the theme, in
this case about a hundred. Many
are numbered in sequence, the
highest figure being No. 98.
A painting of the same subject
(Florence, Museo Stibbert) has a
great deal in common with these
drawings, and Byam Shaw has sug-
gested that it should be dated no
earlier than the 1760s, and pos-
sibly even later. In the Stuttgart
catalogue (1971) it is dated 'about
1770'.

Ref.: Knox-Thiem 1970 No. 44

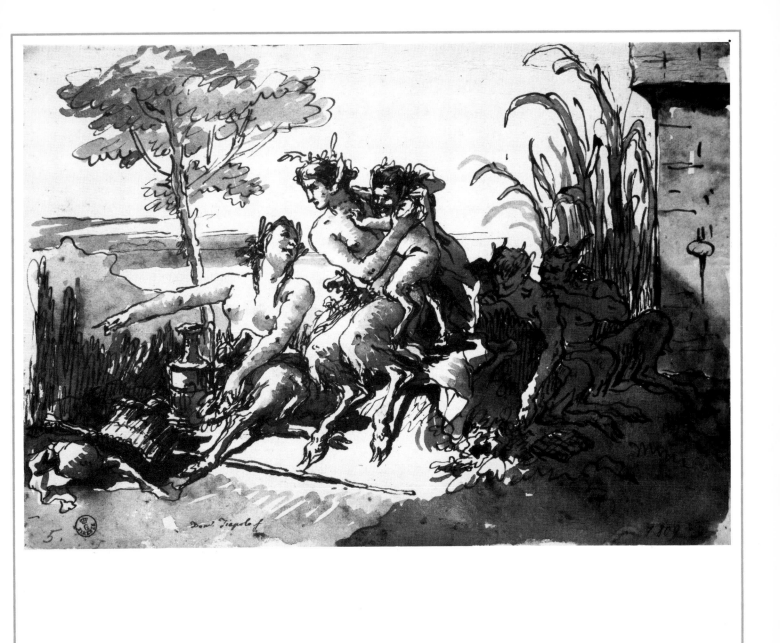

49 Family of satyrs resting

Pen and bistre wash 198 × 284
Signed: *Dom⁰ Tiepolo f.*

Florence, Gabinetto Disegni e Stampe degli Uffizi (780 g S)

This page is strongly characteristic of Giandomenico's style and is one of a long series of drawings now
scattered. Although he decorated two rooms in the family villa at Zianigo with frescoes showing centaurs
and satyrs, there is only the theme to connect the frescoes with this series of drawings.

Ref.: Florence 1967 p. 102; Forlani Tempesti and Petrioli Tofani 1972 No. 97

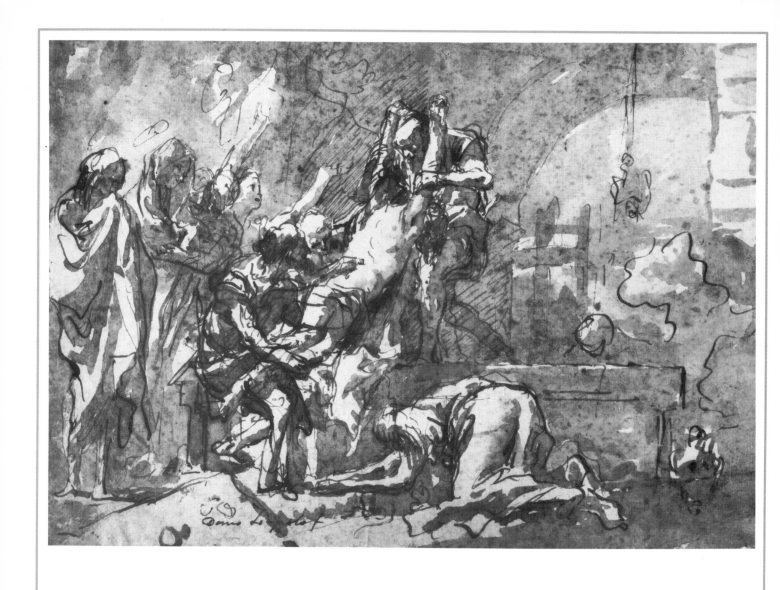

50 The deposition of Christ

Pen and wash 192 × 277
Signed: *Domo Tiepolo f.*

Switzerland, Private collection

There is no known picture by Domenico Tiepolo to link with this remarkable drawing, executed with
such free strokes of the pen and with such an attractive use of wash.

Ref.: *Art vénitien en Suisse*, 1978, No. 136

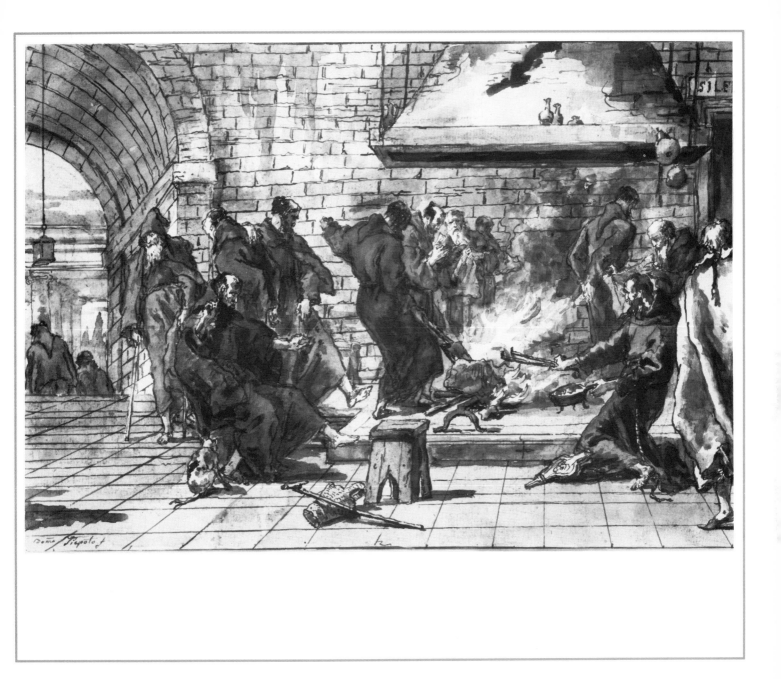

51 Monks at a monastery hearth

Pen and bistre wash on sketch in black chalk 285 × 416
Signed: *Dom⁰ Tiepolo f.*

Rotterdam, Museum Boymans-van Beuningen (I 170)

The Cardinal-Infante Luis of Spain can be seen burning books in an auto-da-fé in a painting of the same
subject sold in London on 7 May 1926. Here the scene is treated in a manner reminiscent of Magnasco, a
Genoese painter whose works were well known in Venice at the time.

Ref.: Paris-Rotterdam 1962

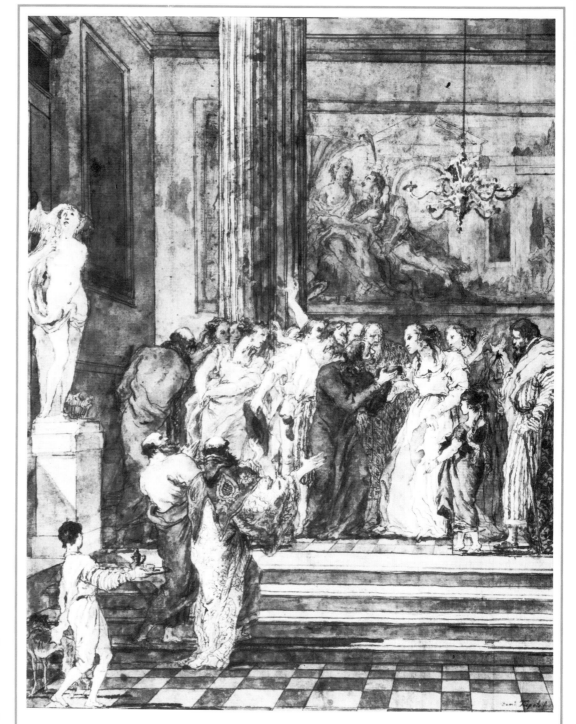

52 Indeterminate biblical scene

Pen and wash in three shades of bistre
on sketch in black chalk
475 × 365

England, private collection

This important drawing is one of a
very large group of some 250,
known today as the *Great Biblical
Series*. A large part of this group of
drawings is preserved in an album
in the Louvre Cabinet des Dessins.

Ref.: Cini 1980 No. 104; J. Byam
Shaw 1962, pp. 36-7

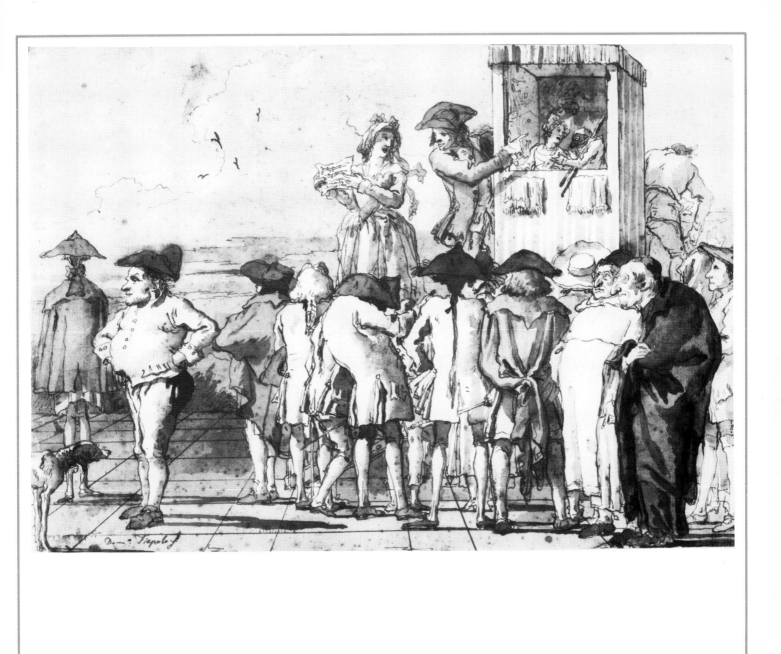

53 A Punch and Judy show on the quayside

Pen and wash in bistre ink 282 × 416
Signed: *Dom⁰ Tiepolo f.*

England, private collection

This drawing is one of a series of scenes that charmingly portray and caricature Venetian life. The style has been described by Byam Shaw (1962, p. 49) as typical of Domenico's last years. It has also been established that he was often inspired by some of his father's caricatures. He must have possessed very many examples of these, which are now dispersed.

Ref.: Cini 1980 No. 101

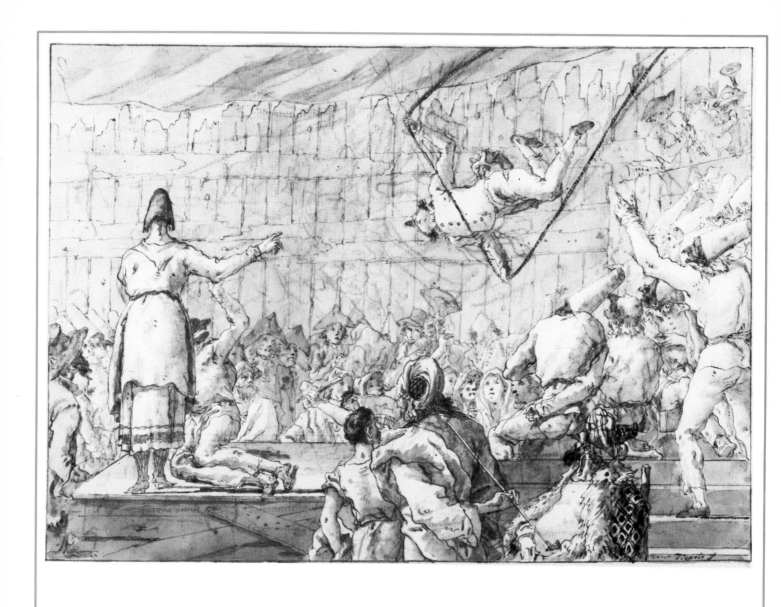

54-5 Punchinello swinging on a rope

Pen and brown wash on sketch in black chalk 350 × 468

England, private collection

One of the famous series of drawings entitled *Divertimento per li regazzi*, illustrating the life of Punchinello from his birth (out of a gigantic egg hatched by a turkey-cock) to his death (with his skeleton in the tomb). The series consists of a frontispiece and 103 drawings. The album remained intact in Richard Owen's possession in Paris until 1921, but is now scattered among various public and private collections. This particularly important series dates from the end of Domenico's life, about 1800.

Ref.: Cini 1980 No. 103

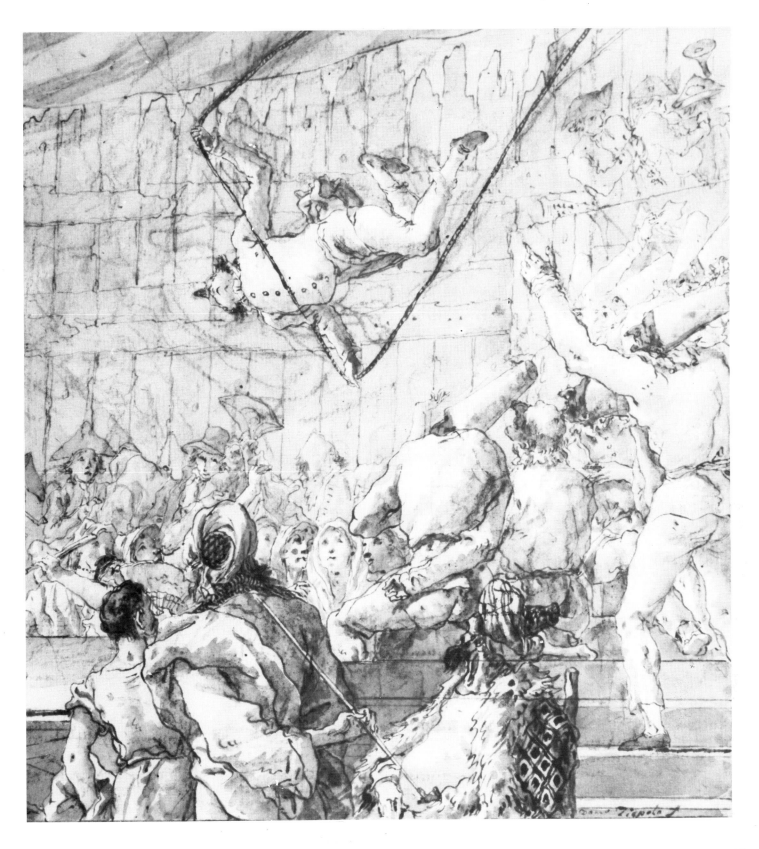

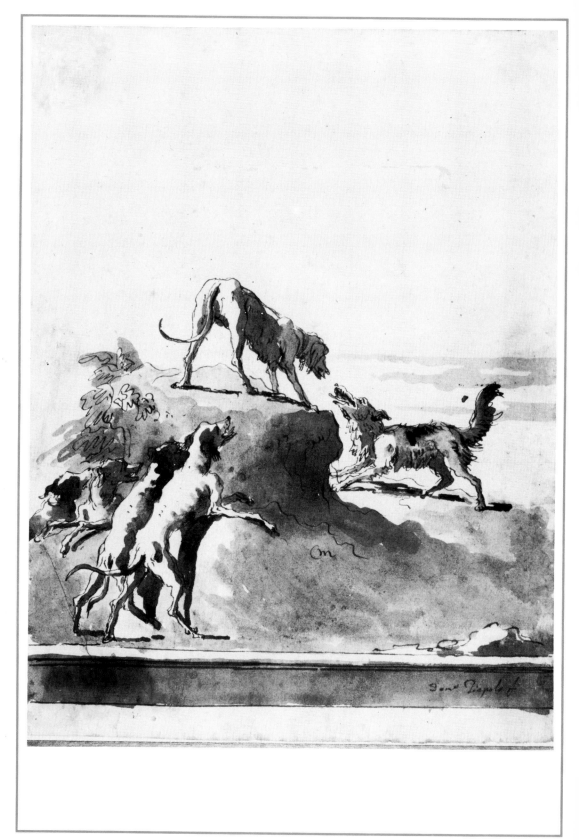

56 Six dogs

Pen and bistre ink with grey wash
260 × 200

Oxford, The Visitors of the
Ashmolean Museum (1095)

This drawing is one of a long series
of scenes depicting the lives of ani-
mals and is characterized by the
parapet in the foreground.

Ref.: Parker 1956 (1972) No. 1095

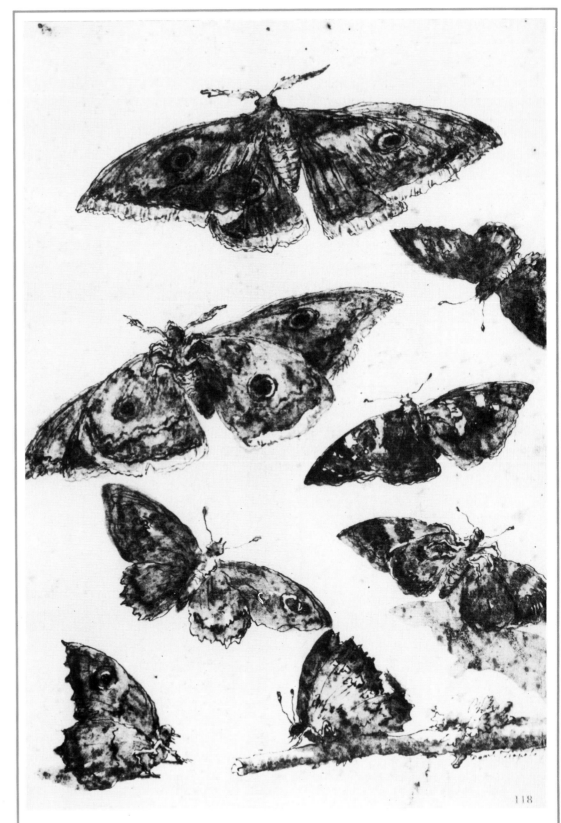

57 Moths

Pen and brown and grey wash
286 × 196
Signed: *Domᵒ Tiepolo*

Udine, Museo Civico

Domenico Tiepolo was especially
interested in living things - not
only horses and dogs, but also, for
example, bats and, in this case,
butterflies and moths. Byam Shaw
has pointed to a link between this
page of drawings and Hollar's
engravings of butterflies (1607-
70). A number of unspecified
engravings by the latter were in-
cluded in the Domenico Tiepolo
sale in Paris (10-12 November
1845, Lot 102).

Ref.: Byam Shaw 1962 No. 51

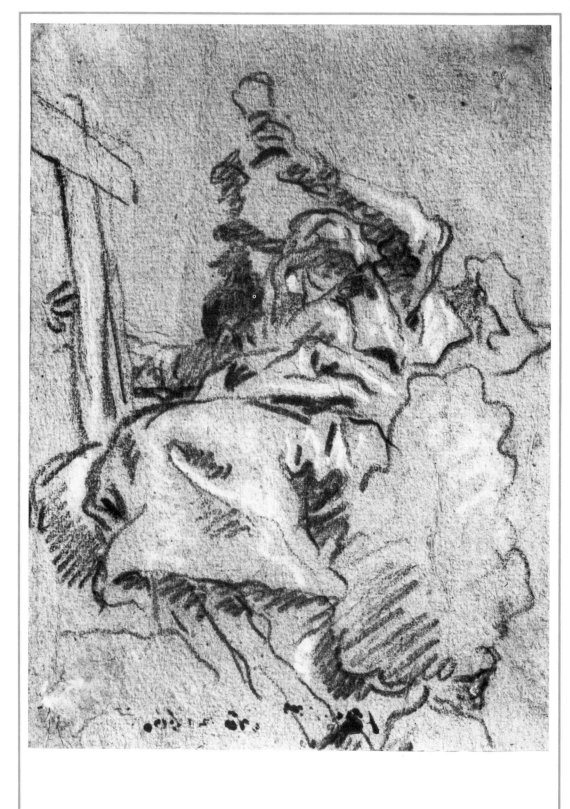

58 The figure of Faith with chalice and cross

Sanguine and white chalk on blue paper
233 × 180

Stuttgart, Graphische Sammlung Staatsgalerie (1443)

Domenico used a technique employed by his father before him in this study for the figure of Faith in a fresco on the right hand side of the choir in the church of S. Faustino Maggiore in Brescia.

Ref.: Knox-Thiem 1970 No. 147

The Drawings of Giambattista Piazzetta

Ugo Ruggeri

From the moment he began working, Giovan Battista Piazzetta produced drawings quite distinct from those of such contemporary artists as Ricci, Pellegrini or Giambattista Tiepolo.[1] Piazzetta's lifelong friend, generous supporter and efficient publisher, Giovan Battista Albrizzi, was fully aware of the uniqueness of his work; in his 'Memorie', a thumbnail sketch of Piazzetta's career prefaced to the *Studi di pittura* (1760) chosen from Piazzetta's work by the engravers Pitteri and Bartolozzi, he stressed the artist's slow, painstaking manner of working. In order to support his family, 'it was his custom to draw every day a number of heads from life in chalk or charcoal on paper. Very many are still in existence and some of them are of unusual quality'.

In the *Storia pittorica d'Italia* of 1972, Lanzi rather more ingeniously linked Piazzetta's daily practice in chalk or charcoal with a propensity or conscious choice of style that was a result of his training in Bologna. According to Lanzi, 'he had worked in Bologna with Lo Spagnolo [Giuseppe Maria Crespi] and had also studied Guercino there. He made efforts to surprise by strongly contrasting light and shade, in which he fully succeeded. Some people believe that he spent a long time observing the effects of light on wooden statues and wax models, enabling him to draw every part of the sketch accurately and intelligently. This ability made his drawings eagerly sought after.'

Indeed, a letter written from Verona by the artist Antonio Balestra to a famous Florentine collector, Francesco Maria Gabburri in 1717, suggests that Piazzetta achieved success with his drawings very early in life. Balestra promised to let the collector have some of his own drawings and added: 'I will also see if I can obtain one of Signor Piazzetta's.' Clearly, the Venetian's drawings had become well known even at this early stage of his career, about which we have very little information.

Piazzetta's drawings are so distinctive that we must take care not to be satisfied by easy explanations. It cannot be denied that the artist drew his *Teste di carattere* and other finished works almost as substitutes for paintings, and partly for practical reasons. Painting was a long, slow process and he needed to produce something almost every day in order to sell it in a market which, while not small, had lower prices. However, the essential motive for the production of these works is undoutedly to be found in the artist's deeply rooted creative impulse (or *Kunstwollen*), his self-awareness as an artist; it is this that led him to work in such a distinctive way. He had an essentially rigorous, academic turn of mind, impelling him to practise his

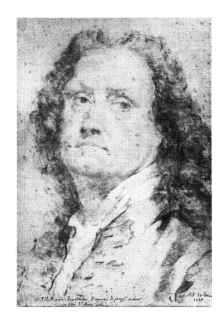

47 Giambattista Piazzetta
Venice 1683 - Venice 1754
Self-portrait
Vienna, Graphische Sammlung
Albertina

[1] R. Pallucchini's classic monographs, *L'arte di Giovanni Battista Piazzetta* (Bologna 1934), and his later work, *Piazzetta* (Milan 1956) are indispensable in this context.

skills every day, and also to work in a closed and rounded form with a vigorous application of chiaroscuro. Piazzetta's closed form is in striking contrast to the open, exuberant, colourful, atmospheric and unrestricted form that is to be found, with individual differences, in the work of such artists as Sebastiano Ricci, Giannantonio Pellegrini and Giambattista Tiepolo, especially in the latter's frescoes in the Palazzo Patriarcale in Udine and in his later work.

Piazzetta's training also played an important part in his choice of working method. After serving, in all probability, an unspecialized apprenticeship with his sculptor father Giacomo, he served for a further period with Antonio Molinari, a painter whose work stood midway between the academic post-Veronese style and the Tenebrism inspired by Caravaggio. Then, in about 1703, he went to Bologna, where he worked in the studio of Giuseppe Maria Crespi.

Crespi is still frequently regarded as a revolutionary who broke all the rules; but in fact he is not difficult to place within the framework of Bolognese art around 1700. Pictorially, his style shows three dominant characteristics: striking and persistent reflections of the Carracci (as in the *Aeneas, Charon and the Sybil* in the Kunsthistorisches Museum, Vienna, which is a major source for Piazzetta's *St James led to martyrdom* in S. Stae in Venice); a revival of the manner of Guercino, reflected even in such Albani-influenced compositions as the *Cupids with sleeping nymphs* in the National Gallery of Art in Washington; and an italianized, almost vernacular, rendering of bourgeois genre scenes, as in the various *Scullery-maids* and *Cleaners* clearly derived from the minor Dutch masters of the seventeenth century. In drawings, such as those in the Louvre, the Albertina in Vienna and the Metropolitan Museum in New York, described by Jacob Bean,[2] Crespi chose a form that is both dense and yet drawn out, closed and clearly outlined, with a skilful balance between light and shade and with religious or narrative themes that are immediately accessible. His drawings are quite different in flavour from those of the 'neo-Venetian', or rather 'neo-Veronesian', school, with their uninhibited colour and brilliant lighting, as in the work of Bolognese and Venetians such as Burrini or Ricci.

This was the background of the young Piazzetta, as is apparent from the study of *Mars and Venus* (British Museum), executed for an early picture now in a private collection in Pordenone.[3] A hesitant, almost unconfident drawing, it gives us a glimpse into a technique of constructing images that, in this mythological theme especially, called for essentially academic skills. These skills, including the study of the nude – in this case male, female and infant figures together – reappear in Piazzetta's posthumous *Studi di pittura,* a thorough textbook for Academy students.

It is obvious that Piazzetta worked methodically, because he clearly distinguished categories of drawings: nude studies, 'character heads' *(Teste di carattere),* portraits, preparatory drawings for paintings, and preparatory drawings for book illustrations and those for single engravings.

The nude had been studied in painters' studios and art schools in the West since the fifteenth century. Piazzetta's Venice had two such academies, both founded in the seventeenth century – that of Pietro Muttoni, known as Pietro della Vecchia, and that of Ludovico David da Lugano; in both of which the study of the nude was an essential aspect of the painter's apprenticeship. This is clear from the nude drawings by Pietro della Vecchia preserved in the Uffizi in Florence, and by Ludovico David's painting in the Palazzo Albrizzi in Venice,[4] whose theme of *Apelles painting Campaspe's portrait* has been turned into a whole academy of nude studies, in which the artist employs models in such classical poses as the *Spinario,* the *Venus Callipyge* or *Venus Anadyomene.* The experience gained by Ludovico David at Carlo Gignani's academy in Emilia is also reflected in this painting, which is in itself a reminder of the important part played by nude studies in the artistic circles in Bologna to which Piazzetta belonged at the beginning of his career. He thus learned his trade within the classical tradition that had been born in the early seventeenth century in Bolognese art, with the Carracci, Guercino and Guido Reni, and died with the work of the Gandolfi brothers at the end of the eighteenth century.

It is hardly ever possible to put Piazzetta's nude drawings in chronological order; it is in fact difficult to do this with almost all his drawings: for example, the great *Standard-bearer* in the

[2] See J. Bean, 'Drawings by Giuseppe Maria Crespi', *Master Drawings* (1966), Vol. 4, No. 4, pp. 419-22.

[3] For this picture, see R. Pallucchini, 'Schede venete settecentesche', *Arte Veneta* (1971) XXV pp. 175-6.

[4] For the drawings of Pietro Vecchia in the Uffizi, see *Gabinetto Disegni e Stampe degli Uffizi. Mostra di disegni veneziani del Sei e Settecento.* This catalogue was prepared by M. Muraro (Florence 1953) pp. 31-2. For Ludovico David, see N. Ivanoff, 'Ludovico David da Lugano e la sua accademia veneziana', *Emporium* (December 1957).

fig. 48

Alverà Collection in Venice could be dated either 1736 or 1716, although the earlier date is suggested by certain stylistic features. This drawing is very similar to the *Male nude* by Crespi in the Fachsenfeld Collection (now in the Staatsgalerie in Stuttgart), which has been dated to the end of the seventeenth century.[5] The *Standard-bearer* exemplifies Piazzetta's way of creating a form with clear plastic outlines and noble, classical echoes. The source is the *Farnese Hercules,* although Piazzetta sees his figure from the side and turned three-quarters away. Flecked with light, it is both humanly present, in a physical and almost tangible sense, and at the same time exalted by that radiant light. This exaltation prefigures what Zanetti, a contemporary of Piazzetta, called 'sunlight contrasted with powerful colour', in his description of the artist's work during his middle period. Through Crespi, Piazzetta came into contact with the work of Annibale Carracci, the pioneer of classicism in Italy, but there can be little doubt that he knew the Venetian paintings of Solimena and appreciated his subtly normative, standardizing approach. But a full understanding of Piazzetta's style in his nude studies cannot be gained simply by tracing their sources. A work like his *Nude woman seen from behind,* in the fig. 49 Albertina in Vienna, which he probably drew between 1730 and 1740, has a relish in the moulding of form and light which transforms an academic exercice into a poetic reality, vital and intensely human.

The drawings that made Piazzetta famous during his lifetime were, however, his *Teste di carattere.* Their style is reminiscent of his nude studies (or 'academies'). They are charcoal and chalk, or white-lead drawings, of heads or half-figures, either in isolation or in groups. Because they are so fully worked out, they are almost substitutes for paintings and give the impression that the artist was trying to reach, in a complex drawing, the absolute perfection of finish that is characteristic of his paintings. The lack of reliable documentation prevents us from considering the chronology of these drawings; the one signed and dated work in this set is a *Diana* in the National Gallery of Victoria in Melbourne (1743).

The sources of these *Teste di carattere* are, like those of Crespi, to be found above all in the Dutch and Flemish art of the seventeenth century. There is a clear relationship between them and the work of Aelbert Cuyp, Gerard Dou, Gabriel Metsu and Nicolaes Maes, among others. Another important source is probably to be found in the work of a Danish painter who worked in Venice between 1651 and 1654. Eberhard Keil, known in Venice as Monsù Bernardo, had been a pupil of Rembrandt, whose naturalism he had learned and was able to transfer to his own *genre* pictures. Remarkably, Piazzetta is able to interpret these and other sources, including, for example, similar works by Pietro Bellotti, Pasqualino Rossi, Antonio Carneo, Lys and Feti, in an absolutely personal and independent way. He only partly followed these artists in their return to the early seventeenth-century style, preferring to draw smooth, closed forms for his *Teste,* both defining their volume and giving them brilliance with his supple use of line. He toned down Monsù Bernardo's vivid naturalism, for example, shaping the heads that can now be seen at Windsor Castle, the Castello Sforzesco in Milan, the Museo Correr in Venice and elsewhere, with a psychologically satisfying intimacy and in a spirit of recollection. As an artist, he also had a marked preference for the faces of children and young people, and probably based his drawings of these on his own children or on prentice boys working in his studio. Examples of such drawings are his *Half-bust of a young man* (Castello Sforzesco), showing in profile a youth with a delicately sensitive face gazing into the distance, *The drum* fig. 50 and the *Standard-bearer* (Museo Correr), both expressing thoughtfulness and even nostalgia, and the *Negro holding a bow* (Windosr Castle), in which the artist has toned down the exoti- pl. 60 cism of the subject by a sentimental treatment that gives it an almost everyday quality.

Piazzetta's portraits are relatively fewer in number, but all were of a high quality, and are very different from the *Teste di carattere.* Perhaps the most striking of all these are two that the artist drew of one of his principal patrons, Marshal Matthias von der Schulenburg, who commissioned him to paint two very important pictures, the *Pastoral scene,* at present in the Chicago Art Institute, and the *Idyll on the beach* in the Wallraf-Richartz Museum in Cologne. The marshal frequently consulted him about the pictures in his collection, which was at that time one of the largest in Europe. He was, moreover, the patron not only of Piazzetta but of

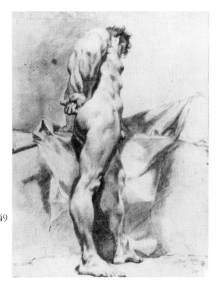

48 Flag bearer
Venice, Alvera Collection

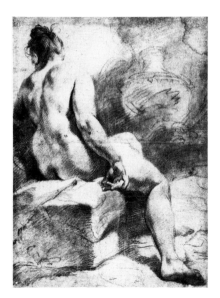

49 Nude woman seen from behind
Vienna, Graphische Sammlung Albertina

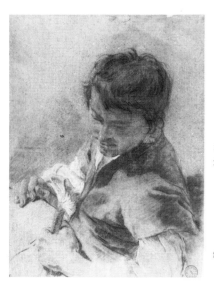

50 The drummer
Venice, Museo Correr

many other artists, such as Gian Antonio Guardi and Ceruti. Piazzetta's two portraits of him are a three-quarter-length profile in the Castello Sforzesco, and a full-face portrait in the Art Institute of Chicago. It is at once apparent from these splendid drawings that the artist understood his model at a level quite different from his relationship with those whom he took as models for his *Teste di carattere*. The first portrait, especially, shows the sitter nervous, even irascible, spontaneous and headstrong, confirming what we know of the famous warrior and heroic defender of the Venetian Republic.

fig. 52
fig. 53
 The same psychological subtlety and deep insight into the sitter's personality can be detected in two drawings in the Art Institute of Chicago. These are the *Portrait of the Count of Oeynhausen,* the marshal's favourite nephew, and the *Portrait of a woman,* an unidentified member of the same Schulenburg family. These portraits, probably drawn in the 1720s, both show that Piazzetta was familiar with the portrait painting of Amigoni and his French contemporaries. Both are elegant, sophisticated and sensitive, displaying a high degree of technical skill, both in the artist's use of charcoal and in his brilliant chalk shading, which give life to the expressions on the faces, without lessening their psychological penetration. Finally, there is

fig. 47 a self-portrait in the Albertina in Vienna, signed and dated 1735, which conveys the intimate and composed impression of a man with noble features and a thoughtful expression, and

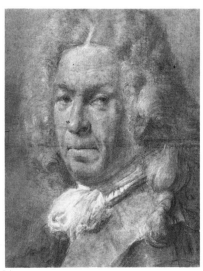

51 The Marshal von der Schulenburg
Milan, Castello Sforzesco

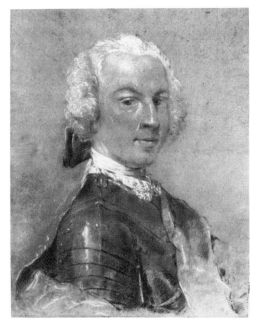

52 Portrait of the Count of Oeynhausen
Chicago, The Art Institute

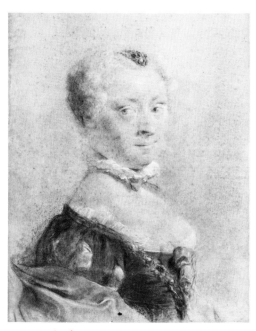

53 Portrait of a woman
Chicago, The Art Institute

6 For the 'preparatory' drawings already attributed to Piazzetta, see T. Pignatti, who provides a usual summary in his article 'Ancora sui disegni preparatori del Piazzetta', *Arte Illustrata* (1973) VI, Nos 55-6, pp. 364-8, with bibliography. For the attribution of these drawings to Pietro Roselli on the basis of the suggestions made by George Knox, see U. Ruggeri, 'Problemi piazzetteschi', *Arte Veneta* (1981) XXXV, p. 192 and note 10.

shows that the artist had an even greater range of techniques at his disposal than is apparent from the Chicago portraits. Here he reproduces his facial expression in a more lively and direct way, and his technique is free and even offhand. This is certainly the effect produced by his touches of charcoal, his less clearly defined outlines, the openness of the drawing and the serenity of the image bathed in light.

 A similar spontaneous approach is also to be found in the artist's many preparatory drawings. The pen drawings of the type of the so-called *Assumption* in the National Gallery of Art in Washington (more probably a study of *St Mark in glory*) have recently been reattributed, mainly because of inferior quality, to a little-known Venetian painter called Pietro Roselli.[6] The preparatory drawings in charcoal and chalk, on the other hand, are among the most interesting in the whole body of Piazzetta's art. The *Studies of a sleeping child* in the Louvre and another *Sleeping child* in the Berlin Kupferstichkabinett belong to this group. It has not been

possible to establish a link between these studies and later paintings; they would seem to be youthful works, since they are closely related to the *Adoration of the shepherds* (Museo Civico, Padua) and their style resembles that of the *Two nude children* in the Hessisches Landesmuseum, Darmstadt, which is a preparatory study for an oil sketch or *modello* in the Gemäldegalerie, Kassel. This *modello* is a pendant to the *modello* of an altar-piece representing the *Guardian angel,* probably painted about 1718,[7] and formerly in Cà Sagredo (its surviving fragments are now preserved in the Detroit Institute of Arts).

This work belongs to the early years of Piazzetta's career, the period following his drawing of *Mars and Venus* in the British Museum. But even at this stage his characteristic, firmly out- pls 73-4 lined shapes, and his nude anatomies brilliantly defined by light can be detected, for example, in his Louvre *Studies of a sleeping child.* With certain variations, following a development in style that is parallel to that of his paintings, the preparatory drawings reach a very high level of formal excellence. *The Peasant woman's head* (Alverà Collection, Venice), which is the preparatory drawing for the *Peasant woman ridding herself of fleas* (Museum of Fine Arts, Boston; painted well before 1720), is a typical example of this. Another is the Cleveland *Angel* – the angel in flight describes a wide circle of light in the space around the central form. The drawing was a preparation for the figure of *St Dominic* (1725-6) in the church of S. Giovanni e Paolo in Venice. Finally there is the *Oriental* in the Scholz Collection, a rather more analytical preparatory drawing, for the *Allegorical Tomb of Lord Somers* (c. 1726) in the collection of the Earl of Plymouth, in Birmingham.

It is difficult to know, in the case of some drawings, whether they were really preparatory studies for paintings or whether they represent a working out of ideas that might either have been used in paintings or in other more finished drawings of the *Teste di carattere* type. The *Profile of a girl* in the Castello Sforzesco in Milan, which is undoubtedly connected with the Cleveland *First blossoming of love,* and can also be compared with *Rebecca at the well* (Pinacoteca, Brera), is, I think, certainly one of the latter kind. The *Head of a young man in a hat* in the Castello Sforzesco may also have originated as an independent drawing, although there can be no doubt that it was used as a model for the last figure on the right in the Chicago *Pastoral scene,* painted about 1720.

These works of the artist's maturity were executed with great spontaneity, an animated and high-spirited line, and great subtlety in the handling of light. Two such drawings are the *Head of a girl with a hat* (Albertina, Vienna), which has been dated on the basis of a comparison with the *Clairvoyant,* in the Venetian Accademia, to about 1740, and the *Head of a dying man in the Scholz Collection, which is a preparatory drawing for the Death of Darius* in the Museo di Cà Rezzonico, dated approximately to 1745. This drawing remarkably anticipates modern pictorial images, executed with rapid, vigorous strokes.

In this type of drawing, Piazzetta used quite different methods from those he used in the nude drawings or academies and in his *Teste di carattere.* Different again are the preparatory drawings for engravings, the most important collections of which are in the Biblioteca Reale of Turin and the Pierpont Morgan Library in New York. The Pierpont Morgan album contains mainly preparatory drawings for the *Studi di pittura,* which have a clear didactic purpose. Most of the sketches in the Turin albums became illustrations for the Works of Bossuet, published by Albrizzi, in 1745. These sheets are remarkable for a wide spectrum of artistic influences, from Titian to Cantarini, Della Bella, Rubens, Jordaens, Jan Fyt, Jacob de Gheyn II, Jean le Pautre and Charles le Brun.[8]

They display, despite the large number of sources, a great homogeneity of style, whose predominant influence is clearly French, both in the more roughly executed sketches – such as the designs for vignettes in the fourth volume of the Bossuet (Fondazione Cini, Venice) – and in the much more finished drawings in the Turin collection. The sketches in the Fondazione Cini were at one time attributed to Pietro Longhi, which serves to stress the freedom and improvised quality of Piazzetta's line. Those in the Turin albums, together with other related sheets, such as the *Allegory* at present in a private Swiss collection, point to the artist's probable familiarity with the techniques of drawing practised by Watteau and his circle. It is quite

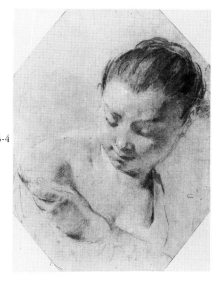

54 Peasant woman's head
Venice, Alvera Collection
See Nos 68, 69

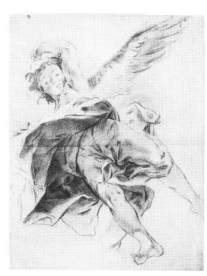

55 Angel
Cleveland, Museum of Art

7 For this dating, see G. Knox, 'Giovanni Battista Piazzetta and the Scuola dell'Angelo Custode in Venice', *Los Angeles County Museum Bulletin* (1979) Vol. XXV, pp. 25-31.

8 For the Turin albums, see the exemplary study by D. Maxwell White and A.C. Sewter, *I disegni di Giovan Battista Piazzetta nella Biblioteca Reale di Torino. Catalogo* (Rome 1969). There is, however, as yet no really profound study of the Contini Bonacossi album, which was at one time in the Kress Collection and is now in the Pierpont Morgan Library in New York. J. Bean and F. Stampfle have considered a few

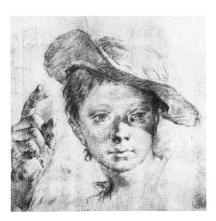

56 Girl with a hat
Vienna, Graphische Sammlung Albertina

many other artists, such as Gian Antonio Guardi and Ceruti. Piazzetta's two portratis of him
likely that Piazzetta acquired this knowledge through Jean de Julienne's 1739 edition of Watteau's engravings: *L'Oeuvre d'Antoine Watteau gravé d'après ses tableaux et dessins originaux.* This work was most certainly known in seventeenth-century Venice – Canaletto's patron, Consul Joseph Smith, had a copy of it.[9]

These drawings reveal a cosmopolitan tendency on Piazzetta's part which inclined him to follow the Rococo style rather than the Baroque that had featured so prominently in his paintings and previous drawings. One sheet of sketches for engravings, now in a private collection, is covered with numerous studies for the vignettes of Pasquali's edition of the Office of the Blessed Virgin, or Book of Hours *(Beatae Mariae Virginae Officium,* 1740). They are not only beautiful in themselves, but display the artist's development at an initial stage of his conception of the image, moving towards the very accurate line that he employed in his engravings, while allowing more room for light in a looser network of hatching. Similar effects can be observed in his design for a ceiling featuring the *The birth of the Virgin,* also in a private collection. Perspectives and architectural structures drawn in the Bolognese manner are clearly related here to the composition of the *Glory of St Dominic* in the Venetian church of S. Giovanni e Paolo, but more fully bathed in light, and drawn with a lighter and more airy hand. This *Birth of the Virgin* is a good example of the effect of sunlight that Piazzetta was able to introduce into his drawing from about 1735 onwards, with a similar yet freer hand to that of his preparatory drawings for engravings.

The aspects of Piazzetta's work as a whole to which I have drawn attention play a rather less significant part in these last examples, especially with regard to his academic concerns. On the other hand, some of the drawings executed in preparation for separate engravings – such as the *St Paul* in the Chicago Art Institute, engraved before 1742 by Marco Alvise Pitteri, undoubtedly Piazzetta's best engraver – are much more strictly functional. This drawing, and others of the same period, display what Zanetti regarded as early as 1733 as one of the artist's most important characteristics, namely a 'profound understanding of chiaroscuro'. In the finished engravings this is expressed in images with a high degree of dramatic tension, revealing a close link between the artist and his engraver. Piazzetta's drawings at this period are, like the earlier *Teste di carattere,* finished works which lack the improvisatory quality of the sketches for paintings; but now they are more aggressive, compact and powerful than the *Testi di carattere,* mainly because Piazzetta emphasizes in them the academic techniques which I have described as basic to his art, and which he taught to those who followed him. Despite individual differences, the work of such followers as Lama, Angeli, Dall'Oglio, Marinetti, Maggiotto and Capella had this in common: it was basically academic.

fig. 57

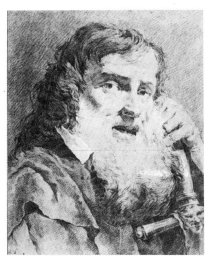

57 Saint Paul
Chicago, The Art Institute

sheets in their *Drawings from New York Collections,* III. *The Eighteenth Century in Italy* (New York 1971) pp. 44-7.

[9] See F. Vivian, *Il Console Smith mercante e collezionista* (Venice 1971) p. 155.

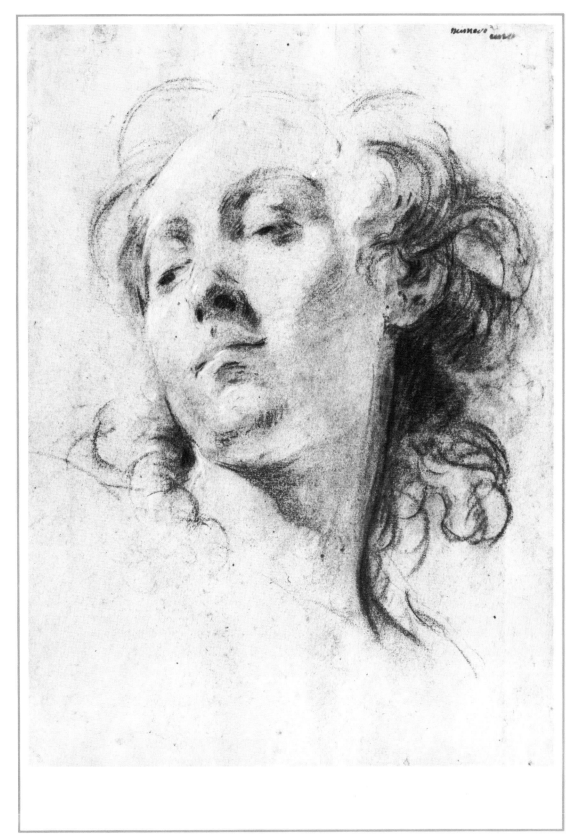

59 Head of guardian angel

Black and white chalk on dark blue paper
399 × 301
Inscription: serial number

Private collection

This exceptionally fine page is a study for a guardian angel with Saint Anthony and Luigi Gonzaga in the church of S. Vitale in Venice. The picture was dated by Zanetti to 1732, but by R. Pallucchini to the end of the 1720s.

Ref.: R. Pallucchini 1956, p. 48, Pl. 132; Sotheby's sale, 18 November 1982, No. 74

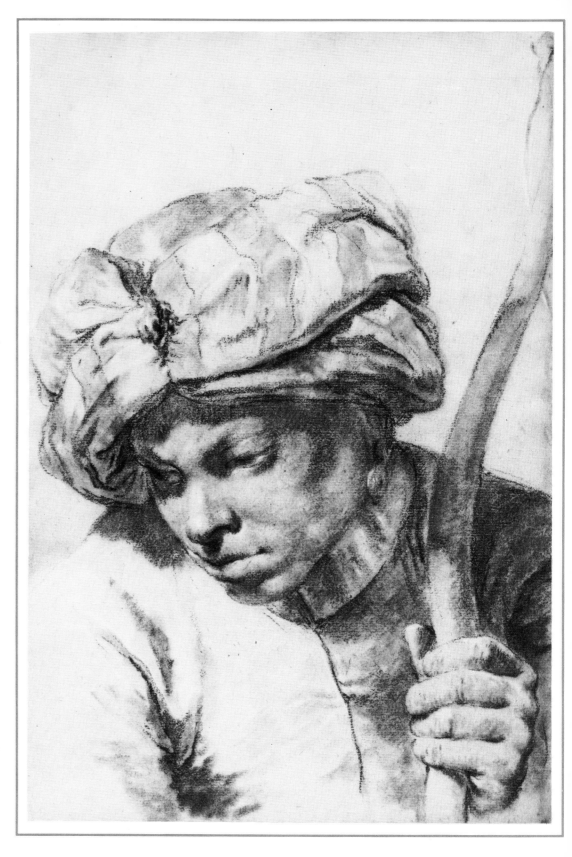

60 Negro holding a bow

Black and white chalk on brownish paper
389 × 271

Her Majesty Queen Elizabeth II

This drawing is preserved together with Nos 61, 63 and 66 in the Royal Library at Windsor Castle. Anthony Blunt included no less than thirty-five drawings by Piazzetta in his catalogue, in which he has also given reasons why this extraordinary series was probably added to the royal collection through the offices of the English consul, Smith. The collection also contains outstanding sets of drawings by other Venetian artists of the same period. Perhaps the most important of these are by Antonio Canaletto (see Nos 89, 91, 93, 96-100), all of which, one assumes, must have reached the royal collection by the same route. Blunt dated the Piazzetta drawings to about 1730. Another version of this striking example is in the Cleveland Museum of Art, but is sufficiently different for both to be regarded as authentic.

Ref.: Blunt No. 34

Giambattista Piazzetta

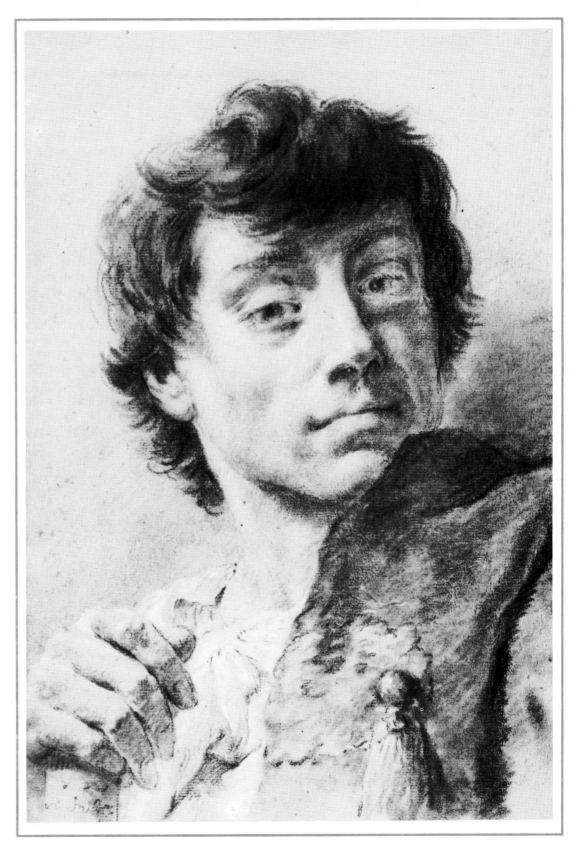

61 Man's head

Black and white chalk on brownish paper
389 × 293

Her Majesty Queen Elizabeth II

See the previous number.

Ref.: Blunt No. 57

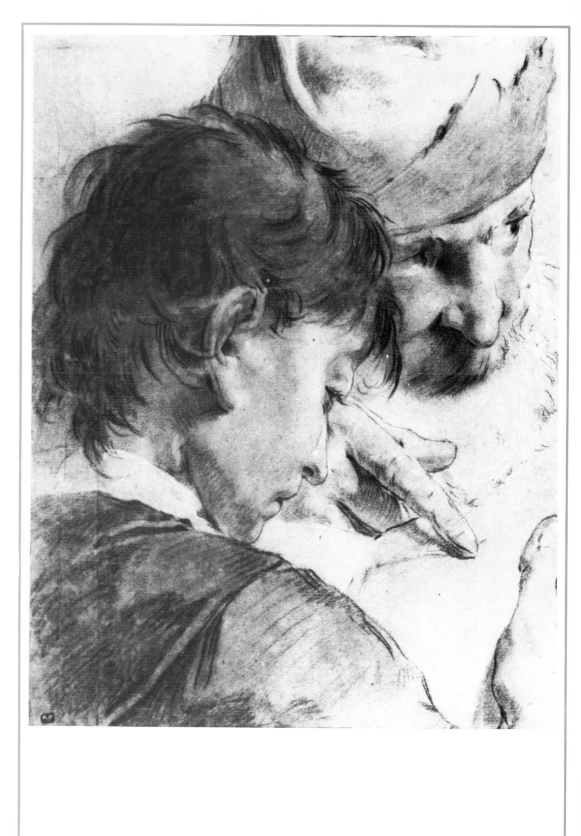

62 Youth and old man

Black and white chalk on pale-grey paper
340 × 275

London, Courtauld Institute Galleries (Witt Collection 1645)

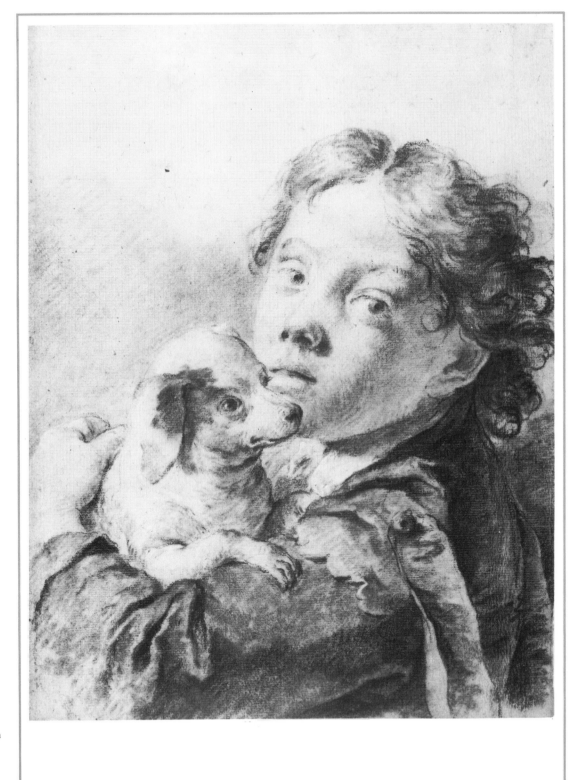

63 Boy with dog

Black and white chalk on brownish
paper
387 × 301

Her Majesty Queen Elizabeth II

See No. 60

Ref.: Blunt No. 55

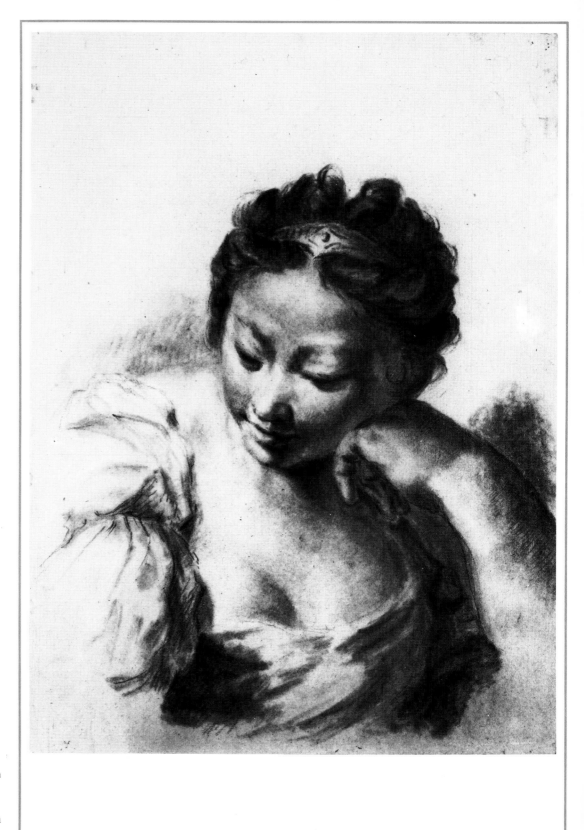

64 Girl's head

Black and brown chalk, set off with white
400 × 305

Rotterdam, Museum Boymans-van Beuningen

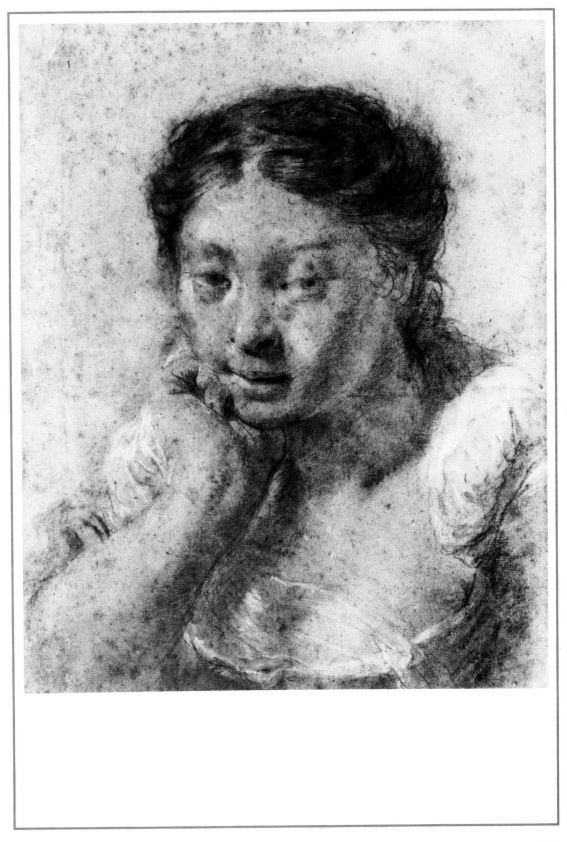

65 Woman's head
Cambridge, Fitzwilliam Museum

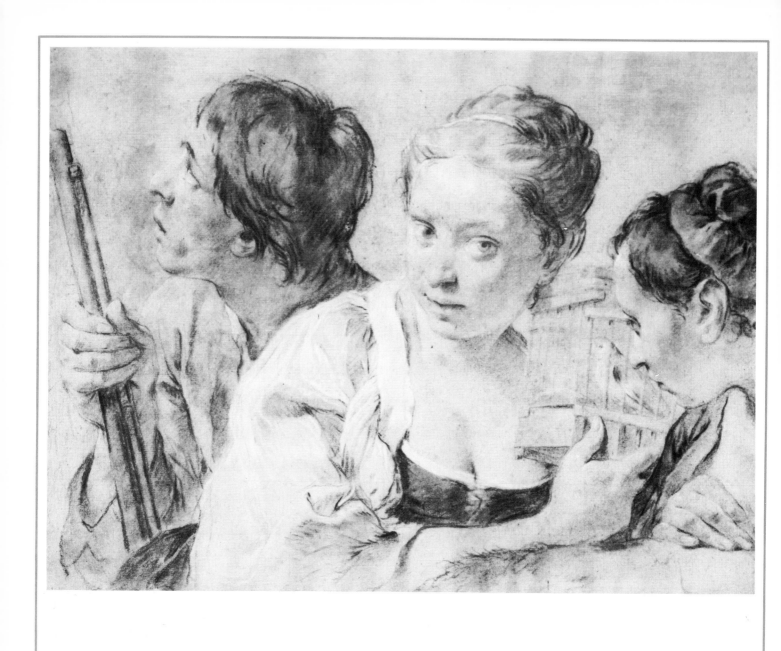

66 Two girls with a cage and a young man with a stick

Black and white chalk on brownish paper 412 × 556

Her Majesty Queen Elizabeth II

One of the most attractive drawings in the Windsor set. It was engraved by G. Cattini in the *Icones ad vivum expressae* (A. Ravâ, *G.B. Piazzetta*, Florence 1921, p. 73).
See No. 60

Ref.: Blunt No. 34

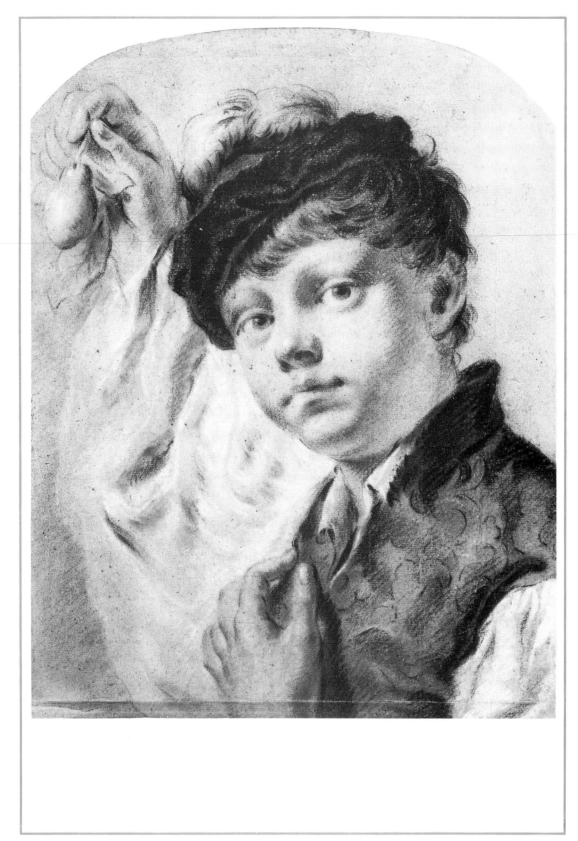

67 Young man with flag and pear

Black and white chalk on brown paper
390 × 306

Berlin, Staatliche Museen Preussischer Kulturbesitz, Kupferstichkabinett (KdZ 5874)

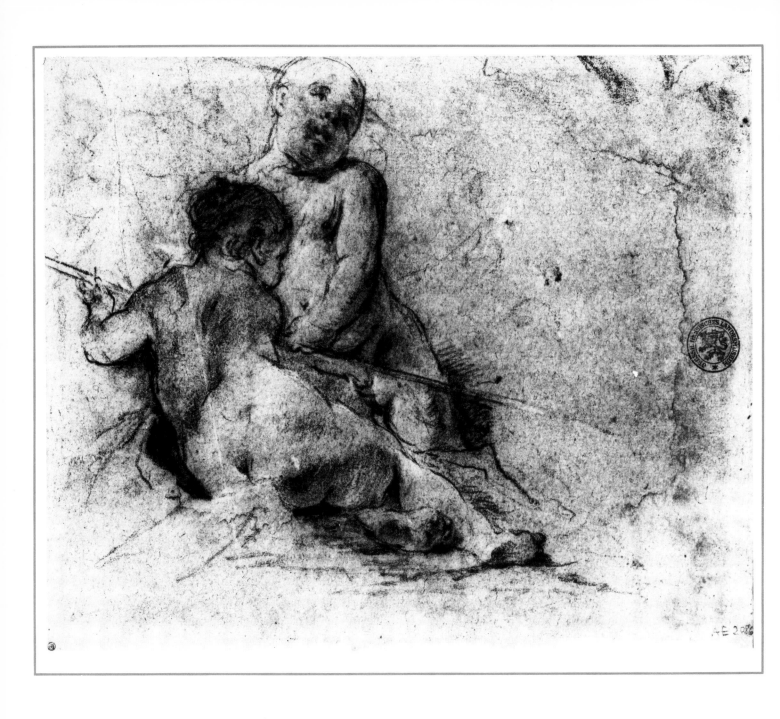

68 Two nude children

Black chalk 255 × 205

Darmstadt, Hessisches Landesmuseum
(AE.2248)

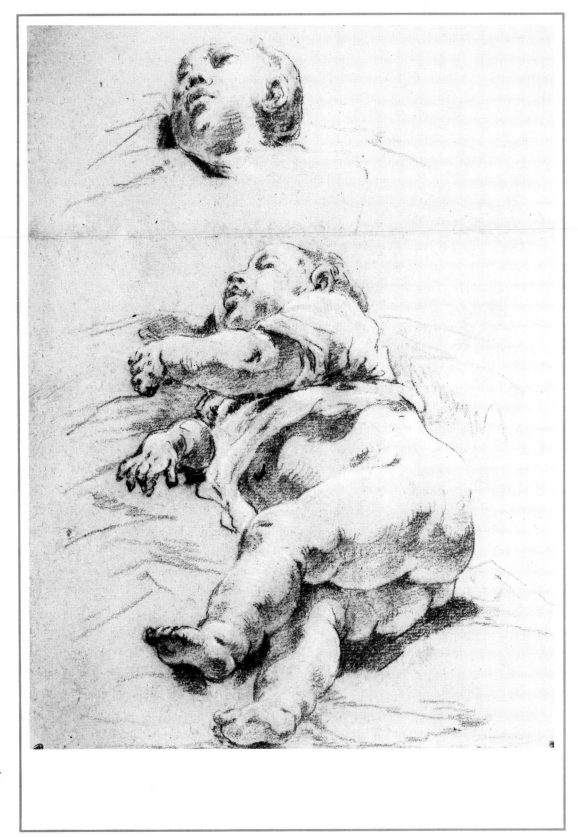

69 Studies of a sleeping child

Black chalk heightened with white on
grey paper
344 × 254 (two joined pieces of paper)

Paris, Louvre, Cabinet des Dessins
(5266)

There are very few studies of this
kind among Piazzetta's drawings.
He did not seek here the most
pleasing or flattering aspect of the
model as in most of his drawings of
people, but to capture the real
attitudes of a sleeping child.

Ref.: Paris 1971 No. 141

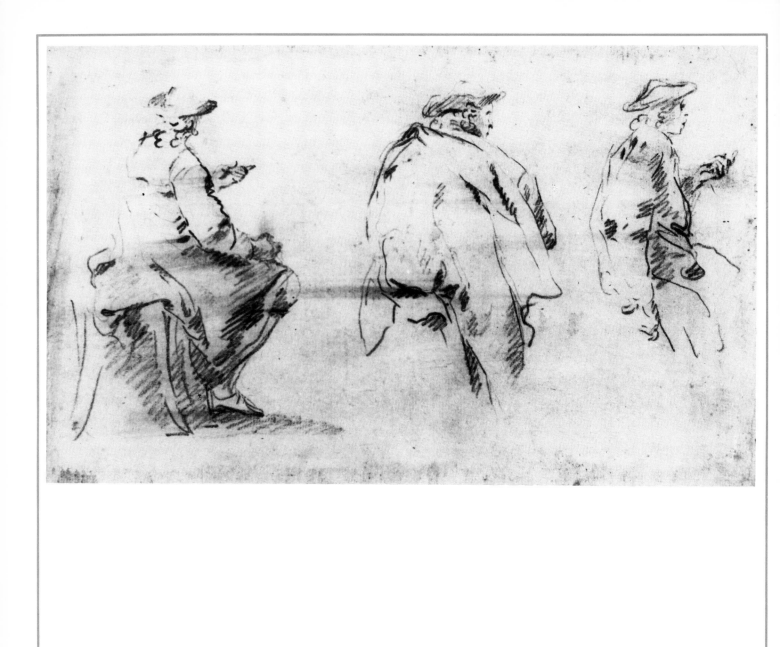

70 Page of studies

Black chalk 162 × 263

Venice, Fondazione Giorgio Cini (30.070)

Sewter and Maxwell White (1961) attributed these two pages of studies to Piazzetta. There is clearly a
direct link between them and the illustrations done by Piazzetta for Albrizzi, the Venetian publisher, in
a work on the 'Histories of variations of Protestant churches' that appeared between 1736 and 1758.
Many of the more fully developed drawings made for this work are preserved in the
Biblioteca Reale in Turin.

Ref.: Cini 1972 No. 34

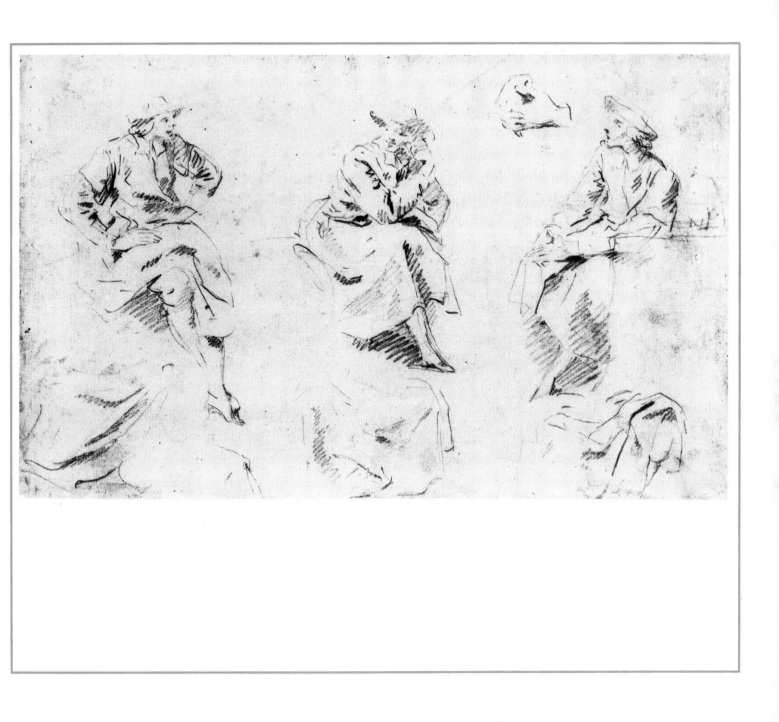

71 Page of studies

Black chalk 160 × 260

Venice, Fondazione Giorgio Cini (30.071)

See No. 70

Ref.: Cini 1972 No. 35

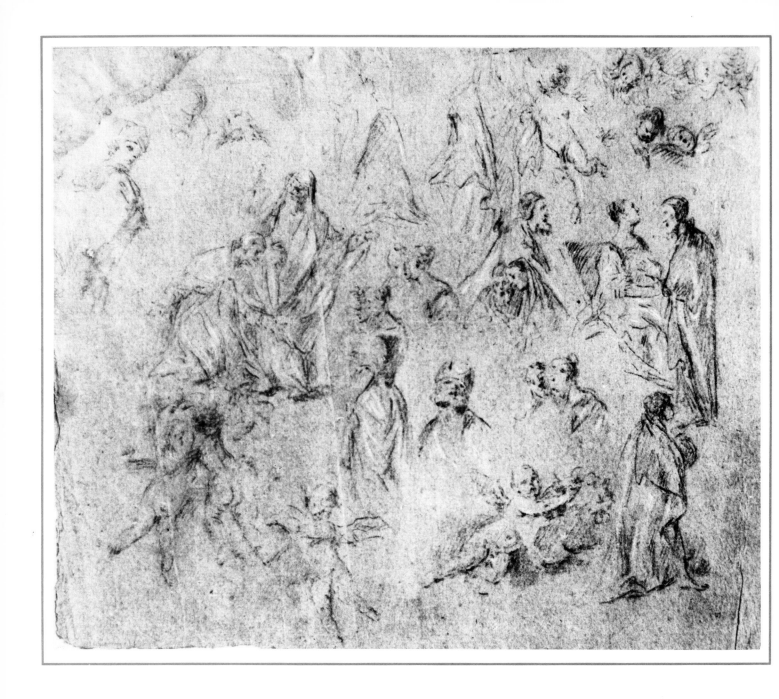

72 Page of studies

Black and white chalk on blue paper 220 × 250

Venice, Private collection

The numerous sketches on this page were made in connection with the illustrations for the work *Beatae Mariae Virginae Officium* (Venice 1740). The sketches can be matched with certain details in the engravings, although there are slight variants.

Ref.: V. Ruggeri in *Itinerari* 1979

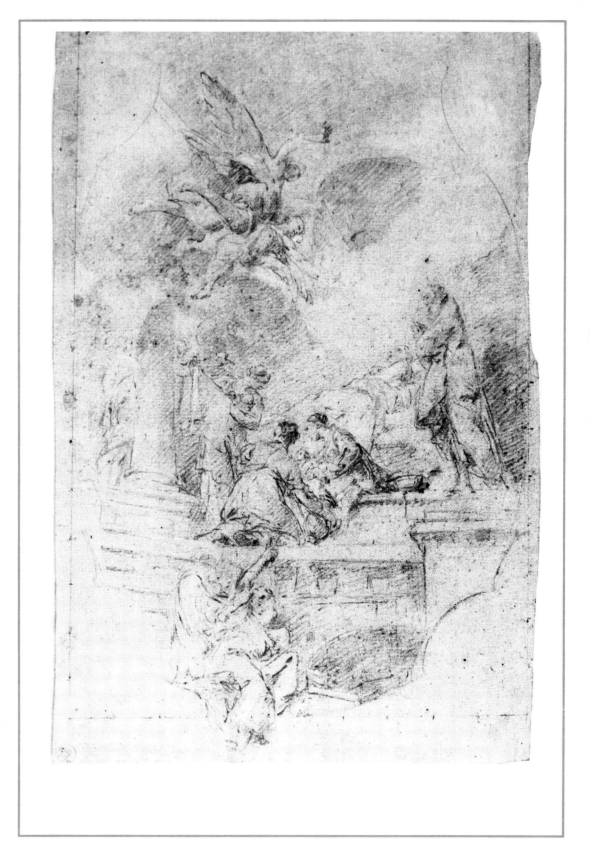

73 The birth of the Virgin

Pencil and white chalk on blue paper
372 × 245

Venice, Private collection

R. Pallucchini was the first to draw
attention to this study for a ceil-
ing, which was probably never car-
ried out, and to the fact that there
are stylistic similarities be-
tween it and the *Glory of Saint
Dominic* (*c.* 1725) in the church of
SS. Giovanni e Paolo in Venice.
Ugo Ruggeri has dated it later than
this, relating it to the *Assumption
of the Virgin* (Musée de Lille),
which was painted about 1735.

Ref.: R. Pallucchini *Arte Veneto* 1959-
60, p. 220

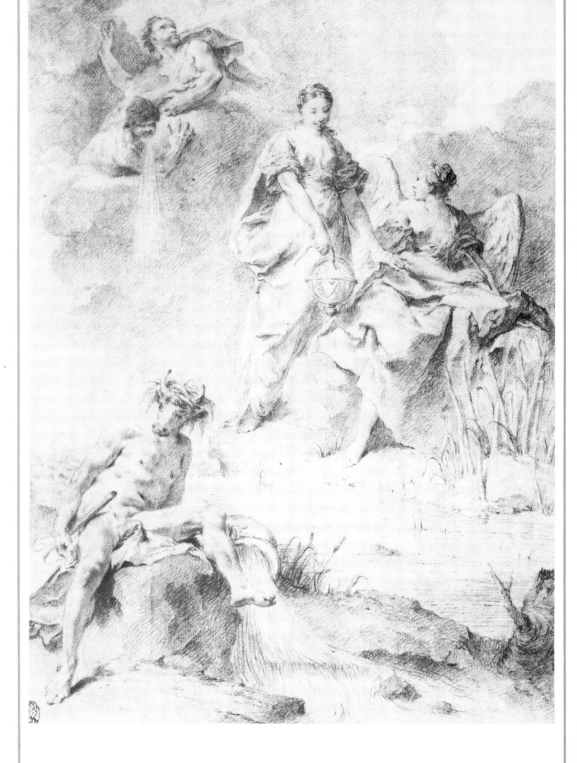

74 Allegory

Black chalk 290 × 215

Switzerland, Private collection

The meaning of this allegory is unclear, even though the figure with the bull's head may be a representation of the River Po and the two figures in the top left-hand corner may represent Aeolus and Zephyrus. It is certainly a design for a book-illustration, similar to those preserved in the Biblioteca Reale in Turin that were made with the illustrations for the Venetian *Opere* of Bossuet in mind. This drawing was probably made between 1740 and 1745.

Ref.: *Art Vénitien en Suisse* 1978 No. 114

The Drawings of Pietro Longhi

Terisio Pignatti

Most modern critics agree in attributing a very special place in eighteenth-century Italian art to the Venetian Pietro Longhi (1702-85), a place, as a painter of social customs, that can be compared with that occupied by Watteau and Chardin in France. Because of his 'realistic' approach, he is in many respects similar to the *vedutisti* and portrait painters who, like him, rejected the customary themes of the Rococo. His own choice of themes does not seem to have imposed any serious limitations on his artistic imagination; his exceptional critical intelligence enabled him to make full use of the latest forms and formal developments in European art.

The question that confronts us at the outset is: Why did Longhi at the age of about forty cease to do what his famous master Balestra had trained him to do, namely history painting, and devote himself for the remaining forty or more years of his life to depicting social customs? There are many possible explanations for the choice of what was described in his own lifetime as 'conversations and encounters, with episodes of amours and of jealousy' and 'masquerades'.[1] What is certain is that once he had chosen this path he never left it.

One of the first masterpieces he produced during this second phase in his career has been dated 1741. It is the *Concert,* now in the Venice Accademia, and it provides a number of clues to help us understand why the artist changed direction at this time. Longhi had been taught in Bologna by Giuseppe Maria Crespi, who produced paintings of the 'popular' Italian kind, and he may also have been influenced by other artists such as Gamberini, Ghislandi and Cerutti, who were doing similar work at the same time. In recent years, critics have compared his work with that of foreign painters and have concluded that he was acquainted with both Dutch and English *genre* painting, particularly that of Troost and of Hogarth, Highmore and Hayman. It has also been suggested that he was influenced by paintings, drawings or engravings produced by Watteau's circle or his followers: this might have come about through Flipart, the French engraver of some of his paintings.

Too much emphasis should not be placed on the importance of these parallels, for it would be wrong to exaggerate the receptiveness to influences of a painter who was very far from adventurous. It cannot, however, be denied that Longhi was responsible for providing a Venetian equivalent of the English conversation pieces of Mercier, Hogarth and others, and of the French interiors of Watteau and Chardin. We do not know how he became familiar with these forms of art, but the most obvious way would have been through engravings. It seems reasonable to assume that Longhi saw the edition of Watteau's engravings published in 1735 by Julienne, or separate prints like the *Fêtes vénitiennes,* one of Watteau's works reproduced by Laurent Cars (1732). These would seem to be the influences which led Longhi to choose a figurative (and especially graphic) style, and a set of themes that were different from those faishionable in the Venice of his own time.

His drawings have only rarely claimed the attention of critics, and then only quite recently. Mariette and the Goncourt brothers were aware of their originality, and we shall have more to say about their judgments later on, but it was not until Ravà's monographs were published (in 1909

58 Pietro Longhi
Venice 1702 - Venice 1785
Portrait engraved by Alessandro
Longhi

[1] A. Longhi, *Compendio delle vite dei Pittori Veneziani* (Venice 1762).

and 1923) that many of the artist's drawings were reproduced. (These were the drawings given to the Museo Correr in Venice at the beginning of the nineteenth century by Pietro Longhi's son, Alessandro.) Roberto Longhi seems to have been the first to draw attention to the artist's very modern way of drawing (1946), and he was followed in 1956 by Moschini and in 1960 by Pallucchini. In my own catalogue of all the paintings and drawings of Longhi (Pignatti, 1968), I have tried to explore the importance and the meaning of the artist's drawings.[2]

Longhi's drawings are sufficiently numerous to form the basis of a thorough study of his personality as an artist. There are in all 162 sheets, many of them with drawings on the back as well as the front, and, of these, 145 are preserved in the Museo Correr in Venice, nine in the Berlin Kupferstichkabinett and the rest in the British Museum, the Accademia, and a few others in private and public collections. One's first impression is that they have very little in common with the mainstream of drawing in the eighteenth century, not only in Venice, but also in Italy as a whole. Longhi was a pupil of Balestra, but there is hardly any trace of a Romanizing academic influence in these drawings, which seem to have been made from life. They are entirely without formalism or idealization, either in composition or in language. The artist was also a pupil of Crespi, yet it is difficult to detect, even in his youthful drawings, any sign of the great Bolognese graphic tradition that extended from Carracci to Guercino. Longhi's transition from 'popular' subjects in his earlier years to social themes when he was more mature – in other words, his break with the Venetian tradition – can also be discerned in the style and language of his drawings.

In many ways, then, these drawings are totally original. They are contained on sheets of album paper, each page crowded with full-figure drawings and anatomical and other details, often repeated almost obsessively and accompanied by written notes of the colours, materials and particulars of the subjects' dress. Unlike most of his contemporaries in Venice, Longhi drew from life, and his intention was clearly to provide a factual record, just as his painting is documentary and realistic. There is one picture, *The café,* now in Pasadena (but formerly in the Hallsborough Gallery; see Pignatti, 1968, p. 187), which shows the artist as a tireless chronicler of social customs and fashions with a pencil and paper in his hands noting down his impressions in a drawing.

His technique in drawing is also quite distinctive and different from that of his Venetian contemporaries. He preferred charcoal and soft chalks or crayons, and took great pains to heighten the light areas with white chalk, making a striking contrast with the brown or grey-blue paper. His outlines are flowing, the individual lines are broken but very precise, and he seems to have delineated his figures with great rapidity and to have reinforced them with repeated strokes which serve to establish colour. He sometimes used shading obtained by retouching with charcoal or white lead, and this creates a roundness similar to that obtained in pastel technique by rubbing with the tip of the finger.

His drawings are entirely self-sufficient, and in this Longhi differs from even the greatest Venetian draughtsmen of the eighteenth century, such as Ricci, Piazzetta and Tiepolo. These produced many drawings, but they were always essentially painters. Longhi, on the other hand, was an artist who made notes on what he saw, who constructed his figures with composite elements, and analysed them in great detail; but this was not done simply as a better preparation for a painting. He did it as an independent exercise in which he deepened his own grasp of a reality that he found fascinating in itself. In this, he was a true man of the Enlightenment – much more so than any follower of the fading myths of the Rococo.

Some of the notes added to the drawings are very illuminating, and give an impression of immediacy and intimacy. It is obvious that Longhi was powerfully drawn to express the truth, to a degree that was most unusual at the time. His notes on the *Parrot* in the Museo Correr, for example, are so limpidly precise that they have an almost poetic quality: 'Its bill dark, the spot beneath its neck yellow, red around the eye and above, the body pale green, some little feathers pink on yellow below, the eye pink and the pupil black.' Another note, less well known, is found on a drawing of a manservant in the Berlin Kupferstichkabinett: 'Yellow shirt, dark blue breeches, white stockings, silver buckle'.[3]

[2] T. Pignatti, *Pietro Longhi* (Venice 1968), with a full bibliography.

[3] ibid., plates 384 and 304. The original descriptions are: 'Il Grugnetto oscuro, la machia in sotto il colo Gialla, rosso a torno a l'ochio e suso, il corpo verdolin, qualche peneta rosetta su zalla abasso, l'ochio rosetto e la pupilla nera'; 'Camisiola zala; bragon blu scuro, calza bianca, fibia argento'.

Who were Longhi's teachers in the art of drawing? It is not easy to discover any real forerunners in Venice, even among those artists whose attitudes and themes his own most closely resembled. It was suggested some years ago that it might have been Carlevarijs who inspired him to see reality 'through the sketchbook'.[4] A glance through that artist's sketches in the Museo Correr – pencil studies of sailors, porters, elegantly attired merchants and so on – reveals that the themes are similar to those of Longhi, but that the language is quite different. Longhi's vocabulary is much more clearly defined, his line is more flowing, richer in painterly subtleties of shading. There are also analogues with Longhi's realistic vision in the Roman sketchbooks of Gian Paolo Panini, an artist known to Venetians through his connections with Canaletto. Despite this similarity, however, there are important differences: the Roman artist was more meticulous in his use of the pencil, and his work was more formally elaborate and more obviously Rococo in its stylization. He also drew with a routine professionalism which Longhi's work, in its poetic freshness, constantly transcends.

There is, on the other hand, a real similarity both in language and in style between Longhi's drawings and those of such French artists as Watteau and Chardin. This was already obvious to the connoisseur Pierre-Jean Mariette (1694-1774), who wrote in the notes of his *Abecedario* that Longhi, when he turned to conversation pieces, parties and masquerades, 'became another Watteau'.[5] The Goncourt brothers also commented on Longhi, whose drawings they had admired in Venice when they went there in 1855-6. They saw in his drawings 'a complete assimilation with the sketches of Lancret, with his legs done in stick-like lines in imitation of his master Watteau, with his strokes of blunt black pencil, so usual in the drawings of French artists.'[6]

These comments are quite right, but it is necessary to analyse and clarify them. I have already said that the change of direction in Longhi's style dates back, in my opinion, to about 1740, by which time the artist had fully made his own the themes of the 'conversation piece'. I also believe that this change can be attributed to a particular event in the artist's life, and perhaps to a single direct influence. Pallucchini suggested more than twenty years ago that this interest in social customs as a subject for drawings and paintings goes back to French sources, and in particular to the movement from Watteau to Chardin; he refers also to the fact that the French engraver, Joseph Flipart, lived and worked in Italy for many years and may have acted as an intermediary.[7] Little is known about this artist, but he was certainly born in Paris in 1721 and worked as an engraver there, reproducing Chardin's paintings. He arrived in Venice in 1737 and worked in the Wagner studio until about 1750. His connection with Longhi is borne out by the numerous prints that he made of the latter's work. Well-known examples of his Longhi engravings are *The dancing lesson, The procurator's visit, The declaration,* and *The lady's awakening.* Nothing is known about Flipart's own drawings, but to judge from his engravings his style cannot have been very different from those of the lesser masters working in the tradition of Watteau. It is clear, then, that Longhi's move in the direction of the French style of drawing can be satisfactorily explained on the basis of Flipart's presence in Venice, and that prints of the works of French painters of social customs undoubtedly played a part in fashioning Longhi's style of drawing and in influencing him in his choice of themes.

A collection of engraved reproductions of Watteau's drawings was published in Paris in 1726-8. This publication, entitled *Figures de différents caractères,* was followed, as we have seen, in 1735 by *L'Oeuvre gravé de Watteau.* Flipart arrived in Venice two years after this, coming from France, where he had worked close to where prints after Watteau had been produced. It is surely not unreasonable to think that he brought with him in his bags those valuable books of engravings, and even possibly some original drawings of Watteau, Pater, Lancret and Bernard Lépicié.

This hypothesis is at once confirmed by a comparison between some of Watteau's or Pater's figures and a number of the drawings executed by Longhi in the 1740s, such as *The painter's studio* or *The declaration* (which Flipart engraved with great accuracy). These are characterized by long and accentuated lines and parallel hatching. Another important factor that must be taken into consideration is that Chardin's style in his few charcoal and white-lead drawings,

[4] A. Rizzi, *Carlevarijs* (Venice 1967) p. 47.

[5] P.-J. Mariette, *Abecedario* (Paris 1854-6) p. 221.

[6] E. and J. de Goncourt, *L'Italie d'hier* (Paris) p. 39.

[7] R. Pallucchini, *La pittura veneziana del Settecento* (Venice and Rome 1960) pp. 179 and 190.

fig. 59

fig. 60

59 J. Flipart, The dancing lesson (engraving based on Pietro Longhi)

115

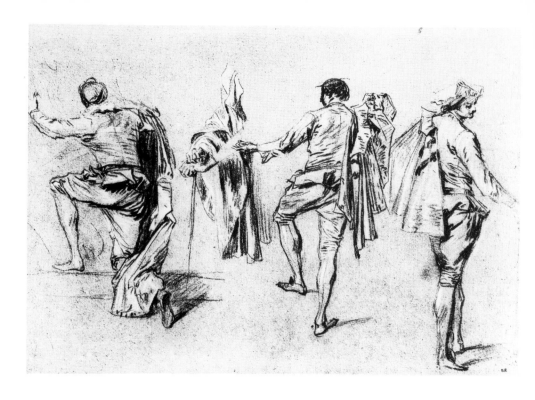

60 A. Watteau, Three studies of an actor (drawing)
Paris, Cabinet des Dessins, Musée du Louvre

such as *Sedan-chair* in the National Museum of Stockholm, is so similar to Longhi's that it is easy to confuse the two.[8] This may well mean that the Venetian artist chose from the various available French models the one that was closest to him spiritually – and that happened to be Chardin's.

61 J.B. Chardin, Sedan-chair (drawing)
Stockholm, National Museum

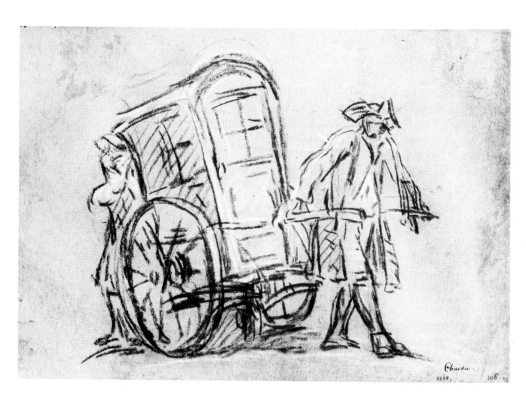

[8] Inv. 42/1898. See T. Pignatti, *op. cit.*, p. 28, Fig. 10.

116

One final factor must be considered if we are to account for the new style and themes adopted by Longhi during the second stage of his career. A single example may be enough, that of Molière's *Comédies,* published in 1734 with Boucher's illustrations engraved by Cars. These plates are similar in so many ways to some of Longhi's paintings that it is reasonable to suppose that there was a direct influence. I am thinking here especially of Cars' *Visit to the library,* which can be compared with Longhi's painting of the same subject in Worcester, Mass.[9] Other books were published in Paris at about the same time (1735-40) with engravings after Pater, Boucher or Chardin. The illustrations most likely to attract the attention of Longhi were those by Chardin, engraved by Lépicié or Flipart.

There is, I am certain, only one conclusion that can be drawn from all these comparisons between Longhi's style and that of certain French artists. It is that Longhi must have consciously chosen to follow the French pattern, because he was unable to find other models in his native Venice through which he could express sufficiently poetically his new and independent way of drawing.

Longhi's method of working can also be analysed by a careful study of his drawings. It is important, however, to recognize at the very outset that, even if his drawings help us to follow his movement as an artist from nature to pictorial interpretation of nature, they are more than simply instrumental in this process: they are not, in other words, merely preparations for later paintings. Seen in their true perspective, they form part of a continuous process of experiment in drawing from life, and are as autonomous as are all poetic creations.

Sometimes Longhi fills his drawings with an analysis of the whole scene, with the intention of completing it and giving it its final form in the painted version. But he does this very rarely: there are perhaps only ten such sheets in the whole body of his extant work. His studies of the *Gentleman's awakening* (Windsor Castle) provide what is perhaps the best example. They are very rapid sketches containing only essential features.[10] In all other cases, his drawings are much more fully elaborated, with some central detail standing out in the foreground, such as the *Nobleman lying down fanned by a woman* (Museo Correr, Venice) and *The card-players* (Berlin), which was drawn in candle light with vibrant shadows producing a fantastic effect of instability.[11] In other drawings it is the details that strike us. Longhi has obviously sketched the head of the Museo Correr *Dancer* with very rapid strokes, but we can already feel the density of colour in the lace collar that surrounds the subject's delicate neck.[12]

The most difficult problem with Longhi's work is that of chronology; but although it is possible to identify and classify his work over the whole range of his artistic activity by a careful examination of his drawings alone, it is important to bear in mind that there is a continuity of style in his drawings that does not seem to correspond to the slow evolution of his paintings. Although not drawn in Longhi's usual manner, his *Pastoral scene* (Pierpont Morgan Library) reflects the style of his youthful drawings, which was above all Bolognese in inspiration.[13] The trees in the background arouse a faint echo of Carracci's landscapes, but they are seen as if though a coloured filter, in a way that is reminiscent of Zuccarelli. This drawing was probably executed before 1740; the *Shepherd* in the Museo Correr can be dated before 1740 with certainty. This is a preparatory sketch for a youthful painting in the Bassano museum.[14] The line is frayed, and the shading is not executed in the French manner, as the artist did when older. The style is similar to Piazzetta's, as we would expect during Longhi's early period, when he was influenced by Crespi.

His drawing of a *Peasant woman drawing wine* in the Museo Correr has been linked with a fig. 62 similar painting in the Castello di Zoppola dated about 1745-50. This is a very difficult drawing to date. On the one hand, the powerful pictorial shading and the plastic effect of the chiaroscuro remind us of the earlier drawings done by Longhi while he was still influenced by the school of Bologna. On the other hand, the strong accent on light, casting brilliant reflections on the folds of the woman's dress, points to the artist's more mature period. This impression is strengthened by the heightening with white chalk.

The painter's studio and *The declaration* show us Longhi at his most sensitive, during the fig. 64 period when he was coming into contact with French drawings. His line is extremely subtle

[9] T. Pignatti, *op. cit.,* Fig. 5 and Plate 51.

[10] *ibid.,* Plates 56-61.

[11] *ibid.,* Plates 324 and 301.

[12] *ibid.,* Plate 339.

[13] *ibid.,* Plate 131.

[14] *ibid.,* Plate 8.

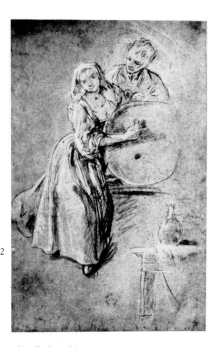

62 P. Longhi, Peasant woman drawing wine (drawing) Venice, Museo Correr

117

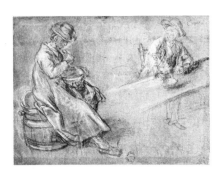

63 P. Longhi, Peasants eating (drawing)
Venice, Museo Correr

and vibrant and the details are cut out with great freedom. His figures are sharp and sophisticated. It is almost as though he is trying to record his own spontaneous reaction to a new form of art which, to a young artist, inevitably appeared much more amenable, pleasing and sensitive than that of the Bolognese school in which he had been trained.

It becomes increasingly difficult to detect a clear development in Longhi's style with the passing years. It is, for example, surprising to come across a painting such as *Hunting in the valley,* which is full of subtle shading, reflections and effects of mist, and to learn that the preparatory drawing is characterized by strongly accentuated lines, quite brilliant light and rapid, confident movement.[15] The figure of a wet nurse, who is an unimportant detail in another painting, a *Family portrait,* in the Albrizzi (Venice), first appears in a dazzling drawing where it is drawn with aggressive strokes and stands out vibrantly in the light.[16] A final example is *Peasants eating,* the preparatory drawing made for a picture in the Querini, painted about 1765. The two figures recede into shadows of varying intensity, and the chiaroscuro of the underdrawing is lost in subdued but subtle colour effects.[17]

The artist produced fewer and fewer drawings in his later years, but it is still possible to be surprised, as, for example, in the case of *A Poet reciting his verses.* This drawing was until recently attributed to Pietro's son Alessandro, but there is very good reason for believing that it was done by the father. Both Byam Shaw and Watson have compared it with a very animated painting in the Port Sunlight museum.[18]

I have compared 162 drawings with 250 pictures which were, in my opinion, painted by Longhi, and have come to the conclusion that seventy-four of the drawings were preparatory: in other words, about half.[19] I am sure that it will eventually be possible to establish a link between most of the remaining drawings and one or other of the artist's paintings: all his drawing seems to be inseparable from the recording of truth. Longhi's drawings form a clearly defined body of work, with characteristics both general and specific which belong to it alone: a group of drawings which bring to vivid life the individuality of one of the most remarkable painters in Venetian artistic history.

[15] *ibid.,* Plate 240.

[16] *ibid.,* Plate 219.

[17] *ibid.,* Plate 244.

[18] *ibid.,* Plate 278a.

[19] T. Pignatti, *Pietro Longhi dal disegno alla pittura* (Venice 1975).

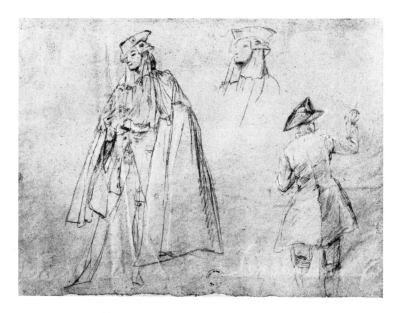

64 P. Longhi, Painter's studio (drawing)
Venice, Museo Correr

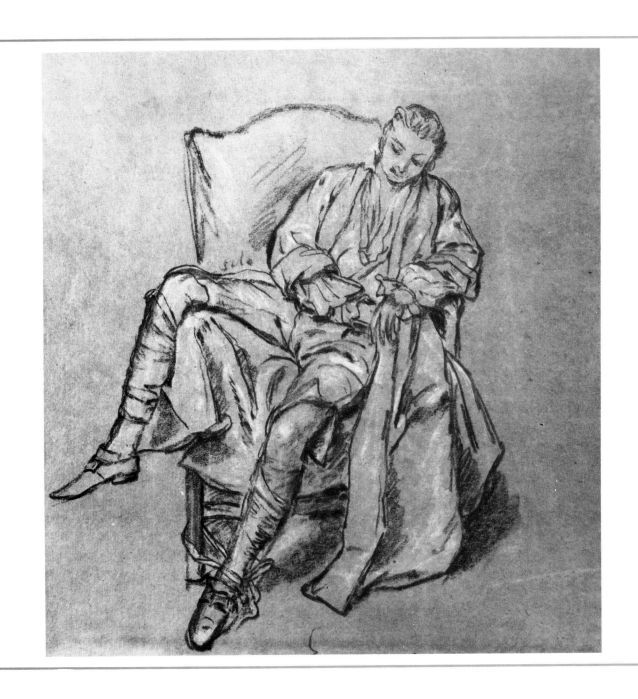

75 Young man asleep

Black and white chalk on grey-brown paper 280 × 388

Berlin, Staatliche Museen Preussischer Kulturbesitz, Kupferstichkabinett (KdZ 11644)

Preparatory drawing for the picture *Tickle the sleeping man* (Private collection, Pignatti 1968, Pl. 214)

Ref.: Pignatti 1968, 215

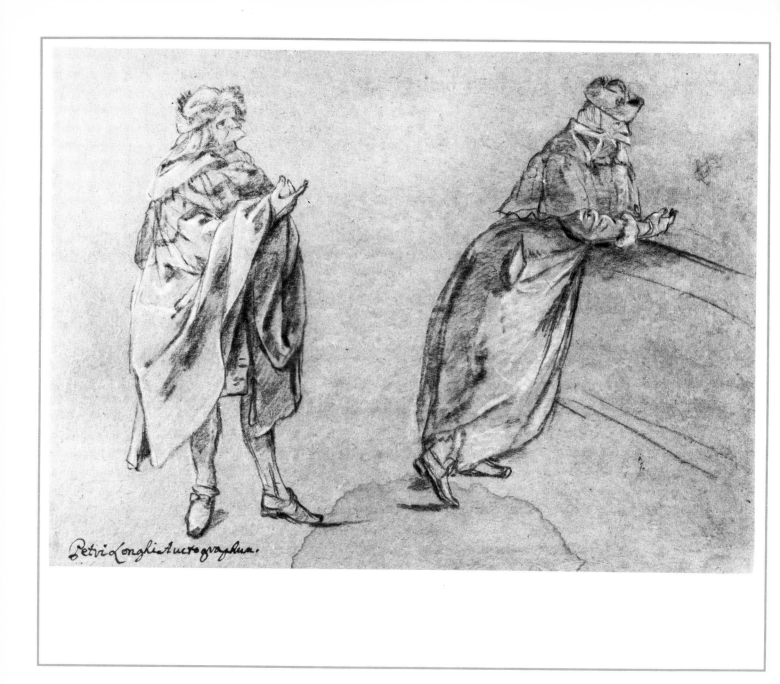

76 Two masked noblemen (in *bautta*)

Black and white chalk on paper 285 × 407
Inscription: *Petri Longhi Autographum*

Berlin, Staatliche Museen Preussischer Kulturbesitz, Kupferstichkabinett (KdZ 11699)

Pignatti has connected this drawing with a painting entitled *Il ridotto (The playhouse)*
(Private collection, Pignatti 1968, Pl. 168).

Ref.: Pignatti 1968, Pl. 169

120

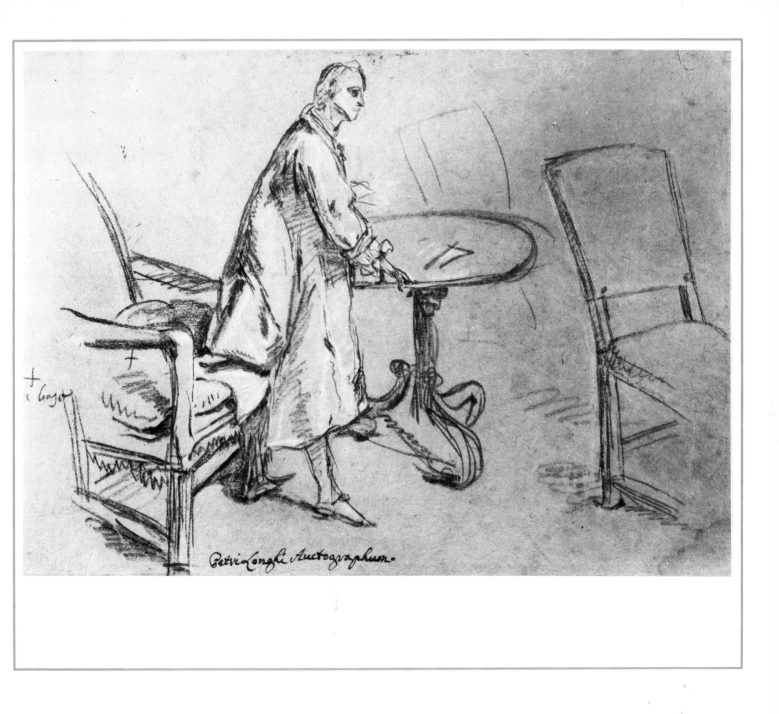

77 Nobleman leaning on a little table

Black and white chalk 279 × 402
Inscription: *Petri Longhi Autographum*

Berlin, Staatliche Museen Preussischer Kulturbesitz, Kupferstichkabinett (KdZ 11643)

Ref.: Pignatti 1968, Pl. 303

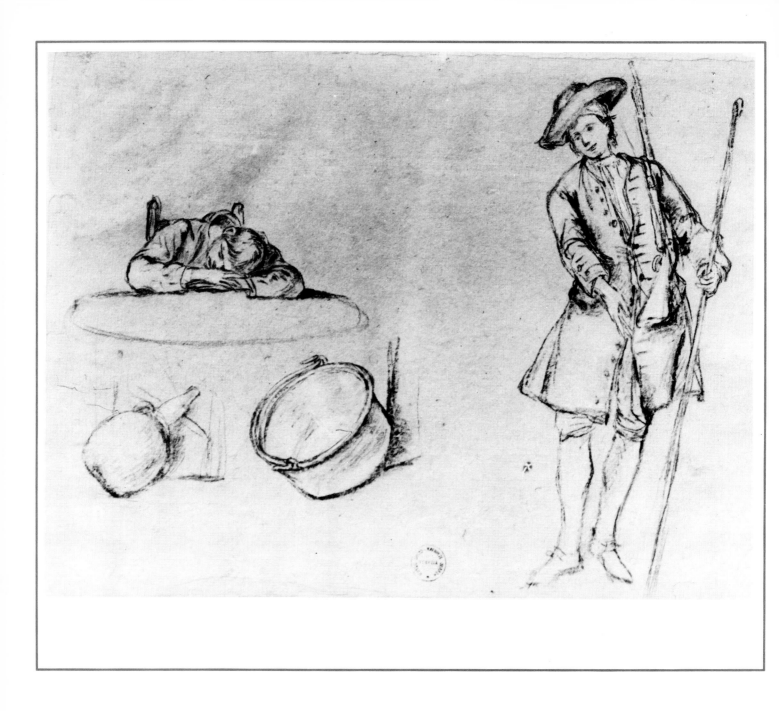

78 Boy asleep; a huntsman

Black and white chalk on reddish-brown paper 300 × 437

Venice, Museo Correr (521)

Studies for the picture *The huntsman and two peasant women*
(Milan, Private collection, Pignatti 1968,
Pl. 97).

Ref.: Pignatti 1968, 98

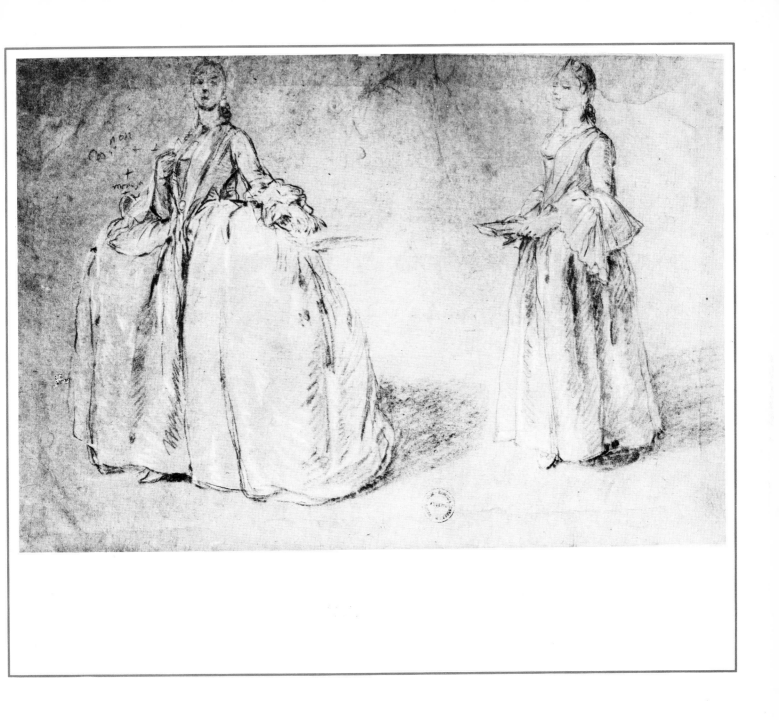

79 Lady in an 'andrienne' dress, with chambermaid carrying a dish

Black and white chalk on brown paper 286 × 414

Venice, Museo Correr (552)

Ref.: Pignatti 1968, Pl. 399

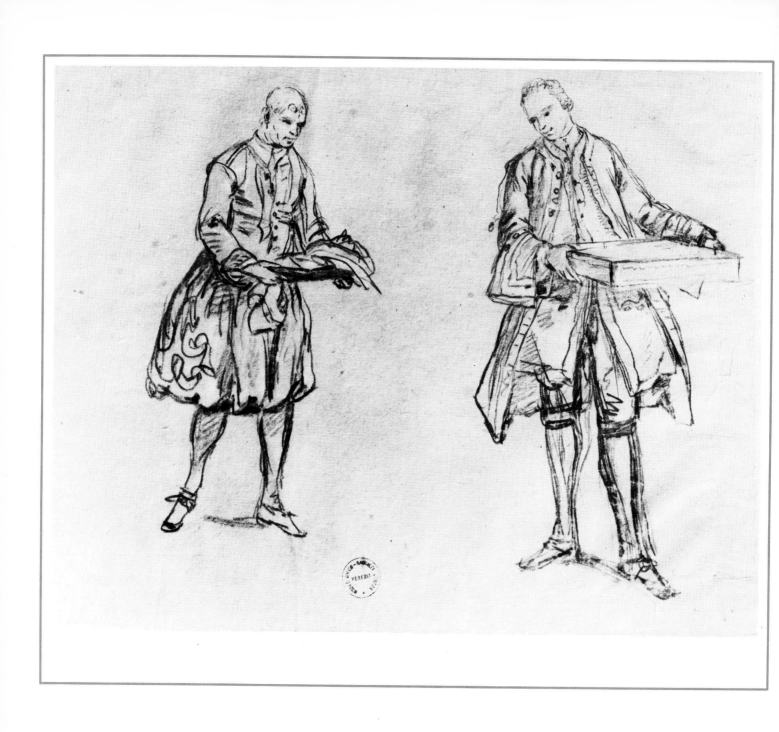

80 Seaman with basket; servant carrying a box

Black and white chalk on reddish-brown paper 286 × 357

Venice, Museo Correr (531)

Ref.: Pignatti 1968, Pl. 382

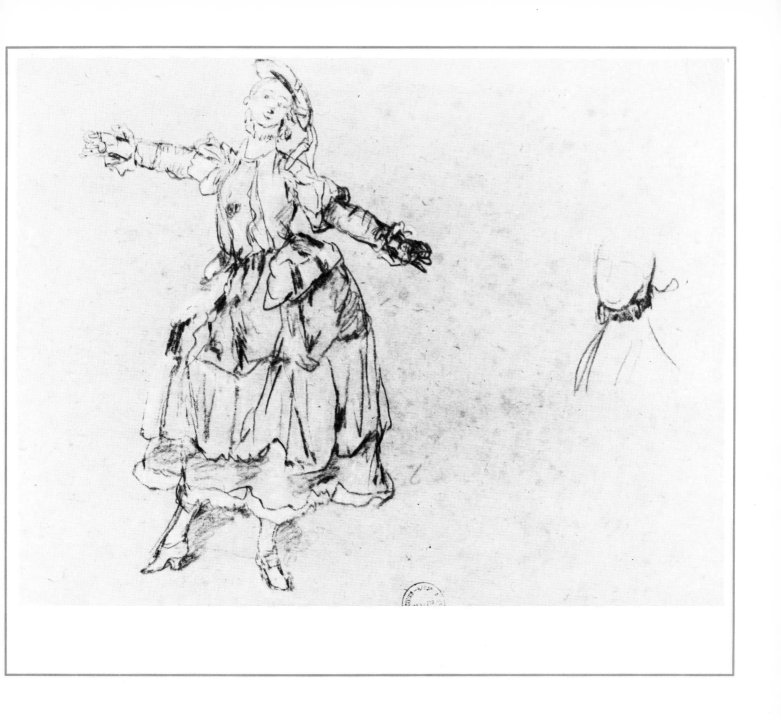

81 Dancer; woman's head

Black and white chalk on grey paper 268 × 333

Venice, Museo Correr (485)

Ref.: Pignatti 1968, Pl. 339

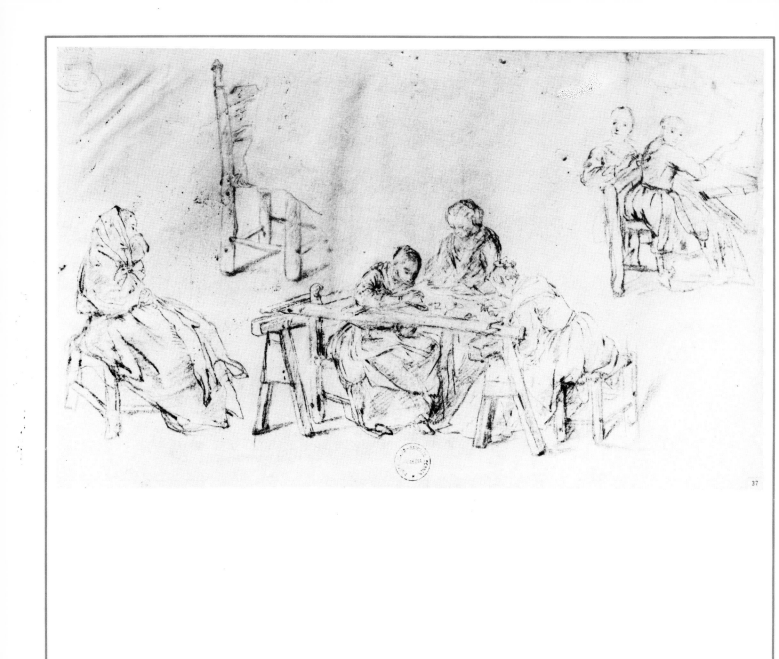

82 Embroiderers

Black, sanguine and white chalk on yellowish paper 228 × 376

Venice, Museo Correr (569)

Study probably made in connection with the painting *The embroidery workshop* (London, National Gallery; Pignatti 1968, Pl. 135).

Ref.: Pignatti 1968, Pl. 134

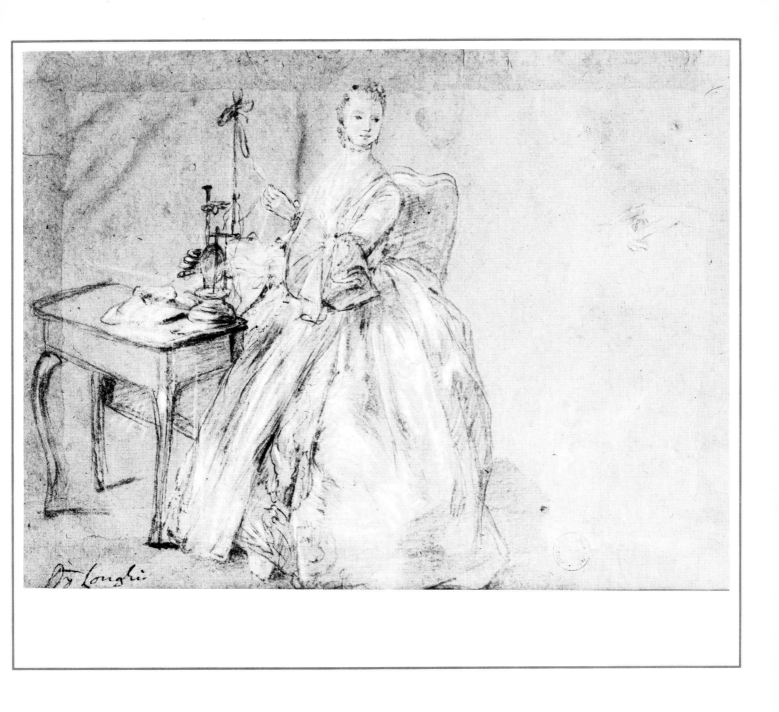

83 Lady at the spinning-wheel

Black and white chalk on reddish-brown paper 280 × 385

Venice, Museo Correr

One of Pietro Longhi's most beautiful drawings. The original picture for which this drawing, and another one also in the Museo Correr (572), served as preparatory studies, has disappeared, but the composition is known because of the print of the French engraver Flipart, who seems to have worked in Venice until about 1750. Two copies made after the original painting are also known.

Ref.: Pignatti 1975 No. 26b; Pignatti 1968, Pl. 451; Cini 1964 No. 48

84 Study of coats *(veleda)*

Black and white chalk on yellowish paper 295 × 495

Venice, Museo Correr (496)

This drawing clearly demonstrates Longhi's concern for detail.

Ref.: Pignatti 1968, Pl. 345

85 Kneeling woman

Black, sanguine and white chalk on reddish-brown paper 290 × 443

Venice, Museo Correr (529)

Ref.: Pignatti 1968, Pl. 378

86 Hunting in the valley

Black and white chalk on brown paper 300 × 437

Venice, Museo Correr (477)

Sketches for two figures in the picture *Hunting in the valley (La posta in botte)* in the Pinacoteca Querini
Stampaglia in Venice.

Ref.: Pignatti 1968, Pl. 240

Pietro Longhi Venez?

87 Lutenist

Charcoal
239 × 15.7
Inscription: *Pietro Longhi Venez°*.

Switzerland, Private collection

This stringed instrument was
known as a *colascione*. It origina-
ted in the East and became popu-
lar in Southern Italy during the
sixteenth and seventeenth centu-
ries.
The style of the inscription is
found on other drawings belon-
ging to a Venetian collector of the
eighteenth century.

Ref.: J. Byam Shaw 1936; *Art Véni-
tien en Suisse* 1978 No. 123

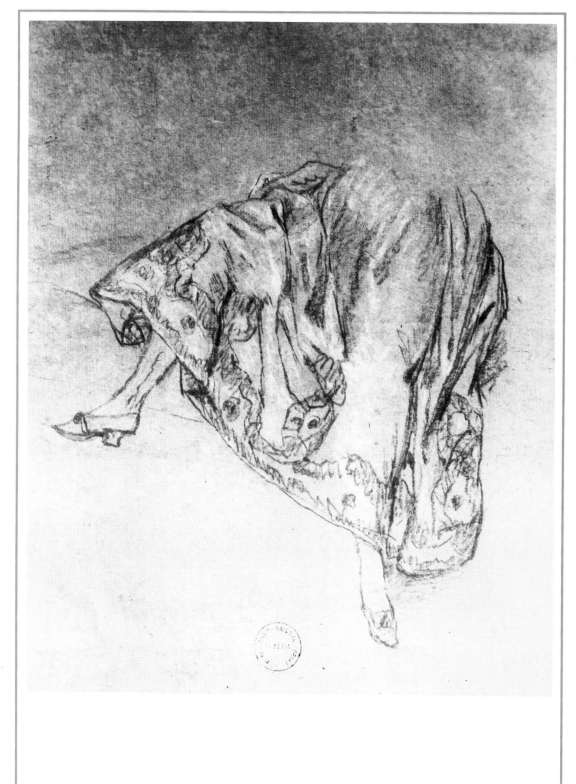

88 Study of a skirt

Black and white chalk on yellowish
paper
274 × 272

Venice, Museo Correr (562)

Study for *The awakening of the
lady,* a painting by Pietro Longhi.
The original seems to have been
lost, but the composition is known
to us through a print by Flipart
and several fairly faithful copies
(Pignatti 1975 No. 27).

Ref.: Pignatti 1975 No. 278

The Drawings of Antonio Canaletto

Lionello Puppi

The earliest known drawings by Canaletto probably date from about 1719, at which time he was living in Rome with his father Bernardo. He had previously been employed, between 1716 and 1718, in Venice by his father, who had quite a high reputation as a scene-painter and was trying to launch Antonio on the same career. As soon as he arrived in Rome, however, the young man, who in Venice must have appreciated the work of Marco Ricci and Luca Carlevarijs, began to come under the direct influence of Panini and Vanvitelli. He solemnly banished the theatre from his life and devoted himself to 'depicting' *vedute,* drawn from nature, 'especially of antiquity' (Zanetti, 1771). It was then that Canaletto's long and happy career as a *vedutista* began.

Thanks to the patient investigation and careful analysis carried out by such scholars as D. von Hadeln (1929), K.T. Parker (1948), F.B.J. Watson (1950), T. Pignatti (1958), verified more recently by W.G. Constable and J.G. Links (1976), the corpus of authenticated Canaletto drawings has been established, a total of 335 works. This figure does not include the 138 pages of the *Quaderno Cagnola* in the Accademia in Venice, nor does it take into account those drawings that have been dispersed, lost or destroyed. The number preserved probably represents only a portion of the artist's production. It is evident, even on grounds of quantity alone, that drawing was a major aspect of his activity as an artist. It has, however, to be seen in the context of the totality of his work. He drew in order to seek the finished form of a subject; the end product of this search was usually a painting, although sometimes it was a finished drawing. His drawings were therefore a fundamental and essential aspect of his work as a whole. The inner dialectical tension inherent in his search for form was, moreover, in no sense a rigid process – it was always flexible and open.

His graphic work had several functions. He drew, for example, as a way of memorizing places and situations, to preserve them for use later, although he did not necessarily know what this use would be. Thus he built up a stock of models that could be submitted to possible patrons. His drawings can in fact quite easily be categorized into two mutually complementary groups. What is more, each of these two groups can be further divided into sections, each representing a stage in the dynamic evolution of the artist's style.

On the one hand, he made rapid sketches that were evidently intended to be documentary notes. Sometimes these were done from life and frequently with the aid of an optical device (I shall return to this practice later on); at other times, he used painted or drawn examples taken from his own work or that of other artists. His sketches were often accompanied by notes about colour or the location, time and circumstances of the drawing. The artist would then use these preparatory sketches in pictures or engravings – works, in other words, that were fully elaborated and complete in themselves.

In addition to making quicker drawings of this kind, however, Canaletto also executed very many which have all the features usually associated with finished drawings. These were clearly

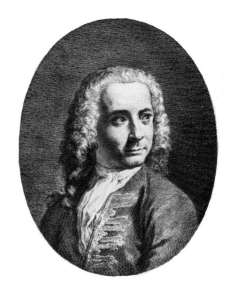

65 Antonio Canaletto
Venice 1697 - Venice 1768
Portrait engraved by Antonio Visenti
after G.B. Piazzetta (1735)

intended for collectors of pure graphic work. He used a wide range of techniques in these finished products, some of them experimental. It is also obvious that they were not simply exercises demonstrating the drawing skills of a virtuoso performer. On the contrary, the artist was clearly trying new techniques here because he was looking for ways of expressing his ideas. He was traditional in his use of chalk or in working with black, and less commonly with red, pencil, but he often replaced these materials – or more usually heightened their effect – either by brushwork or more often by inking these finished drawings with a pen. Parker's very accurate analysis (1948) showed that Canaletto experimented with various kinds of pen, including quills, reeds, and metal nibs, in search of the different effects that could be obtained with them. His use of techniques and implements was constantly developing, always complex. He used a variety of closely integrated techniques to produce a harmonious whole in the finished composition. He sometimes restricted himself to working simply with a pen or a pencil, which he carried to the very limit of its possibilities; he habitually used black pencil or sanguine only for his initial notation. After this first and provisional stage in the process of defining the image, he usually abandoned these materials in favour of the pen or occasionally the brush.

He must also have been very careful in his choice of inks, but it is not easy now to understand how he did this. His line usually appears now as sepia, but it may be that he originally used black ink which has become brown with age. If this is the case, then he must have employed ordinary inks which deteriorated quite quickly. Elsewhere the black tint seems to have been preserved, and the outline has lost none of its sharpness: this points to the use of india ink, which does not brown or spread. Canaletto also did not hesitate to employ a compass or a scribing tool, and in certain drawings made use of a special technique that was clearly his own. Parker called this 'pin-pointing'; it consisted of piercing the paper with a series of little perforations, variable in number and arranged with the purpose of connecting the main points particularly in an architectural composition and of setting out spaces and distances in perspective.

It is also quite difficult to identify Canaletto's first drawings. I agree with those scholars who believe his earliest graphic works to be the twenty-three sheets with views of Rome, now in the British Museum (with the exception of one, which is in the Hessisches Landesmuseum, Darmstadt). These drawings have been attributed to Canaletto because his signature appears on some of the sheets as *Antonio Canal delineò in Roma*, written in small letters which are also to be found in the captions to drawings that were certainly the artist's. A further reason for believing these drawings to be the work of Canaletto is that they passed into the hands of G.B. Brustolon, who engraved them and attributed the original drawings to the artist in the inscription: *Antonio Canal pinc. Romae*. This attribution is also confirmed by the very high standard of the formal arrangement.

This little corpus would thus date back to about 1719, when the artist was, as we have seen, in Rome. It is not easy to find convincing reasons why he produced these Roman views. There is clear evidence in them of what he called his 'excommunication of the theatre', and his decision to devote himself to *vedute* from nature; at the same time, however, they contain echoes of his scene-painting past, especially in their unmistakably Baroque element of restlessness. The images also appear to be in a finished state and to have been executed in a mixture of pencil, pen and ink, and wash that gives an impression of confident mastery. This may mean that the artist had in mind a set of Roman models which he hoped to use later, when the occasion arose, in a more fully elaborated edition of the 'fine ancient buildings' (Orlandi, 1753). If this hypothesis is correct then we must conclude that the young artist, very early in his career, had found the method of working which best suited him and which he continued to employ in all his later work. He certainly applied it after his return to Venice and his meeting with Owen McSwiney in 1722. There is evidence of this, for example, in the sheet in the Ashmolean Museum, Oxford, containing a preparatory drawing for his *veduta* of the Rialto Bridge painted in the summer of 1725 for Stefano Conti, a merchant and collector from Lucca. It consists of simple lightning strokes of the pen. The artist adds a brief title, and notes the effect of sun-

66 The Caldarium of the baths of Caracalla
London, British Museum

light on the water *(Sole)*. His command of his technique is totally assured, and he depicts a vision of the world, with the urban landscape of Venice at its centre, that is both original and quite imcomparable.

In 1949 Guido Cagnola donated to the Accademia in Venice a large album containing many sketches that were obviously intended to be more fully worked out later. It was obviously used by the artist as a sketchbook for rough drawings made from life in the course of walks through the city. They are black-pencil drawings, but the artist has traced over most of them in his studio with pen and ink. There are 148 leaves in this *Quaderno Cagnola,* numbered 1-74, with 138 sketches verso and recto. The present binding was added in the nineteenth century and presumably follows the order of the original binding. In his introduction to the excellent facsimile edition published in 1958, Terisio Pignatti pointed out that 'a great many of the sketches...were used...for paintings in the group of works preserved at Windsor Castle, by the Duke of Bedford at Woburn Abbey, and in the Harvey Collection, formerly at Langley Park' (later dispersed). This is not all, however, since some of these sketches are, according to Pignatti, directly related to 'at least eight engravings by Visentini in the famous collection of views of the Grand Canal', and others can without any doubt be linked with the finished drawings at Windsor. For various reasons, but chiefly because of the homogeneity of the style of drawing, the sketchbook can be dated to a period of two years, between, at the outside, 1728 and 1730. It is clear that he continued to refer to it and to use the work that it contained for a long time afterwards, taking the sketches as points of departure, but adapting them in accordance with the demands of his own powers of artistic expression, never static or inflexible, but always developing.

It is quite possible, too, that Canaletto used the so-called *camera ottica* for these sketches and for other similar drawings, such as those of different dates and sizes that belonged at one time to the Algarotti Corniani and are now scattered among various museums and collections. Algarotti had a very close and friendly relationship at one period with the artist and declared in 1762 that 'the most celebrated painters of *vedute* that we have today make much use of the *camera ottica*'. A.M. Zanetti was even more explicit in a passage written in 1771, which proves

68 Folio 37 (recto) of the *Quaderno Cagnola*
Venice, Galleria dell'Accademia

that the artist used the apparatus critically in the service of his art. He said that 'Canal[etto] taught the proper use of the *camera ottica* and showed what defects could be introduced into a painting when the artist relies entirely on the perspective, and particularly on the colours of the atmosphere, that are seen in the *camera,* and does not eliminate things offensive to sense.'

There is no reason, however, to suppose that Canaletto employed this instrument for the majority of his rapid sketches. D. Gioseffi attached, I think, too much importance to the use of the *camera ottica* in his very thorough study of the problem (1959). What really guided the master in his work was his constant search for new syntheses and new effects of light which would correspond to his insatiable need to translate into drawing what was in his imagination. His idea of the *veduta* was defined very well by Corboz in 1974 as *ideata* – something imagined or conceived. He was therefore impelled to explore every corner of Venice again and again, sometimes discovering new places, but often returning to the same ones after a long interval. He had a passionate affinity with his native city and was incapable of forming the same relationship with other places, with the possible exception of Padua, where he made several drawings. He explored both the most famous and conspicuous sites, such as the Piazza, the Piazzetta, the Bacino, the Molo, the Grand Canal and the Rialto, and the obscure and 'minor' sites – smaller churches and canals, *campi* and *campielli*. He was in constant search of material for his sketches and exploited his great technical skill in constructing increasingly risky and audacious spatial systems, moving the vanishing points further and further away in his distant perspectives, blurring outlines and making the water flash and sparkle.

As the Baroque influences, initially so prominent in his work, were gradually overcome, his style became more clearly defined in the vision of radiant light that increasingly characterized his more mature work. Later still, during the final restless years of his career, the images in his sketches – as in his paintings and finished drawings – became troubled and even more dramatic. At the same time, however, he never lost that generous profusion of inspiration that made him one of the most extraordinary draughtsmen of all time.

From 1722 onwards, while he was still working for Owen McSwiney, he met Joseph Smith and formed a friendship with him that was to last for very many years. Smith, who was later to become British consul to the most Serene Republic, was a rich and cultivated man who collected works of art, including Canaletto's preparatory studies and sketches. It is therefore highly likely that he encouraged the artist to do drawings that were not just preparatory, but self-sufficient. This hypothesis is borne out by the fact that by far the biggest and best corpus of finished drawings – that is, those done between at least 1726-7 and 1760 – were originally in the Smith collection. They are now at Windsor Castle, having been bought by George III in 1763.

The drawings in the Smith collection are clearly the result of the artist's search for style – a search that is identical to the one that he made in the case of his paintings. The drawings can also be compared with his engravings and those of others; some of them can be traced back to paintings that the artist did for Smith, who either kept them in 'his house in Venice, and his villa in Moggiano', or else sold them to other English collectors. These are drawings that were done *concurrently* with paintings, and in them Canaletto was able to confine himself strictly to the techniques of drawing. This concentration on graphic rather than pictorial skills shows how the artist knew and valued the inexhaustible possibilities of drawing as an art in its own right.

The criterion for the choice of the drawings seen here is that of revealing Canaletto's extremely varied technical and formal abilities in this sphere, during the whole of his career from the 1720s until the end of his life, through representative examples of his best and most significant graphic work. The *Boat* is a sketch of exceptionally high quality, which gives the impression of being a preparatory drawing for an image to be included in a *veduta* or a *capriccio* featuring the sea. The artist has handled the pen with such skill that the image seems to encapsulate the luminosity of the surrounding sea and sky. The *Piazzetta looking north* (Darmstadt, Hessisches Landesmuseum) would seem to be the last stage in a process of exploration through drawing, before the artist converts what he has discovered into a painting. The drawing, in

pl. 90

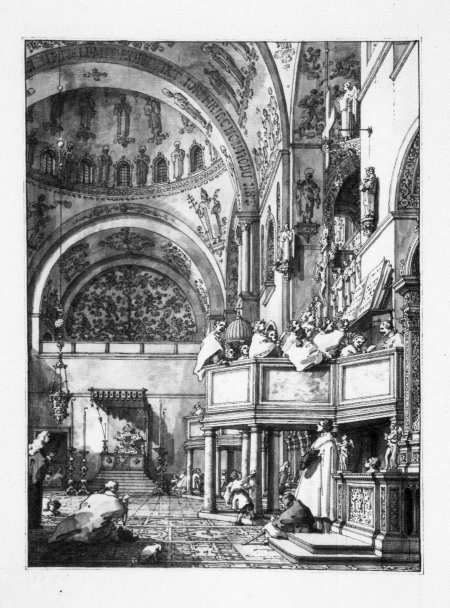

Io Zuane Antonio da Canal, Hó fatto il presente disegnio delli Musici che Canta nella Chiesa Ducal di S. Marco in Venezia in etá de Anni 68 Cenzza Ochiali, Lanno 1766.

69 S. Marco: the crossing and north transept with musicians singing
Hamburg, Kunsthalle

pl. 91 pen and ink alone, is quite translucent and has a visionary quality of enormous space; the artist has stretched perspective to its limit. *The Campanile damaged by lightning,* which is in the Windsor Castle collection, was drawn on '23 April 1745, the day of Saint George, knight'. It is a graphic record of an unrepeatable event. Canaletto drew it in response to his friend Smith's curiosity and to express affection for Venice, and at the same time to put on record a sight that might serve again for other patrons. That this was one of the artist's reasons for producing the drawing is clear from the existence of a later version, now in the British Museum.

137

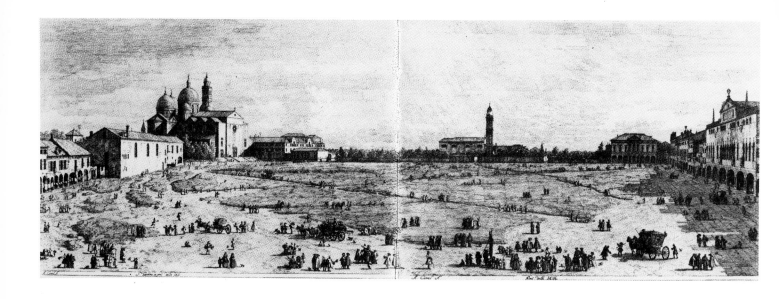

70 Prato della Valle pl. 93
Engraving (see Nos 96-7)

pl. 100

pls 96-7

fig. 69

The *veduta* of *The islands of S. Elena and S. Pietro,* which is also at Windsor, is an entirely self-sufficient work of art. This brilliant drawing is one of a set of views of peripheral aspects of Venice; possibly more striking than the central parts of the city, and more enjoyed by the artist, perhaps because he was able to use the pen and wash as technical means to indicate a wider and ampler horizon. The same applies to the Windsor *Architectural fantasy,* which can, I think, be regarded as the counterpart of the *capriccio* presented as a *morceau de réception* to the Accademia of Venice, since it has the same complicated cultural and social overtones that have been so clearly analysed by A. Corboz (1982).

The two sheets featuring the *Prato della Valle* in Padua, both in the Windsor Castle collection, are, on the other hand, preparatory drawings for the famous engraving of the same subject. The image emerges gradually from the density of the signs that cover the paper – black and sanguine pencil lines, black and brown pen strokes, and a studied application of wash. All these materials are used with an intensity and a concentration that testify to a long and troubled exploration on the artist's part, leading step by step to an understanding of the conditions under which the effects of light and space could be transferred to the copper plate.

There are also several preparatory drawings in the British Museum for the series of *Ducal festivals* engraved by Brustolon. These are obviously more direct and spontaneous. The *S. Marco: musicians singing* in the Hamburger Kunsthalle is an unforgettable drawing, in this case complete in itself, although there are preparatory sketches for it in the Victoria and Albert Museum, London, and the Scholtz Collection, New York. In this very late drawing, the artist has returned to what was for him a favourite theme, namely the interior of the Basilica of St Mark, dealing with it in his own ironical and disillusioned way and producing a very original result. At the same time, however, this drawing has only one purpose: Canaletto is trying in it to measure his skill as an artist against himself. At the foot of the page he has written what might be his spiritual last testament, with these proud words: 'I, Zuane Antonio da Canal, have done this drawing of musicians singing in the ducal church of St Mark in Venice at the age of sixty-eight without glasses, in the year 1766.'

Antonio Canaletto

89 Venice: the angle of the Doge's Palace with S. Giorgio Maggiore beyond

Pen with bistre ink on a pencil sketch
232 × 176

Her Majesty Queen Elizabeth II

This view of the Piazzetta, showing the corner of the Palazzo Ducale on the left and the column of S. Mark on the right, can also be seen in a painting in the royal collection at Windsor.

The top of the campanile of S. Giorgio Maggiore was altered between 1726 and 1728, so this drawing and the works connected with it can be dated to about 1725.

Ref.: Parker 1948 No. 4; C./L. 542; London 1980 No. 47

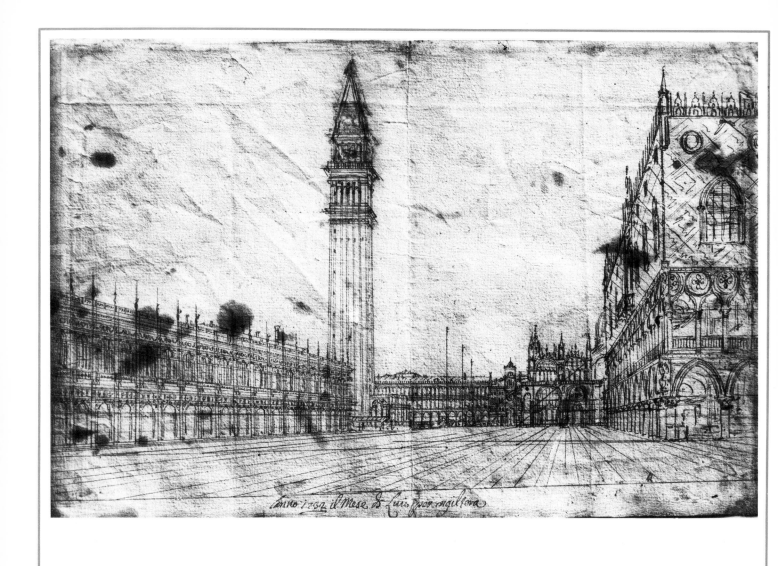

90 The Piazzetta looking north

Pen with bistre ink 255 × 410
Autograph inscription: *lanno 1732 il mese di Luio per inghiltera*

Darmstadt, Hessisches Landesmuseum (AE 2248)

Very precise view, with the Biblioteca Marciana and the Campanile on the left, the Torre dell'Orologio
and S. Mark on the right in the background, and the Doge's Palace on the extreme right. Bettagno has
interpreted the words *per inghiltera* in the inscription as pointing to a possible connection between this
drawing and a picture of the same subject in Woburn Abbey (C./L. 64), or the English consul, J. Smith,
with whom Canaletto was in very close contact at the time.

Ref.: C./L. 551; Venice 1982 No. 10

Antonio Canaletto

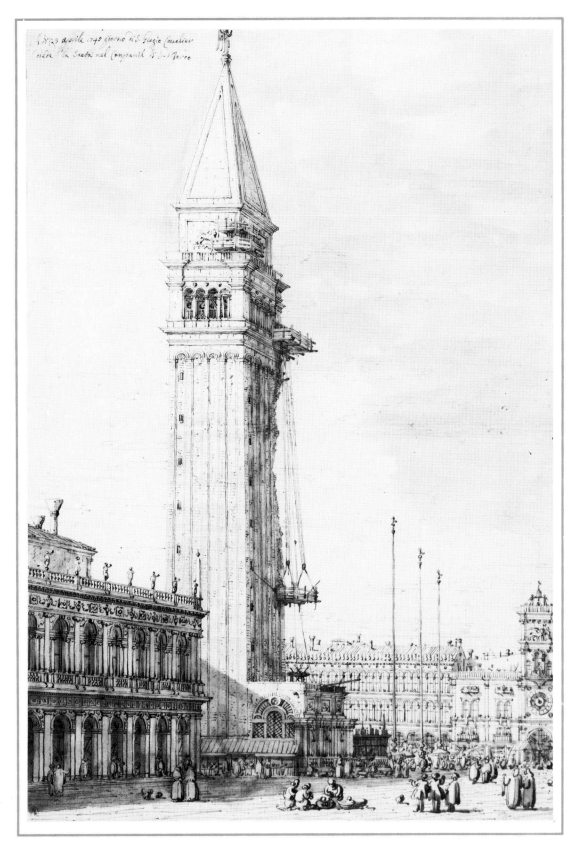

91 Venice: the campanile damaged by lightning

Pen with bistre ink and grey wash on pencil
427 × 292
Autograph inscription in top left-hand corner: *Adi 23 aprile 1745 giorno di S. Giorgio Cavalier / diede la Saeta nel Campanil di S. Marco*

Her Majesty Queen Elizabeth II

The inscription on this famous drawing provides a *terminus post quem* for Canaletto's departure for England. A second, almost identical drawing is preserved in the British Museum, but lacks the inscription (C./L. 553).

Ref.: Parker 1948 No. 55; C./L. 552; London 1981 No. 85; Venice 1982 No. 24

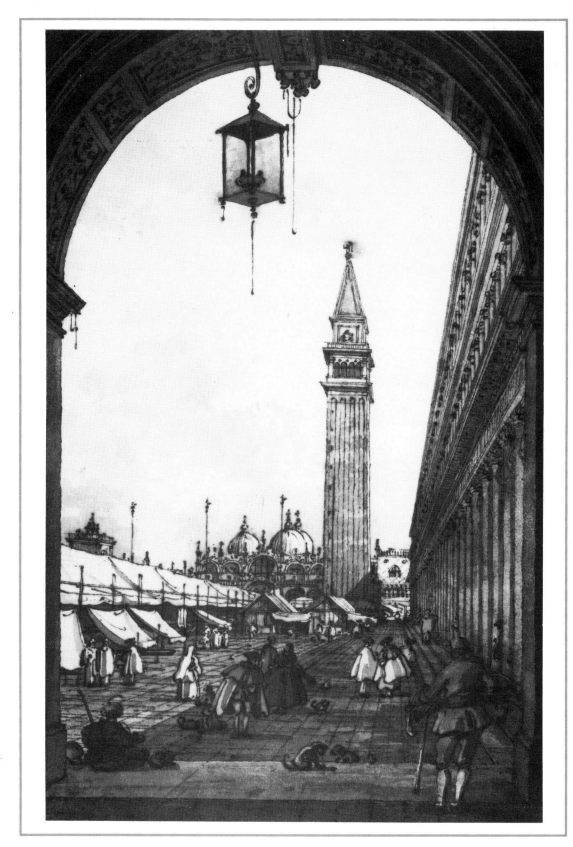

92 Piazza San Marco: looking east

Pen with brown ink and grey wash
335 × 225

Amsterdam, Rijksprentenkabinet, Rijksmuseum (1953: 212)

This fine view of the Piazza with a covered market must have been drawn by Canaletto after his return from England. There is another version of this drawing and it is known that the artist was asked to paint a picture on the same theme.

Ref.: C./L. 527; Paris-Rotterdam 1962 No. 186

93 The islands of S. Elena and S. Pietro

Pen with bistre ink, and grey and pale-brown wash 158 × 347

Her Majesty Queen Elizabeth II

The monastery of S. Elena (now surrounded by modern buildings) can be seen in the middle of this panoramic view, with the church of S. Maria Elisabetta on the west coast of the Lido on the extreme right. This particularly beautiful drawing is one of a group of four views of the lagoon, all of them at Windsor, which the artist must have regarded as works of art in their own right, since there are no known paintings or engravings of the same subjects.

Ref.: C./L. 649 ; Parker 1948 No. 68 ; London 1980 No. 70

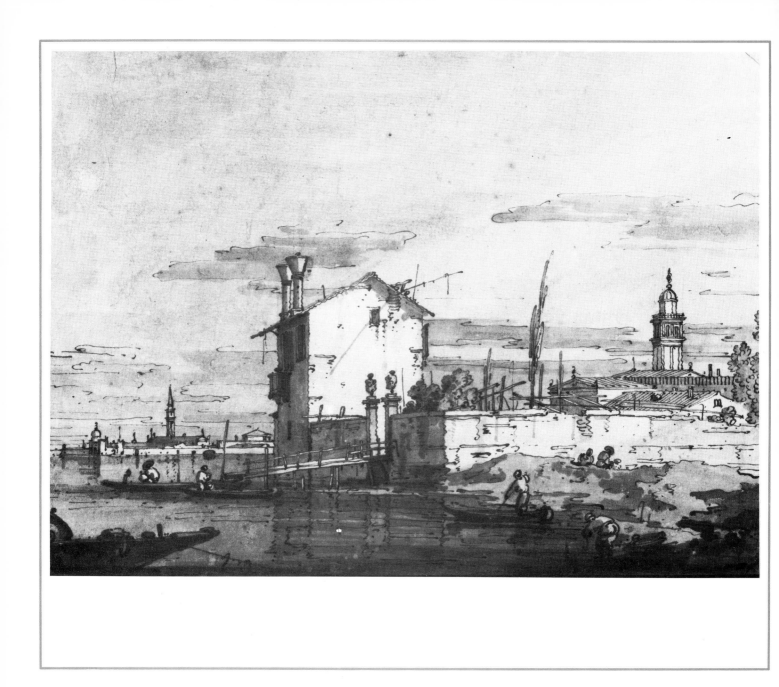

94　The island of S. Michele with Venice in the distance

Pen with bistre ink and grey wash on pencil sketch　200 × 279

Oxford, The Visitors of the Ashmolean Museum

A drawing of the same theme is preserved at Windsor. The subject was identified by K.T. Parker, who
pointed out that a similar picture (at one time in the Lovelace collection, C./L. 367) belongs to a group of
eight paintings, one of which is dated 1754.

Ref.: Parker 1956 No. 980; C./L. 654; Venice 1982 No. 62

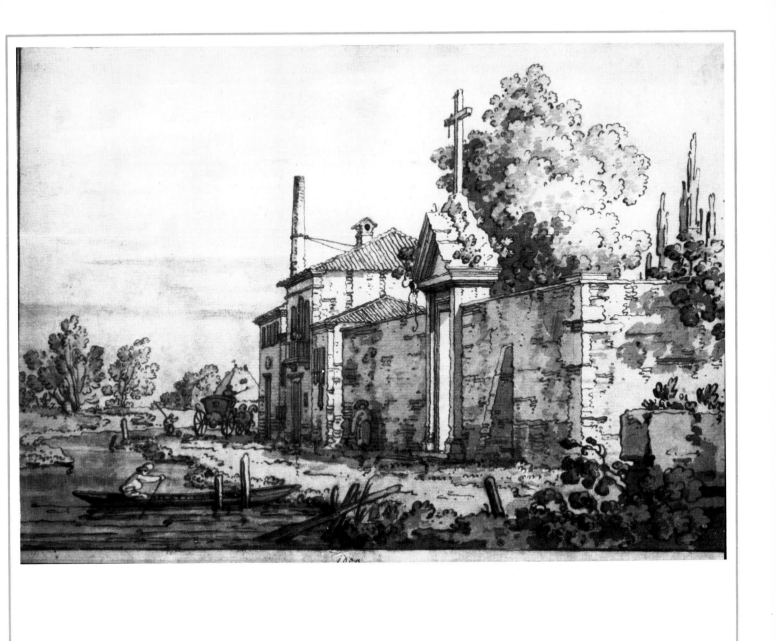

95 Group of houses beside a canal

Pen and wash 212 × 310
Inscription: *idea.*

Switzerland, Private collection

The location has not been identified, but it may be near Padua. Two more drawings are known, with
only slight variations.

Ref.: *Art vénitien en Suisse* 1978 No. 162

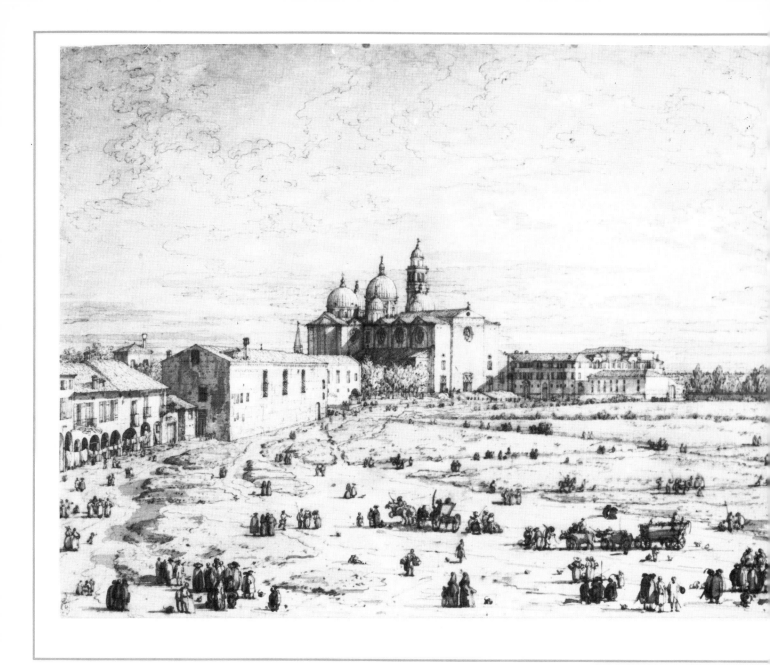

96-7 Padua : Prato della Valle with S. Giustina and the Misericordia

Pen with bistre ink in black, tip of the brush and grey wash on pencil. Composition divided between two pages
271 × 371 / 272 × 372

Her Majesty Queen Elizabeth II

The two halves of this vast panoramic view, at one time separated, are here shown side by side. The engraving for which they served as a model, reproduced as figure 70, shows the work involved in transferring the subject from one medium to another and demonstrates the effects of that transposition. There are five known painted versions of the same subject (C./L. 376).

Ref.: C./L. 689-690; Parker 1948 Nos 72-73; London 1981 No. 77; Venice 1982 No. 35-36

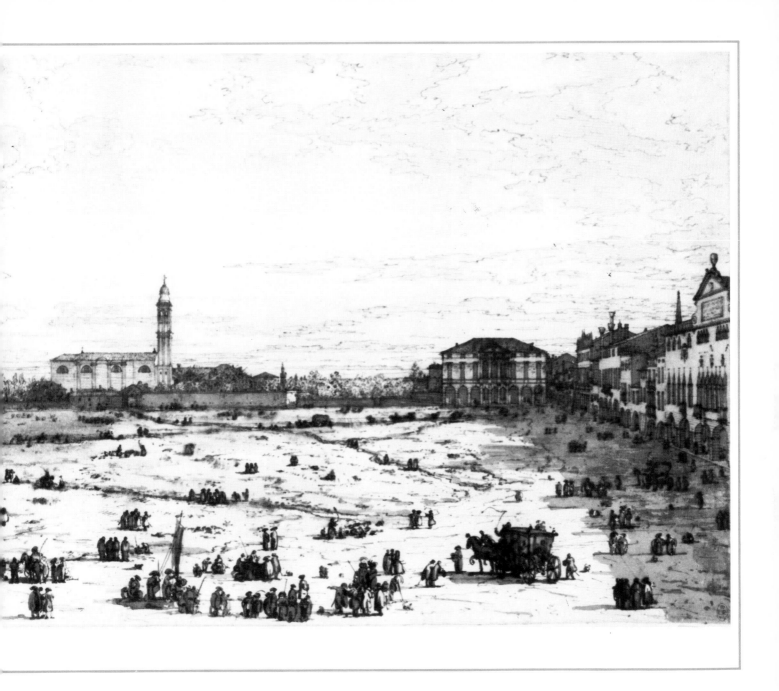

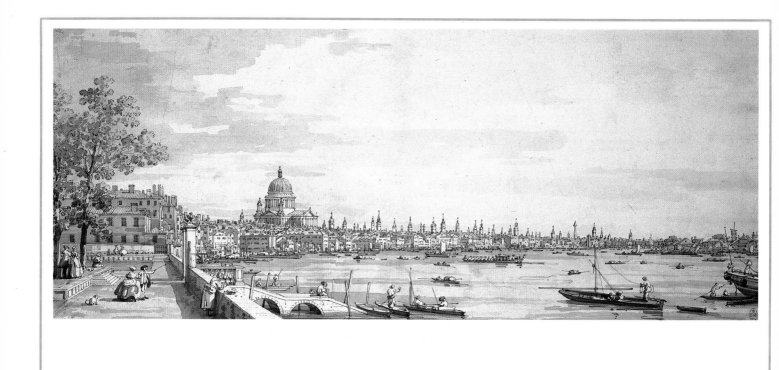

98-9 The Thames and the City of London from the terrace of Somerset House

Pen with bistre ink and grey wash on pencil 201 × 485

Her Majesty Queen Elizabeth II

This panoramic view of the City dominated by the dome of St Paul's is representative of the many drawings made by Canaletto during his long stay in England (1746-55). There are five others in the royal collection at Windsor. An even more important drawing of the same view, came to the Courtauld Institute in London with the Count Seilern bequest.

Ref.: C./L. 745; Parker 1948 No. 114; London 1980 No. 86; Venice 1982 No. 54

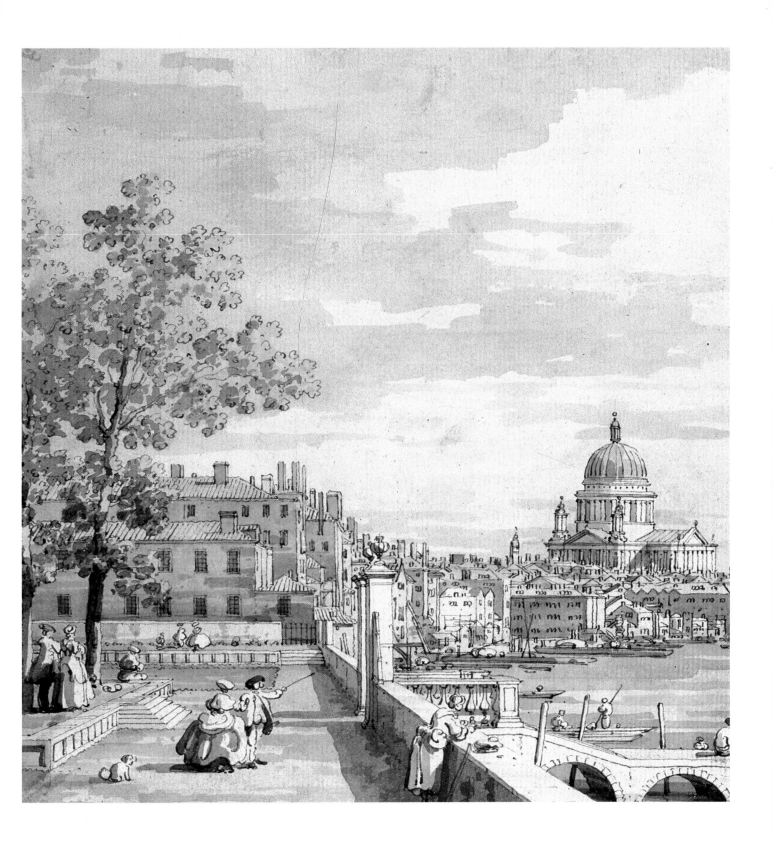

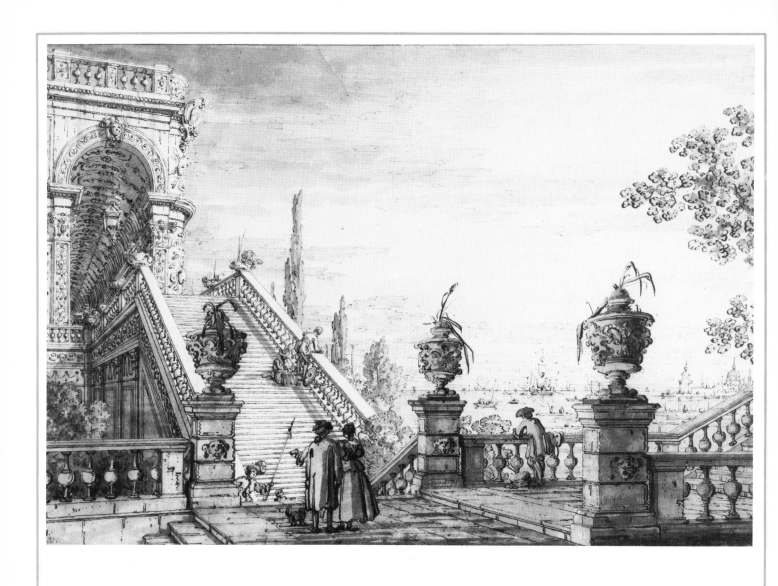

100 Architectural fantasy: a flight of steps leading to the loggia of a palace

Pen with brown and black ink and grey wash on pencil 367 × 527

Her Majesty Queen Elizabeth II

In the catalogue of the recent Canaletto exhibition at Venice (1982), Charlotte Miller calls this drawing 'grandiose in conception and splendidly realized' and says that 'this superb composition is one of the masterpieces of Canaletto's graphic art, and proves that the artist could, even at the end of his career, produce works at the highest level'. In Parker's view, this drawing is a 'tour de force in perspective'.

Ref.: C./L. 821; Parker 1948 No. 141; Venice 1982 No. 63; London 1980 No. 96
See also the front cover of this volume

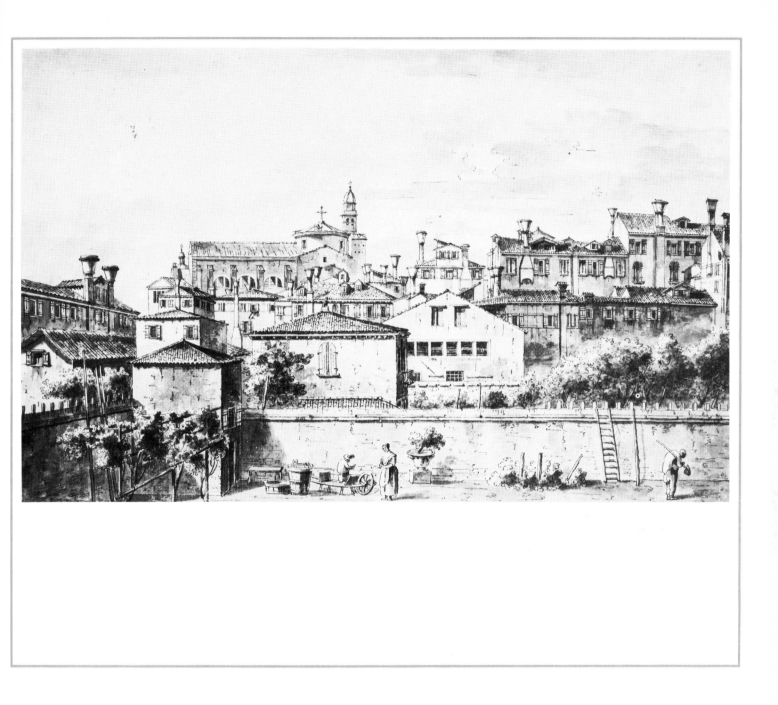

101 S. Nicolò da Tolentino with houses and gardens

Pen with brown ink and grey wash 27 × 37.3

Berlin, Staatliche Museen Preussischer Kulturbesitz, Kupferstichkabinett

A particularly attractive view of a small provincial town.

Ref.: C./L. 619; Toronto 1964

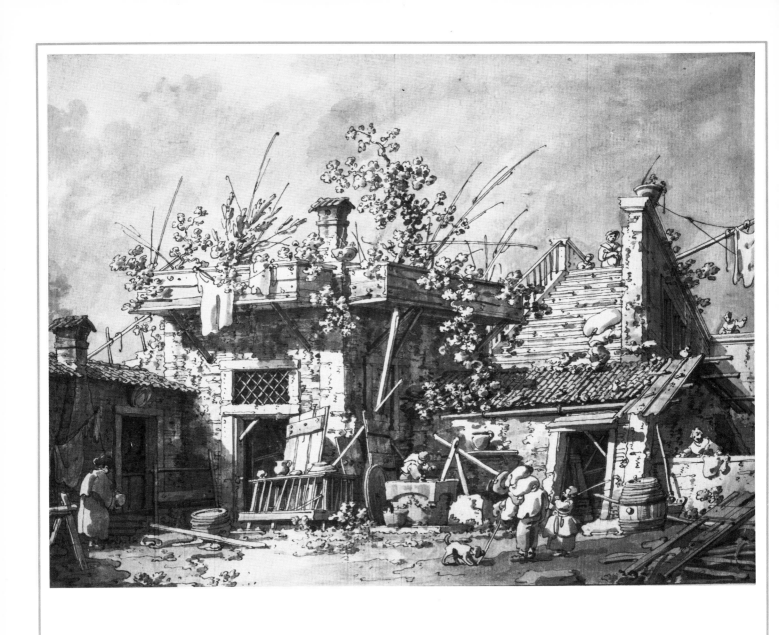

102 A cottage in front of a flight of steps

Black chalk, pen with brown ink and grey wash 251 × 353

Berlin, Staatliche Museen Preussischer Kulturbesitz, Kupferstichkabinett (KdZ 4615)

Ref.: C./L. 699

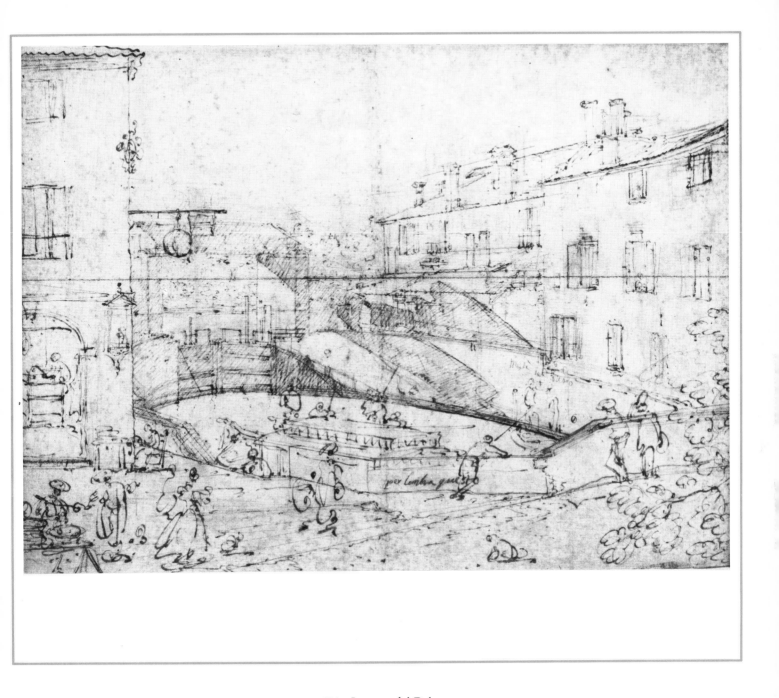

103 Le porte del Dolo

Pen with brown ink on sketch in sanguine 289 × 398
Autograph inscriptions: *per lombra questo* and *meta del quadro.*

Private collection

Campbell Dodgson pointed out in 1938 the connection between this drawing and the engraving entitled *Le porte del Dolo* (Venice 1982 Nos 126, 127). This is perhaps a first sketch made on the site. Opinions are divided on the use of the camera obscura and the significance of the horizontal line in sanguine across the page.

Ref.: Venice 1982 No. 18

104 The travelling showman

Pen with bistre ink 280 × 430
Inscription (serial number): *14.*

Switzerland, Private collection

This most interesting drawing belongs to a series that has recently come to light and is listed in the
Constable-Links catalogue under the numbers 840 to 840*****. Each drawing in the set has a serial
number in the same writing, identical to that found on other drawings, and without any doubt to be
attributed to the master.

Ref.: C./L. 840*****; Venice 1982 No. 39; *Art vénitien en Suisse* 1978 No. 163.

105-6 Two sheets of figure studies

Black chalk, pen with brown and grey ink
275 × 388
Inscription: *5/uolta.*

Berlin, Staatliche Museen Preussischer Kulturbesitz, Kupferstichkabinett (KdZ 16079, 16078)

Hadeln suggested that these studies were used for a picture of a regatta, but they have not been identified with any known painting.

Ref.: C./L. 837

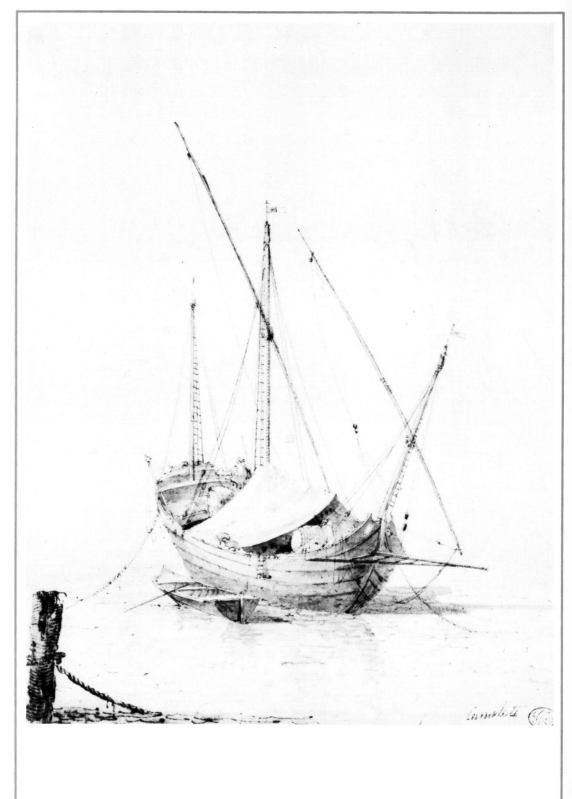

107 A boat

Pen with brown ink, and brown and
grey wash on sketch in black chalk
244 × 191
Inscription: *Canaletto*

Private collection

Studies of boats are very rare
among Canaletto's drawings. One
very similar to this was shown in
the 1982 Venice exhibition (No.
23, p. 38; Florence, Private collec-
tion). Such boats were used to
transport goods.

Ref.: Sotheby's sale, 18 November
1982, No. 70; Venice 1982 No. 23

The Drawings of Francesco Guardi

Terisio Pignatti

Francesco's father, Domenico Guardi, a native of the Trentino, had worked as a painter in Vienna at the end of the seventeenth century. Domenico's eldest son, Gian Antonio, was born in 1699; Francesco followed in 1712 after the family had settled in Venice. A younger son, Nicolò, was born in 1714. The three brothers worked together for some time, eventually under the leadership of Gian Antonio, although Francesco was the only one to achieve fame later in life. Having received his training with his brothers, he spent the whole of his long life in Venice, eventually taking over as the only successor to the famous Canaletto in the production of *vedute* for foreign customers. Unlike Canaletto, however, Francesco Guardi had great difficulty in establishing himself, and received official recognition only in the last ten or so years of his life, being commissioned, for example, to record the visits of the Grand Dukes of Russia and Pope Pius VI to Venice.

Guardi's work was ignored for almost a century, until Impressionism led to a renewal of interest in landscape painting. Now he has been seriously reassessed and is highly regarded: his very name conjures up images of black gondolas shining on slate-grey waters, mother-of-pearl skies streaked with foaming clouds, vibrant and unstable outlines of buildings reflected in the water and odd, spectral figures *(macchiette)* wrapped in fluttering cloaks. The images of his paintings also appear in his drawings – slender buildings outlined in pen and ink, silvery sails picked out with sepia or bistre against the sky or water, windows like hollow eye-sockets in the ghostly palaces along the Grand Canal, romantic ruined arches and columns, and idyllic, fantastic landscapes.

Recent research on Francesco Guardi's drawings has brought to light considerable information on his graphic work. We also know more about the work of the other members of the Guardi family. His elder brother, Gian Antonio, was a painter of altar-pieces and decorations; little is known of the third brother Nicolò, except that he also drew and painted. Francesco's son Giacomo produced mediocre and conventional views of the Venetian lagoon, working well into the nineteenth century.

This renewal of critical interest in the Guardi family has drawn attention to the high quality of Gian Antonio's drawings, that include many works of refined elegance. Comparison with Francesco's works, however, has established his undoubted superiority, for Francesco discovered a Venice that had never been explored by earlier *vedutisti*, even the great Canaletto; and he went further, by transforming Canaletto's rational vision. His drawings have greater poetical freedom, and possess all the qualities of improvisation and imagination. They also have a freshness that brings out the unstable but highly evocative effects of light and colour to be found in that unique city.

Recent studies have also greatly extended the catalogue of the family's drawings. We now have more than 500 sheets by Francesco and several hundred by Giacomo, including 115 in the Museo Correr. After prolonged and animated discussion by art critics, which has led to a more correct evaluation of the part played by Francesco's elder brother as the head of the Guardi

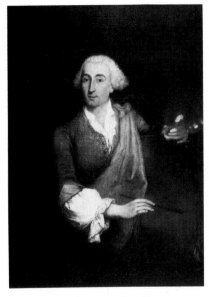

71 Francesco Guardi
Venice 1712 - Venice 1793
Portrait by Pietro Longhi
Cà Rezzonico

studio, 119 drawings have also been attributed to Gian Antonio. An important group of these drawings belongs to the series known as *Venetian Festivals*. Most are preserved at the Fondazione Giorgio Cini in Venice, while others are dispersed among other collections.

Few records of the original collections of Francesco Guardi's drawings have survived. The earliest known collector was the British Resident in Venice, John Strange, who in 1778 inscribed two drawings of his villa at Paese and Levico. It is known that Strange collected works of art to sell them, and many of Guardi's drawings probably found their way into English collection through him and his agent, G.M. Sasso. In 1803, for example, seven of Guardi's drawings were listed in Sasso's sale catalogue (Haskell, 1960). In 1790, one drawing was included in the Vianelli collection at Chioggia. Very few references to others have been traced and we have to wait until 1853 before discovering any more precise information.

It was in that year that one Dr Bernardelli, also from the Trentino and eager to have recollections of his follow-countryman, came to Venice to question Nicolò, Francesco's grandson, who was now more than eighty years old. The interview between them was published in 1904 by George Simonson.[1] According to this interview, Giacomo Guardi had all his father's drawings, for which he was offered 200 *zecchini* or sequins, but he asked 300. The identity of the purchaser is suggested by what appears to be a receipt in Giacomo's handwriting in an album of his drawings in the Museo Correr in Venice : '26 October 1829. From Count Teodoro Correr I have received on account for the 18 drawings of my father L. 14. 5. In case of failure to agree the price, I must return the said sum to him. Giacomo Guardi.' Teodoro Correr was, of course, the founder of the Venetian museum named after him; presumably he acquired the collection after further negotiations of which no record remains. There are now 285 drawings in the Museo Correr, about 100 of them by Giacomo. All the others – and there must have been a considerable number – have been dispersed.

The Correr Collection, which is now kept in the library of the Museo Correr, is therefore the largest and most varied collection of Guardi's drawings in the word. It is, however, a typical 'workshop' collection, without any large-scale views of Venice or other drawings that might have been bought by art-lovers, but full of little sketches of landscapes, *capricci, macchiette* and studies for decorative pictures. There are even designs for pictures with large figures, which are in any case rare in the artist's pictorial work, but these are also rough sketches. Little ones of the same kind, often executed with enormous vivacity, can also be found on the ten sheets in the collection that has been in the Museo Horne in Florence since 1892.

The other important collections are outside Italy, since there was great interest in Guardi abroad, especially in the English-speaking world in the nineteenth century. The ten or so sheets in the British Museum, including splendid views of the Grand Canal, are of great importance, and there are similar sheets in the Louvre and the Berlin Kupferstichkabinett. The Ashmolean Museum of Oxford has ten of Guardi's drawings, including several large landscapes drawn during the artist's maturity. The collection in the Metropolitan Museum in New York is extremely important. It contains some thirty sheets, most of them from the Marquis de Biron's collection. The finest drawings in what used to be the Duc de Talleyrand's collection at Saint-Brice-sous-Forêt near Paris are also from the same source. Among the other private collections, those with the greatest number of important drawings are the Wallraf (now Lehman) Collection in New York, the Seilern Collection, which has ten sheets of Francesco Guardi's drawings and is now in the Courtauld Institute in London, and the Scholz Collection in New York. The rest of the artist's drawings are dispersed among various private collections in England and the United States of America and in museums all over the world.

A few years ago, Morassi provided a study of all Guardi's drawings,[2] a selection of which had already been critically examined by Pignatti.[3] George Simonson's book had appeared in 1904, marking the beginning of modern research into the artist's work, and since that time many valuable books and articles have been written on his drawings. To begin with, interest was naturally concentrated exclusively on Francesco, and the depth of interest in his drawings is clear in the London exhibition of the Burlington Fine Arts Club in 1911. A year later, Damerini included reproductions of twenty-nine of the drawings from the Museo Correr col-

[1] G.A. Simonson, *Francesco Guardi* (London 1904).

[2] A. Morassi, *Guardi, tutti i disegni* (Venice 1975).

[3] T. Pignatti, *I Guardi - Disegni* (Florence 1969).

lection in his work on Guardi.[4] Art critics and historians were, from that time on, fully conscious of the unity between the paintings and the drawings of Francesco Guardi. It was Fiocco, however, in a monograph of fundamental importance on the artist's work, who first applied modern methods to a consideration of the problem of Guardi's drawings[5] and drew attention to the essential part played by them in any critical identification of the paintings. Many sketches by Francesco's elder brother were also reproduced and discussed for the first time in the work of Fiocco, who in addition provided a brilliant reconstruction of Gian Antonio's personality as an artist. Fiocco thus prepared the ground for all later studies of the Guardi family. Thirty-five sheets of drawings were included in the illustrations, showing clearly the stylistic differences between Gian Antonio, Francesco, Giacomo and even Nicolò.

One direct consequence of this renewed interest in Francesco Guardi was the prominent place given to his drawings in the 1929 Exhibition of the Italian Settecento in Venice, where sixty-seven sheets were shown. In 1936 another important exhibition of the drawings of Francesco Guardi was arranged in Venice at the Cà Rezzonico by Lorenzetti: 154 items were exhibited.[6] The publication of all the drawings by Francesco Guardi in the Correr Collection by Pallucchini in 1943 marked a fundamental step forward in this field of study.[7] A year later, Goering's edition of other hitherto unpublished drawings, mainly from the Biron Collection in the Metropolitan Museum, New York, was another major event.[8]

From then on, there was a general increase in interest among scholars in Guardi's drawings, considered as an instrument of critical and philological investigation, particularly after 1944 when Arslan, in his study of the Guardi brothers,[9] took as his point of departure the precise stylistic differences in drawing in order to distinguish the work of Francesco or Gian Antonio Guardi in a great number of pictures of disputed attribution. Lazareff had already suggested this method as early as 1936.[10] Byam Shaw, on the other hand, adopted a different approach in a book on Francesco Guardi which appeared in 1951,[11] maintaining that the two brothers frequently 'collaborated'. This extremely interesting book contains some fifty or more little-known or previously unpublished drawings, thus completing the existing catalogues. Morassi's article on Gian Antonio Guardi's drawings, which appeared in 1953, is also of fundamental importance, since it was the first attempt to approach the artistic personality of the eldest of the three Guardi brothers.[12] In this article, the author published not only the drawing *The triumph of Virtue* (now in the Museo Correr), which was to become a document of critical importance because of the undisputed signature that it bears, but also ten or so other hitherto unpublished drawings of Gian Antonio, many of them unexpectedly beautiful. Ragghianti made good use of the results of this scholarship in his book published in the same year. He summarized the critical and philological situation with regard to the Correr Collection and suggested a number of precise formal definitions. He also pointed to new ways of distinguishing between the drawings, and suggested new criteria for attributing them to various members of the family. His general tendency was to attribute fewer drawings to Francesco and more to his son Giacomo.[13]

More recently, the discovery of new drawings has been accompanied by attempts to form complete organic catalogues of the work of Gian Antonio and Francesco Guardi (Pignatti, 1957) and by the publication of more general studies of a historical and aesthetic kind dealing with the cultural environment in which the brothers worked (Binion, 1976).[14] There were two important exhibitions held in the 1960s, each followed by the publication of a book. The first was by Byam Shaw (1962) and the second by Zampetti (1967), whose publication accompanied an exhibition of the brothers' work in which seventy-six sheets of drawings by Gian Antonio and Francesco were shown. Both the exhibitions and the books opened the way to a new approach to the subject, and a number of studies followed, many of them polemical.[15]

As we have seen, art historians from the very beginning have been confronted by the problem of the nature of these drawings and the purpose for which they were made. They have attempted to visualize them within the framework of the studio in which they were produced and the demand of the collectors for whom they were executed. What is beyond dispute is that Gian Antonio's drawings are all designs either for altar-pieces or for interior decorations in the

4 G. Damerini, *L'arte di F. Guardi* (Venice 1912).

5 G. Fiocco, *Francesco Guardi* (Florence 1923).

6 G. Lorenzetti, *Cà Rezzonico* (Venice 1936).

7 R. Pallucchini, *I disegni di Francesco Guardi al Museo Correr* (Venice 1943).

8 M. Goering, *Francesco Guardi* (Vienna 1944).

9 W. Arslan, 'Per la definizione dell'arte di F., G.A. e N. Guardi', *Emporium* (1944) Vol. C., pp. 3-28.

10 V. Lazareff, 'Francesco and G.A. Guardi', *The Burlington Magazine* (1934) LXV, pp. 53-72.

11 J. Byam Shaw, *The Drawings of Francesco Guardi* (London 1951).

12 A. Morassi, 'A Signed Drawing by Antonio Guardi', *The Burlington Magazine* (1953) pp. 260-7.

13 C.L. Ragghianti, *Epiloghi guardeschi* (Florence 1953).

14 T. Pignatti, 'Un disegno di Antonio Guardi donato al Museo Correr', *Boll. dei Musei Civici Veneziani* (1957) 1-2, pp. 21-32; A. Binion, *Antonio and Francesco Guardi* (New York and London 1976).

15 J. Byam Shaw and K.T. Parker, *Canaletto and Guardi* (Venice 1962); P. Zampetti, *I Fratelli Guardi* (Venice 1965).

fig. 72

72 G.A. Guardi, The triumph of Virtue Venice, Museo Correr (gift of Morassi)

Rococo style, whereas there is a much greater variety of themes in Francesco's drawings. Certain art historians (especially Pallucchini, 1943, Byam Shaw, 1951 and Morassi, 1975) have attempted to provide a more or less complete conspectus of the drawings and have consequently classified them according to such categories as figures, decorations, topographical views, landscapes or *capricci*. This method of dealing with the drawings has certainly proved valuable in cataloguing collections such as the Correr Collection in Venice, but its faults have become apparent when it has been applied to the whole of Francesco's graphic work. There is a risk of neglecting aspects of the artist's language and of missing the development of his style.

Nevertheless it has not often proved possible to establish chronological links between Francesco's drawings and his paintings. The latter have been dated more frequently and with greater accuracy. On the other hand, it has been possible to define a number of stages at least in the formation of Francesco's style in drawing (Pignatti, 1969).

73 F. Guardi, The Assumption of the Virgin
Munich, E. Hanfstaengl Collection

pl. 109

Francesco Guardi undoubtedly began work as an artist in figure painting, which he learned from his elder brother. He soon transformed Gian Antonio's free and flowing line into one that was drier, sharper and more capable of producing blocked shapes. These were reminiscent of a tradition that flourished in the region of Italy bordering on Austria from which the Guardi family had come, or of the earlier expressionism of Callot or Magnasco. Examples of his work at this time are *The Assumption of the Virgin* in the Hanfstaengl Collection and *The Virgin* in the Museo Correr. Both drawings have certain features in common with *Faith* and *Hope* and other youthful works now in Sarasota (1747?). There are also drawings of *The Sacraments* in the Museo Correr, based on prints after Longhi, which date back to about 1755.

Between 1750 and 1760, Francesco began to paint *vedute* of Venice. His model was certainly Canaletto, who was by then approaching the end of his active life. The master's influence can be seen clearly in the younger artist's incisive line, prolonged strokes and rather static shading and use of chiaroscuro. Good examples of this are the large views of the Grand Canal now in Cambridge, and in the British Museum and Davis and Knowles Collections in London.

74 F. Guardi, The Grand Canal at the
Cà Pesaro pl. 111
London, British Museum

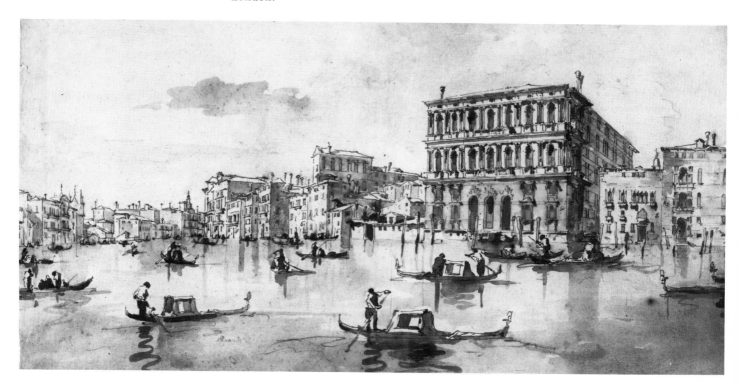

During the 1760s, Francesco drew much more animated subjects, but all of them were still directly connected with life in Venice, such as ducal festivals and ceremonies. In these drawings, he seems to have been even more anxious than before to reproduce faithfully the vibrant and sparkling atmosphere of the city and all the minute subtleties of its light and colour. These aspects are translated into linear terms, expressed in the lightest of penstrokes that are both approximate and contradictory, the scintillating lines losing all continuity and breaking into fragments in contact with the air and the reflections of the water. Many of the artist's drawings reveal this technique: *A race of gondolas on the Grand Canal, The Piazza S. Marco decorated for the Festa della Sensa,* both in the British Museum, and other drawings of ducal festivals. There is also the *Procession of triumphal cars in Piazza S. Marco,* which was at one time in the Oppenheimer Collection and commemorates the visit of the 'Conti del Nord', the Archduke and Archduchess of Russia incognito, to Venice. These drawings of festivals and ceremonies form a special group within the corpus of Guardi's graphic work. He gives particular attention in them to the dress of his human figures, which he depicts very faithfully, and he perfects the style of his *macchiette,* giving them an improvised, almost sketchy, but clearly defined outline with irregular and prominent features. Sometimes, as in the famous drawings executed in 1790 for *The Polignac wedding,* now in the Museo Correr, he had recourse to watercolour in order to reproduce the scene with greater fidelity and to achieve a more brilliant effect.

fig. 75

pls 121, 124-5

During the last period of his active life, Guardi's style was more concise, improvised and subtle. He shaded his lines with fine strokes of bistre, thus heightening the quivering effects of light in his drawings. This is apparent in the *vedute* that he continued to draw at this time. The Venice portrayed in them is unreal and almost ghostly, an effect that is particularly noticeable, for example, in his sketches of *The Rialto Bridge* and the *Fenice Theatre,* both in the Museo Correr. Guardi also used this style both in several natural landscapes and in a number of *capricci,* of which there are examples in the Boymans-van Beuningen Museum, Rotterdam, the Ashmolean Museum, Oxford, and the Museo Correr, Venice.

fig. 76

The masterpieces drawn during this final period – that is, about 1790 – include *The Bucintoro* in the Seilern Collection, the *Panorama from the Bacino di S. Marco* in the Robert Lehman Collection, and *The Bucintoro returning from the Lido,* at one time in the Petit Collection in Paris. In all these drawings, the artist's images seem to dissolve in light and colour. It is almost as if Guardi were anticipating Turner here – to such an extent that he has been described, wrongly no doubt, as a forerunner of Impressionism.

Technique also plays an important part in Guardi's graphic work, although he employed very simple means to achieve his ends and his materials were scanty. This led certain art critics

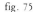

75 F. Guardi, A procession of triumphal cars in Piazza S. Marco
Formerly Oppenheimer Collection fig. 77

76 F. Guardi, The garden of the Palazzo Contarini del Zaffo
Oxford, Ashmolean Museum

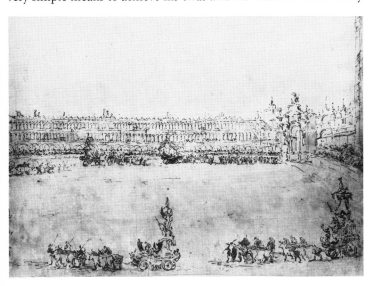

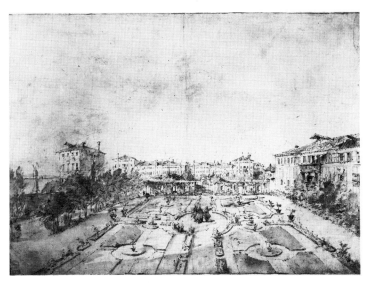

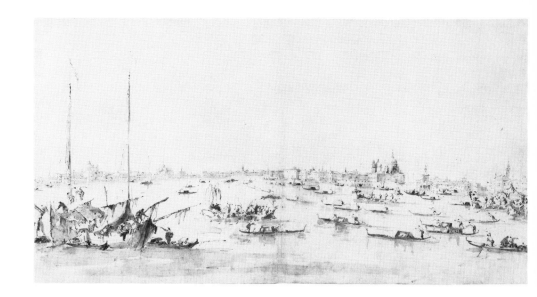

to accuse him of indifference, carelessness and even a kind of 'bohemian' negligence, but this was far from his intention.[16]

It is true, of course, that possibly half of Guardi's drawings are on paper of very poor quality which contains practically no size – wrapping paper, in fact. There is no sign that he ever prepared the paper that he used; and it is almost as if he preferred to exercise his great skill on a coarse surface and a rough, hairy texture of paper tinted brown, grey-blue or green.

Using these papers, obviously intended to be employed in the Guardi studio for practical exercises in drawing, must have been normal practice on Francesco's part, and there are many examples of this type of drawing in the Correr Collection. The collection, we may conclude, consists largely of work that had not been sold, and which may in fact never have been intended for sale, to foreign visitors or other customers. There are, however, also many drawings that are clearly not 'workshop' sketches. These are for the most part large sheets intended to be sold to foreign collectors, and they undoubtedly formed Francesco's principal source of income. Here he used either good-quality laid paper or real drawing paper with a fine grain and a sized and fairly glossy surface. Sometimes his paper has a surface like shot silk, giving his pen and brush strokes a delicate pictorial effect.

Guardi preferred to use gall-nut ink with a goose-quill sharpened to a fine point. More rarely, especially when he was working on a rough surface, he employed a coarser quill point, or even a reed. It is difficult, even in the case of his large youthful *vedute* of the Grand Canal, to establish with certainty the use of a pen with a metal nib.

He made very few drawings with soft materials alone, and although there are some for which he used black pencil or sanguine, it is clear that these were not his favourite materials. They probably did not give him the opportunity to shade with the brush, using diluted brown or grey wash; shading was undoubtedly the key-note in the total pictorial effect of his finest drawings. He also used watercolour in certain drawings in order to demonstrate what he intended to paint later on a canvas of the same theme. The famous *Polignac wedding* sheets in the Correr Collection are watercoloured in this way. One is bound to admit, however, that he obtained the most striking and convincing effects with bistre and sepia. Using these in a drawing, he was able to achieve almost magical pictorial results.

In conclusion, I have to mention one further aspect of the Guardi drawings – they frequently contain inscriptions and notes. Byam Shaw analysed these inscriptions in his book (1951) and attributed some to Francesco and others either to his son Giacomo or to various collectors. Unlike Giacomo and Gian Antonio, Francesco rarely signed his own drawings.

pls 121, 124-5

[16] See especially the detailed arguments in R. Pallucchini, *op. cit.,* p. 23ff, and J. Byam Shaw, *op. cit.* (1951) p. 39ff.

Francesco Guardi

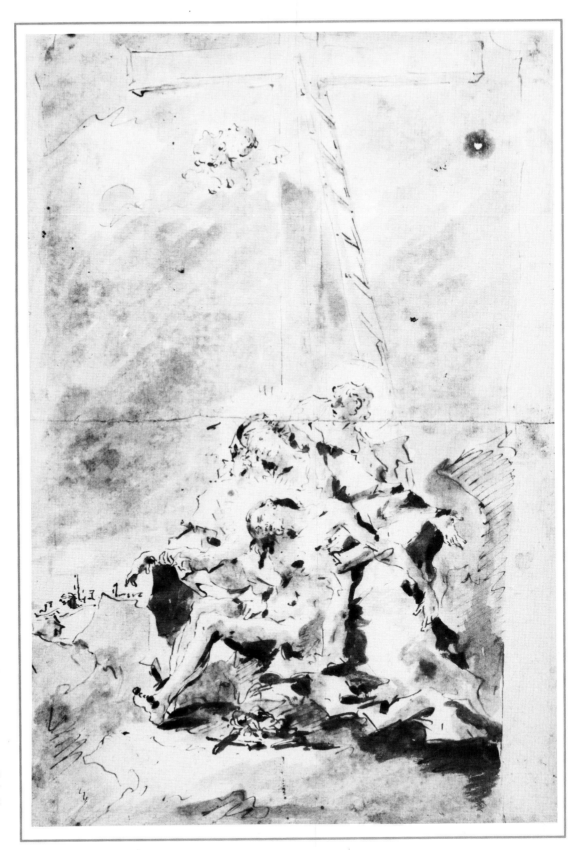

108 Pietà

Pen and wash on greyish paper
432 × 298

Bassano del Grappa, Museo-
Biblioteca-Archivio

Morassi connects this drawing with
a picture in a Milanese private col-
lection. He describes it as an
'astounding work'.

Ref.: Morassi 127; Cini 1956 No. 73

Francesco Guardi

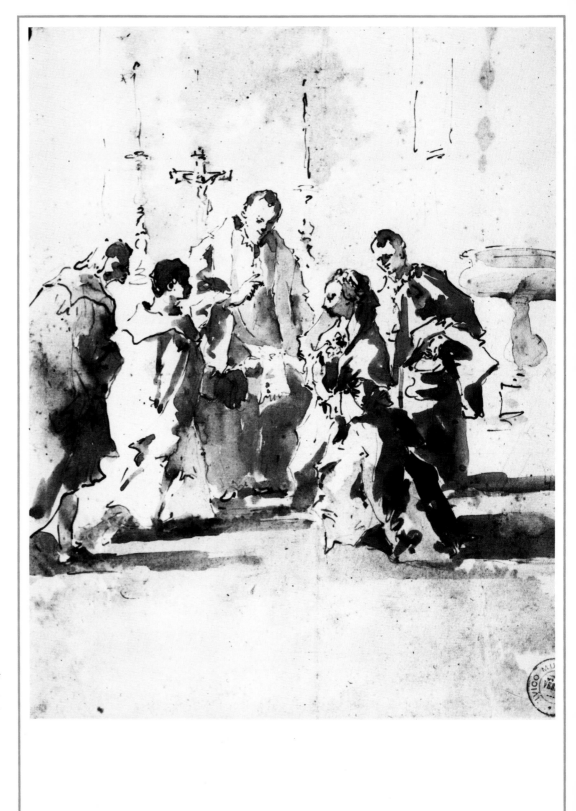

109 Marriage

Pen and bistre wash on pencil sketch
319 × 258

Venice, Museo Correr (7294)

This is one of a superb series of
drawings illustrating the Seven
Sacraments, now in the Museo
Correr. They are freely based on
Pietro Longhi's pictures on the
same theme, now kept in the Pina-
coteca Querini Stampaglia in
Venice. Byam Shaw first made the
now generally accepted attribution
to Francesco Guardi.

Ref.: Cini 1964 No. 75 ; Morassi 181

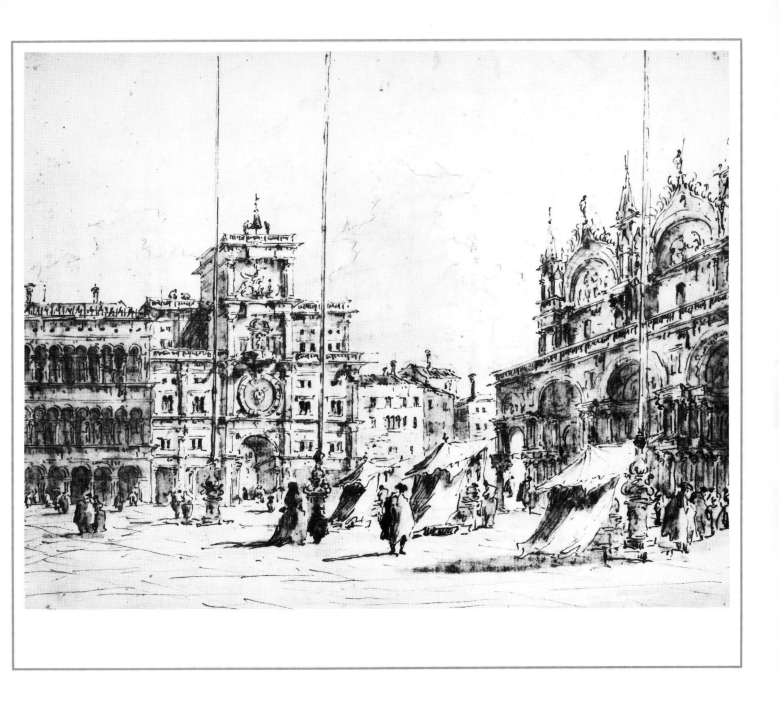

110 The Torre dell'Orologio in the Piazza San Marco

Pen and wash on sketch in black chalk 285 × 384

Paris, Musée du Petit Palais

Preparatory drawing for a painting in the Akademiegalerie in Vienna (Morassi 1973, I, cat. 356).

Ref.: Morassi 333; Paris 1971 No. 99

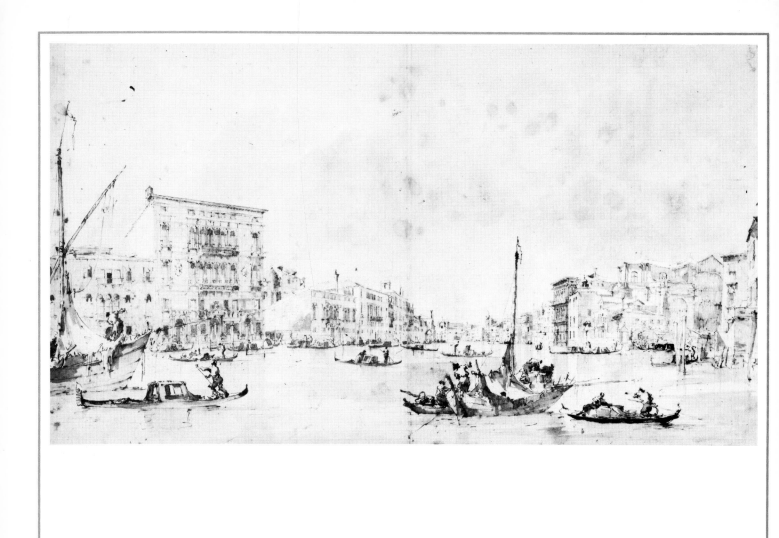

111 The Grand Canal with Palazzo Bembo and S. Geremia

Pen and wash on sketch in black chalk, with notes on colours 410 × 755

Cambridge, Fitzwilliam Museum (PD 18-1959)

On the left is the Palazzo Bembo, remains of which were still visible at the beginning of the nineteenth century. On the right is the Church of S. Geremia, consecrated in 1762, providing a *terminus post quem* for this great work. Two paintings of the same subject are known (Morassi 1973, I, 569, 570), and the composition was engraved by Valesi.

Ref.: Morassi 381

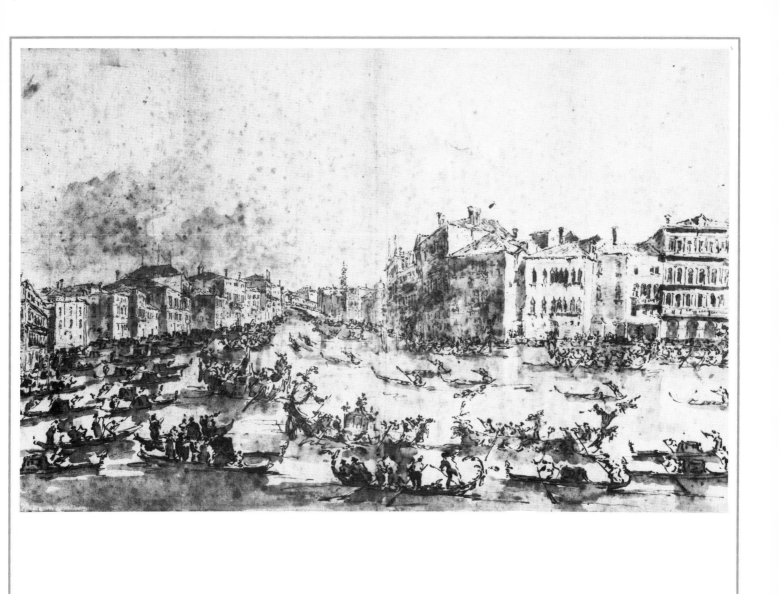

112-13 Regatta, looking towards
the Rialto Bridge

Pen and bistre wash
365 × 605
On the verso: The Grand Canal with
the Rialto Bridge (Morassi 363)

England, private collection

Morassi thinks this drawing 'extremely important and among the finest of its kind' and sees it as 'a preparatory drawing for a picture unknown to us'. He dates it to about 1780-5.

Ref.: Morassi 301

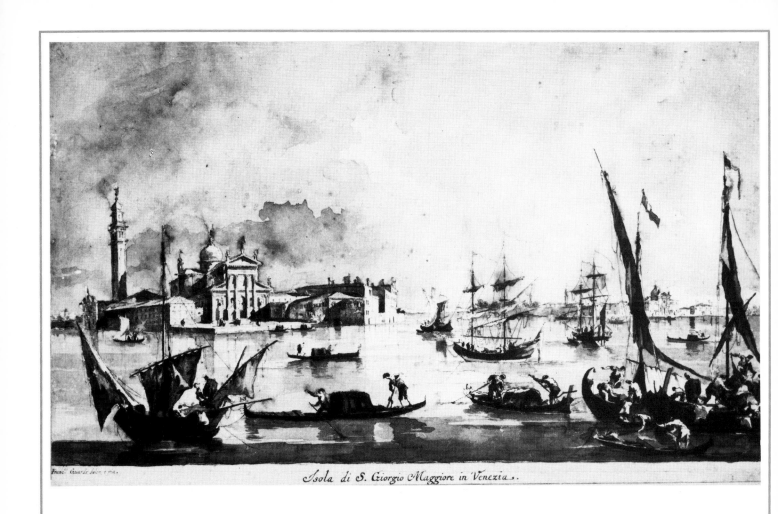

Isola di S. Giorgio Maggiore in Venezia.

114 View of S. Giorgio Maggiore

Pen and bistre and grey wash on sketch in black chalk 370 × 620
Autograph inscription, below, centre: *Isola di S. Giorgio Maggiore in Venezia,* and a signature, left: *Fran.co Guardi del. et pin.*

Venice, Fondazione Giorgio Cini

Morassi, who links this drawing with a series of other similar pages, dates it to the artist's mature years, when his work was characterized by 'faithfulness of vision ... combined with an intensely vibrant atmosphere, saturated with luminosity'.

Ref.: Morassi 348; London 1972 No. 120

Francesco Guardi

115 Capriccio of palace courtyards

Pen and bistre wash on pencil sketch
354 × 227

Switzerland, Private collection

Several variants of this drawing
(Morassi 534-536), representing an
unusually splendid *capriccio,* were
made during the 1790s.

Ref.: *Art vénitien en Suisse* 1978
No. 176

View of the Seat of S.E. Loredano at Paese near Treviso at present in the possession of John Strange Esqr. — N.B. grass ground within the Fence, without the post road from Treviso to Bassano

116 The Villa Loredan at Paese

Pen with bistre ink, grey wash on sketch in black chalk 321 × 535

Oxford, The Visitors of the Ashmolean Museum (1015)

This important drawing, discovered by Byam Shaw, is believed by Morassi to be a preparatory sketch or a *ricordo* for a painting belonging to a London collector. Morassi calls it one of Guardi's 'finest works, full of his characteristically Venetian spirituality, and extraordinary for the way in which his use of light anticipates the *plein air* of the French Impressionists.'

Ref. : Morassi 424

117 A comedy performed in the garden of the Villa Gradenigo at Carpenedo

Pen and wash on black chalk 417 × 707
Autograph inscription: *Veduta del Giardini del N.H. Gradenico a Carpenedo in tempo di Carnovale*, and, on the right, *Guardi F.* in the hand of Giacomo Guardi.

Canterbury, The Royal Museum and Art Gallery

The location of the scene in this large drawing is the same as that shown in the wedding of the Duke of Polignac and the banquet that followed it (see Nos 121 and 124-5). The play is not necessarily related to these festivities.

Ref.: Byam Shaw 1977 No. 5; Cini 1980 No. 119

View of Borgo di Val di Sugana, with the Castle Giovanelli; and neighbouring mountains, between Bassano and Trent.

118 Borgo di Valsugana from afar

Pen with bistre ink, grey wash on sketch in black chalk 360 × 532
Inscription (in the hand of the first collector, J. Strange): *View of Borgo di Val di Sugana, with the* Giovanelli *castle, and neighbouring mountains, between Bassano and Trent.*

London, Private collection

Guardi visited the Val di Sole in the autumn of 1778, when he probably made this fine drawing of the village Borgo di Valsugana, as part of a series executed on that occasion. Morassi describes it as a 'forerunner of modern *paesaggismo* and of major importance'.

Ref.: Morassi 416; Venice 1965 No. 47

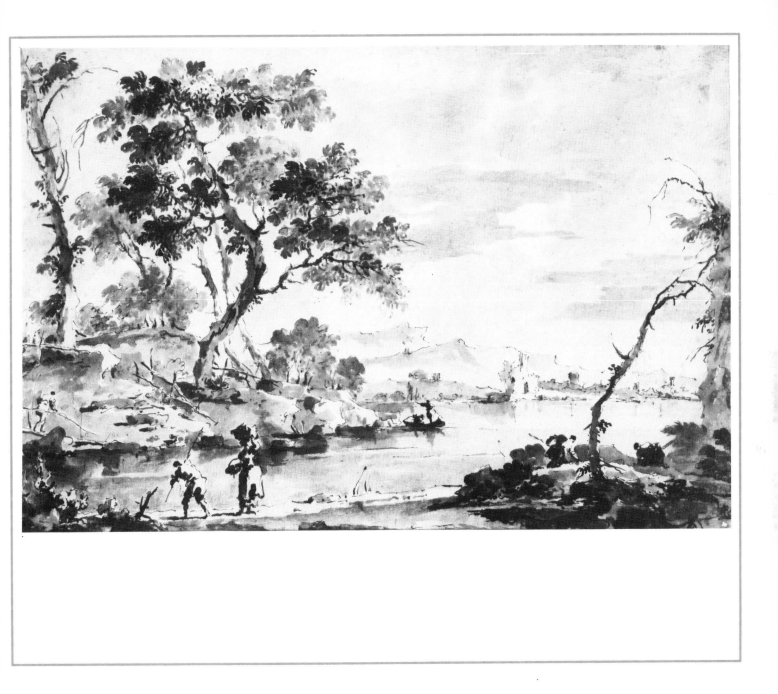

119 Landscape

Pen and bistre wash 258 × 388

Rotterdam, Museum Boymans-van Beuningen (I. 141)

A substantially developed study for a picture now preserved in the National Museum of Stockholm
(Morassi 1973, I, Cat. 999).

Ref.: Morassi 649; Paris-Rotterdam 1962 No. 196

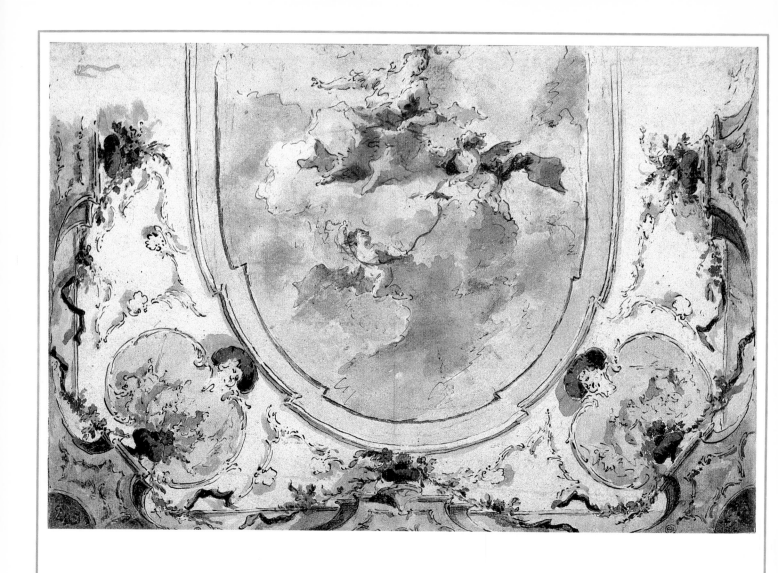

120 Design for a ceiling

Pen with brown ink, brown and grey wash, and watercolour 270 × 395

Paris, Ecole Nationale Supérieure des Beaux-Arts (2316)

Several decorative studies by Francesco Guardi are known to us, mostly dating from the period of his
maturity. This watercolour, certainly one of the most striking of a very 'rococo' genre, cannot be linked
with any existing ceiling.

Ref.: Morassi 459; Paris 1971 No. 108

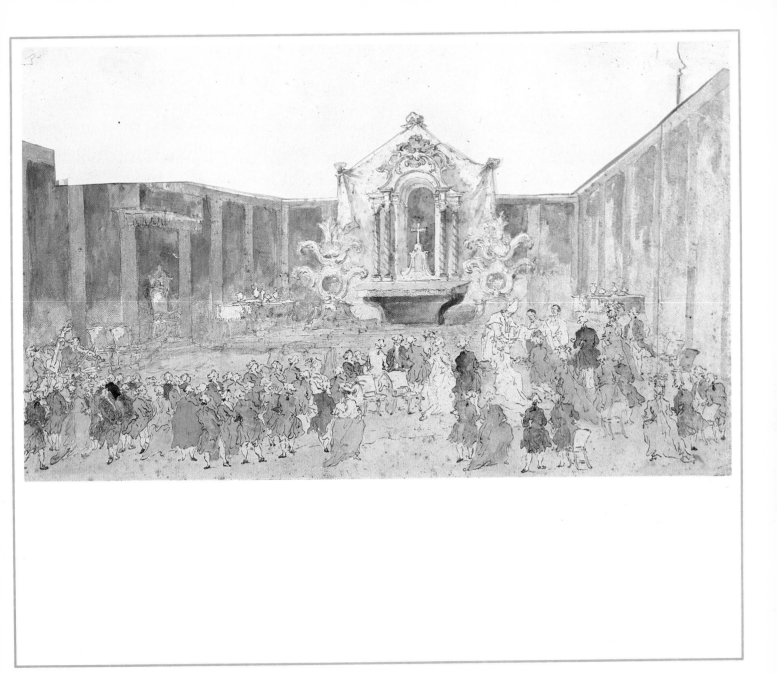

121 The Polignac wedding

Pen with bistre ink and watercolour 250 × 455
Inscription: *Chiesa del N.H. Gradenigo a Carpenedo; nella fonzione delli sponsali del figlio del Duca Polignac.*

Venice, Museo Correr (1202)

This watercolour is one of a set of four (see also Nos 124-5), all preserved at the Museo Correr and executed by Guardi on the occasion of the wedding of Duke Armand de Polignac to Baroness Idalia of Neukirchen at the Villa dei Gradenigo at Carpenedo on 7 September 1790. Rudolfo Pallucchini (1943) felt this work was 'executed in a more *dolce*, subtle and calculated way, very studied in its effects of local colours …'.

Ref.: Pallucchini (1943) pp. 10-11; Morassi 316

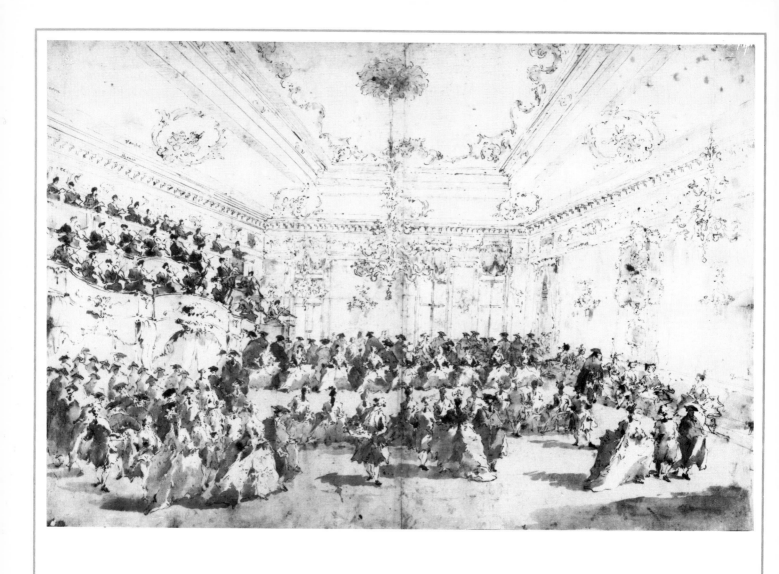

122-3 The concert in honour of the Conti del Nord

Pen with bistre ink and wash on a few traces of pencil; on two joined pieces of paper 518 × 777
Autograph indications of colours, etc.

Canterbury, The Royal Museum and Art Gallery

Morassi was unable to include this breathtaking work in his book on the drawings of Guardi (winter of 1975), since it was found a month after its publication, by Kenneth Reedie, recently appointed curator of the Royal Museum of Canterbury, among a very important group of drawings by Francesco Guardi and Domenico Tiepolo in a portfolio bequeathed to the Museum in 1897 and ignored thereafter. The drawing is a sketch for Guardi's well-known picture *The concert*, one of the most prized possessions of

Francesco Guardi

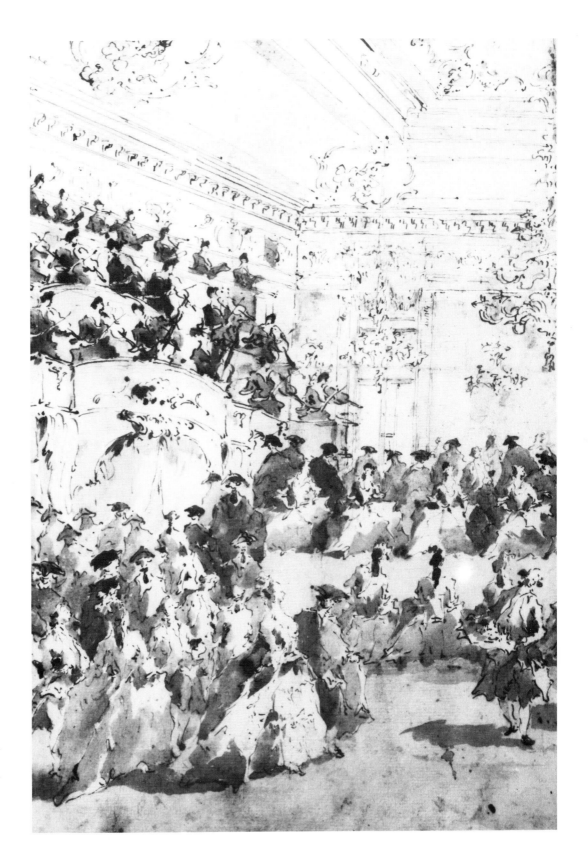

the Alte Pinakothek in Munich and scarcely larger than the present drawing. It illustrates a concert given by eighty orphaned girls in the Sala dei Filarmonici on the occasion of the visit to Venice of the 'Counts of the North' - the name used by the Grand Duke of Russia, Paul Petrovitch, and his wife when they were travelling.

Ref.: Byam Shaw 1977 No. 1; Cini 1980 No. 118

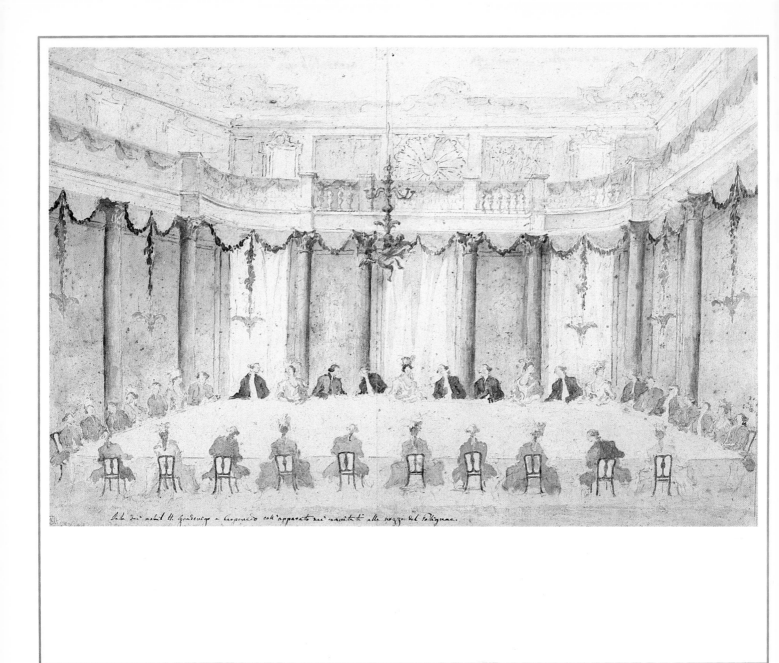

124-5 The banquet for the Polignac wedding

Pen with bistre ink and watercolour on pencil sketch 275 × 419
Inscription (in the hand of Barozzi, the first curator of the Museo Correr): *Sala del nob. H. Gradenigo a Carpenedo coll'apparato dei convitati alle nozze del Polignac.*

Venice, Museo Correr (29)

This delicate drawing, executed with astonishing freedom - Pignatti has described it as *graziosissima* - belongs to the same series as No. 121.

Ref.: Morassi 318; Cini 1964 No. 88

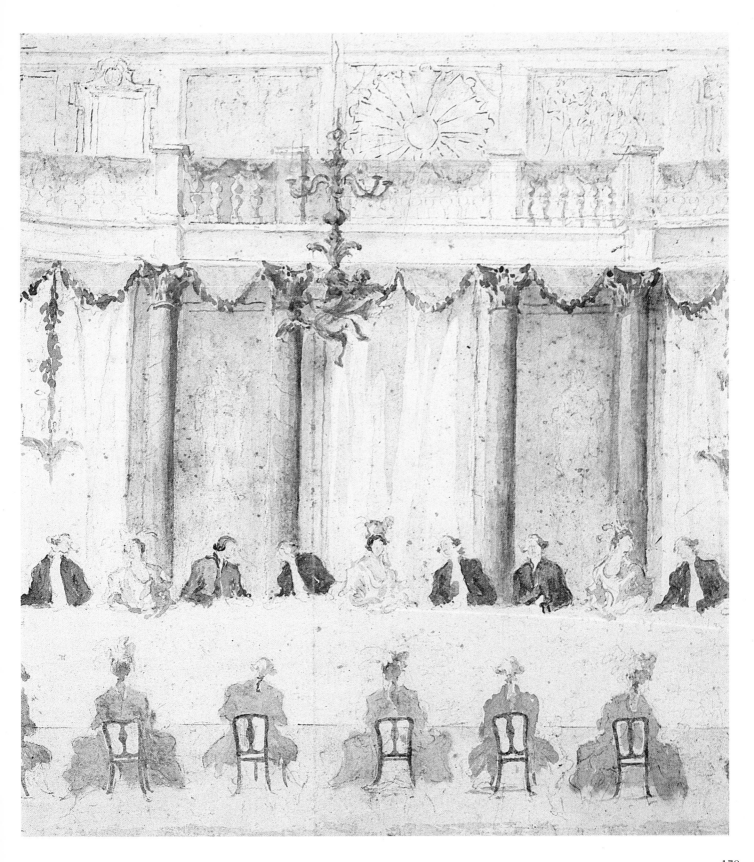

126 A *bissona* with a figure of Fame

Pen and watercolour on pencil sketch 400 × 550

London, Victoria and Albert Museum (143)

This and the following drawing bear witness to Guardi's 'inexhaustible imagination' (Morassi). Taking existing boats as his model, the artist decorated them so exuberantly that the result was almost surreal.

Ref.: Morassi 303

127 *Bissona* with Chinese gondoliers

Pen and wash on pencil sketch 345 × 500

London, Victoria and Albert Museum (144)

See the previous number.

Ref.: Morassi 304

128 A state galley

Pen and wash 305 × 495

Berlin, Staatliche Museen Preussischer Kulturbesitz, Kupferstichkabinett (KdZ 12506)

The same boat is found in a painting at one time in the Prase collection in Venice (Morassi 1973, I, Cat. 289). Morassi dates this 'very exact' drawing to about 1770-80.

Ref.: Morassi 292

129 Two ladies and a gentleman seen from behind *(macchiette)*

Pen and brush with brown ink 90 × 160

Paris, Private collection

According to Morassi, this delicate little sketch was drawn about 1780. Guardi frequently used sketches of
this kind for the human figures in his pictures.

Ref.: Morassi 226

130 Two dogs

Pen and bistre wash 119 × 122

Amsterdam, Rijksprentenkabinet, Rijksmuseum (1981: 72)

This little page bears two of Guardi's very rare animal drawings. Pallucchini was the first to claim it for Francesco Guardi - it had previously been attributed to Domenico Tiepolo - and he was followed by all the specialists. Byam Shaw drew attention to the fact that the lying dog can be seen in one of Guardi's pictures of the Piazza San Marco (New York, Private collection).

Ref.: Morassi 447; Paris-Rotterdam 1962 No. 197

The Drawings of Giambattista Piranesi

Alessandro Bettagno

It is only relatively recently that the drawings of Piranesi have attracted the attention of art historians. It was in fact not until 1954 that any serious study appeared. In that year, Hylton Thomas published his pioneering work in which he considered the whole corpus of Piranesi's drawings critically, and examined many problematical issues. More recently, exhibitions of Piranesi's work in London, Washington, Rome and Venice in 1978 have marked the bicentenary of the artist's death. Exhibitions have always played an important part in the study of Piranesi's work, and these in particular demonstrate a growing appreciation of his drawings that is leading to a deeper and more widespread knowledge. Piranesi's place as a star in the firmament of Venetian graphic art has at last been confirmed.

We have been slow to recognize the quality of Piranesi's drawings. This delay has to be considered within the wider framework of Venetian eighteenth-century art. Our understanding of the development of art and culture in Venice during that period has tended to lag behind that of other regions and periods in Italy, and this applies in particular perhaps to graphic art. Piranesi's drawings have consequently suffered from a general indifference and a particular lack of knowledge. They are also few in number. By contrast, his many magnificent engravings have certainly succeeded in interesting both collectors and art critics.

Of Piranesi's drawings, approximately six to seven hundred have survived. We have no accurate list at our disposal, but the total number cannot be far off that figure. Scholars specializing in Piranesi differ in their estimates, depending on the data they have collected and their personal convictions and conclusions, but the precise number of surviving drawings is probably less important than the total number that the artist must have made in his life, a number that we shall never know, but which must amount to several thousand at least. Firstly, he had a long and intensely active life as an artist, working for almost forty years. Secondly, the drawings that have been preserved are very varied, and each of his etchings must have been based on preparatory studies recording his initial ideas. Thirdly, there must also have been countless drawings not directly associated with the etchings that followed. Bearing all these factors in mind, we can only conclude that an incalculable number of drawings must have been lost. In addition to so many drawings, countless papers and documents of every kind must have disappeared, as well as innumerable letters, since Piranesi wrote to correspondents all over Europe. We do not know exactly how this material vanished; it may have been in his lifetime, at Rome, Naples or Paris, or some dramatic event possibly occurred in the home of one of Piranesi's heirs, probably that of his restless son Francesco. What exactly took place is impossible to say, but it resulted in the irrecoverable loss of what survived Giambattista's last illness and death.

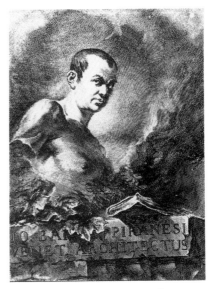

78 Giambattista Piranesi
Mogliano (near Mestre) 1720 - Rome 1770
Engraving

Giovanni Battista Piranesi was born of a Venetian family at Mogliano near Venice on 4 October 1720. His father, Angelo, was a master-mason, and his mother, Laura, was the sister of the architect Matteo Lucchesi, who first aroused Piranesi's interest in architecture and acted as his mentor when he began to study the subject. It was above all this preoccupation with architecture that led the young artist to follow the Venetian ambassador, Francesco Venier, to Rome in 1740. That city had for a long time occupied a predominant place in his thoughts, and it eventually held him completely in its spell. He spent three years there initially, followed by a period in Venice, and then for a short time, in 1745 or 1746, 'commuting' between Venice and Rome. After that, he settled finally in Rome and never again visited the lagoons.

It is important to bear in mind that Piranesi continued throughout to adorn himself with the title of *architetto veneziano*. In describing himself as a 'Venetian architect' he certainly did not wish to give the impression that he was one of those who, like Carlevarijs, Canaletto, Bellotto or Marieschi, produced views of Venice in architectural perspective. He rejected that superficial interpretation and saw himself as a man who had aimed to be a true architect since his earliest years. His conviction is sincerely reflected in a letter to Nicola Giobbe which he used as the dedication for his *Prima parte di architetture e prospettive* of 1743, and which is little less than a 'romantic confession'. (The text of the letter can be found on p. 16 of the catalogue of the 1978 exhibition of Piranesi's etchings in Venice: *Piranesi: incisioni*.)

There is no room to consider here the artist's slow downward slide from his youthful dreams of architecture until he found his destiny as an engraver of genius, both of sublime fantasies like *Le carceri* (1743-6) and of ancient buildings such as *Le antichita romane* (1756). I can only here recall some of the main steps on that path of unceasing and prodigious creativity. The *Della magnificenza ed architettura de' Romani* (1760) was followed by the *Campo Marzio* in 1762. His *Vedute di Roma* were engraved at various times throughout his career and only later published in book form. His *Antichita d'Albano e di Castel Gandolfo* also appeared about this time, as did his *Antichita di Cora* (1764). In 1769 he published *Diverse maniere d'adornare i cammini* and, in 1778, *Vasi candelabri e cippi*. We can end this incomplete list with his *Différentes vues ... de Pesto*, which was published after the artist's death on 9 November 1778 by his son Francesco.

It is obvious from this brief outline that, apart from a vary short period when he was restoring and restructuring the church of S. Maria del Priorato on the Aventine in Rome, Priranesi expressed himself as an artist exclusively through his etchings. He used them as an unrivalled means of disseminating his images and ideas. He was always regarded as an engraver of *vedute*, and especially of *vedute* of Rome, and he was much praised by followers of the Romantic movement because of his celebrated *Carceri*. Recent research has brought to light other aspects of his personality as an artist, and the more deeply we delve, the more problematical, intangible, complex and elusive that personality seems. Despite all appearances, he was a difficult artist with a difficult temperament. Both his contemporaries and his biographers – Bianconi, Legrand, Louis and Robert Adam – were aware of this.

Piranesi produced an enormous number of etchings, in which it is possible to see what André Chastel has described as 'the deep shadows of the age of Enlightenment'. They remained popular because they were, for various reasons, favoured by both neo-classicists and Romantics. This popularity continued later in a much wider context because they came to be regarded as artistic representations of man's existential distress: but it had one clearly negative consequence: the artist's drawings were eclipsed. The freedom of Piranesi's line, the direct way in which he expressed his forms, the rapid execution of his themes often reduced to the roughest of sketches, and the rich pictorial quality of his images – all these aspects of his drawings have deep roots in the Venetian tradition. Despite this, they were long denied their critical due.

This situation was eventually rectified first by connoisseurs and then by art critics. Piranesi's graphic work has been discussed in many articles and longer studies since the appearance of A. Giesecke's classical monograph in 1911 and the review of it by A. Grisebach. Individual drawings by Piranesi and groups of his sketches from private collections have also featured in nume-

rous exhibitions. Finally, there are also many prestigious public collections in museums all over the western world. These include, among others, the British Museum, the Kunsthalle in Hamburg, the Pierpont Morgan Library in New York, the Kunstbibliothek in Berlin, the Ashmolean Museum in Oxford, the Ecole Nationale Supérieure des Beaux-Arts, Musée du Louvre and Bibliothèque Nationale in Paris, Sir John Soane's Museum, London, and the Avery Library of Columbia University, New York. Many of the drawings in these collections have also been exhibited in recent years. A great deal has therefore been done to fill a major gap in the history of art in general and the history of Italian and European drawing in particular.

Generally speaking, engravers' drawings are detailed, careful and precise. They are a preparation for the final work – the engraving. The situation, however, in the case of Piranesi is very much more complex, since it is difficult to apply the traditional concept of 'preparatory drawing' to his work. His idea of a drawing can best be understood as that of an image which stands as it is, almost autonomous, in a state of suspense, while at the same time reflecting a pictorial notion that is preconceived and already formed.

Traditionally, the drawing was always first and foremost a study or 'preparation' for another work. The image would be outlined on paper using a technique other than painting (or sculpture or architecture): this had been the case in drawing for a long time, certainly in Venice. But the situation had begun to change with Giambattista Tiepolo. The drawing had gradually ceased to be a mere preliminary to the painting. It no longer simply preceded the painting, but existed in parallel with it. It became autonomous. The same original idea was common to both the drawing and the painting.

We do not know whether Piranesi was ever in Tiepolo's studio, but we can be sure that he was in Venice when the older artist was producing particularly good work. In fact, Piranesi's way of drawing can be explained only with reference to Tiepolo's graphic work between 1743 and 1746, when Tiepolo's art was fully mature; Piranesi was also in Venice between first visiting and finally settling in Rome. Tiepolo had just finished the frescoes in the Villa Cordellina and was busy decorating the ceiling of the Scalzi church. He had already published his *Capricci,* and his drawings had emancipated themselves from problems of form, so his work in this sphere had achieved a translucent and fluid quality that was heightened by the application of wash. Dated sheets of this period in the Sartorio Collection in the Musei Civici in Trieste have precisely this luminous pictorial quality. Examples that come to mind are the drawing of 17 February 1744 (G. Vigni, 1972, No. 118) showing *Three nudes,* and decorative drawings such as the two cartouches (*ibid.,* Nos 105 and 106).

pl. 44

79 Three nudes
Trieste, Civici Musei di Storia ed Arte

It is, I believe, only by referring to such works that it is possible to account convincingly for the magical graphic creations of Piranesi in the Venetian Rococo spirit found in the Pierpont Morgan Library, or for such frenzied inventions as the *Composition with figures* in the Ashmolean Museum, Oxford, the *Group of masked Venetians* in the Kunsthalle, Hamburg, or the *Capriccio, design for a frontispiece* in the British Museum, to mention only three of the artist's most famous drawings.

fig. 84

The extent of the young draughtsman's development in the 1740s can be measured by comparing his *Two courtyards in diagonal perspective* and its verso in the British Museum, with the examples given above which are entirely Venetian in spirit. These were also the years when Piranesi made the first *Carceri* plates. The two *Prison* drawings in the Kunsthalle, Hamburg, are relevant here.

pls 134-5

It is difficult, but a task worth attempting, to illustrate Piranesi's development as an artist and a personality by means of his drawings. The difficulty arises because relatively few drawings survive and because their loss has been so random: our judgments are not always confident and our conclusions must often be one-sided. Works dating from after Piranesi's final move to Rome include the *Architectural fantasy* (Kunstbibliothek, Berlin) with, on the verso, the study of the *Castel S. Angelo* which is the fourth *veduta* in Volume IV of *Le antichità romane* (1756); the *Grand vestibule with arcades* in the Biblioteca Comunale of Bologna, with

fig. 81

fig. 82

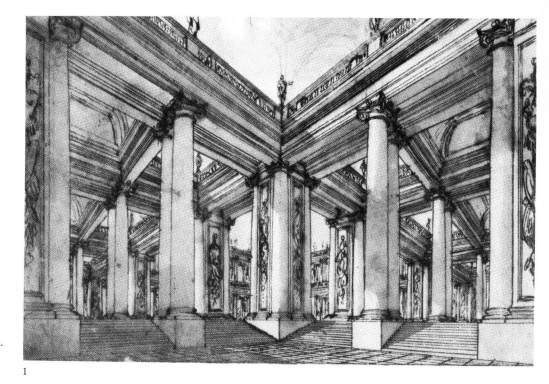

80 Two courtyards in diagonal perspective
London, British Museum

81 Architectural fantasy
Berlin, Kunstbibliothek

82 Grand vestibule with arcades
Bologna, Biblioteca Communale dell'Archi-
gimnasio

1

2

3

its grandiose and spacious architecture; and the *Reconstruction of the Circus Maximus* in the pl. 131
Kupferstichkabinett, Berlin. In these drawings, a grandiose perspective gives unity to the com-
position. Piranesi's archaeological method leads him to bring together in a single drawing a
great number of different kinds of ancient monuments, some based on fact and others purely
fantastic, in a strange combination of rigorous reconstruction and architectural invention.

Piranesi began to concentrate increasingly on architectural inventions with a fantastic
emphasis. The fantasy had always been latent in his work, but now it was expressed in the
form of a dynamic tension between the Baroque or Rococo and the ancient and archaeological
elements. His version of antiquity is imbued with a powerful sense of Roman grandeur which,
with the passage of time, overlaid his early Venetian training.

From 1760 onwards, after the successful publication of his volumes of the *Antichità romane*
which established his reputation as a *vedutista*, this tendency slowed down and became less
pronounced. For about ten years he experimented with a variety of techniques in drawing,
sometimes using pencil and at other times ink and wash. Towards the end of his life, in the
1770s, he developed wider interests as an artist and dealt with a greater variety of themes. He
produced, for example, a set of memorable drawings of Hadrian's Villa at Tivoli, made almost
fiery with sanguine. There is also a series of preparatory drawings for the engravings of Paes-
tum, with their temples and shepherds in a desolate landscape. These are drawings in which
wash predominates, giving a translucent and intensely pictorial effect.

Piranesi also drew a number of human figures which seem to form a special category in his cor- figs 149-69
pus of drawings and one that has given rise to a good deal of discussion. They are often quite
small and would appear, generally speaking, to have as their subject those little figures that
play a special part in the artist's *vedute* and *antichità*. They are almost always drawn with rapid
strokes of the pen, sanguine or pencil, which gives them a mad, unsteady appearance. They
seem to be reeling under the impact of the tragic predicament of suffering humanity, and the
contrast between them and the relics of mighty architecture in the drawings is dramatic.

Rather than human figures, they become shaggy outgrowths, like grass and moss, of the majestic but decrepit structures that dominate the scene.

pl. 147

This brief essay must end with a reference to Piranesi's designs for furniture, for decorative schemes, for architectural modifications and for the restoration of monuments. These are all characterized by the artist's distinctive use of line and by an unmistakable personality which lavished on every drawing the abundant resources of his prolific genius.

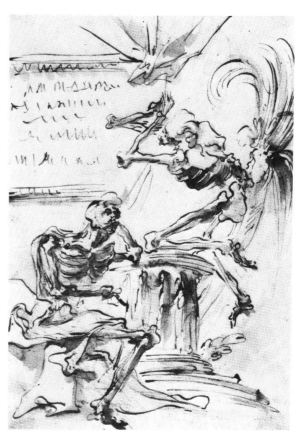

84 Design for a frontispiece
London, British Museum

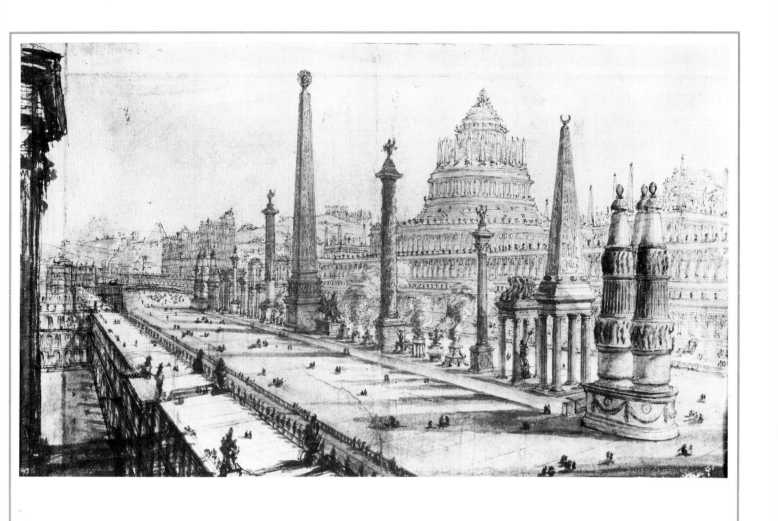

131 Reconstruction of the Circus Maximus

Pen and wash on pencil and sanguine sketch 278 × 452

Berlin, Staatliche Museen Preussischer Kulturbesitz, Kupferstichkabinett (8458)

This drawing is evidence of Piranesi's work as an 'archaeologist'. It is a preliminary study for the second frontispiece of the third volume of the *Antichità romane* (Focillon 287), showing a 'reconstruction' that owes much to the artist's occasionally excessive imagination.

Ref.: Berlin 1967 (Winner) No. 44; Cini 1978 No. 36

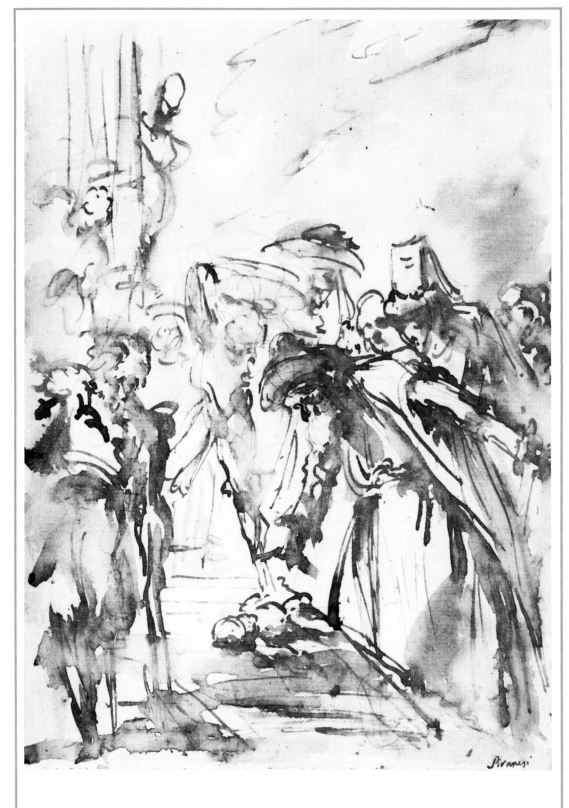

132 Composition with figures

Pen and wash on pencil sketch
257 × 187
Signed on the right: *Piranesi*

Oxford, The Visitors of the Ashmolean Museum (1038)

The subject-matter of this drawing has always puzzled critics and the suggestion that it represents *The Adoration of the Magi* has been disputed. Together with the following drawing, it belongs to a group of four, all in the same style and of much the same measurements. They date back to 1744, shortly before Piranesi left Venice to settle permanently in Rome.

Ref.: Parker 1956 No. 1038; Cini 1978 No. 11

192

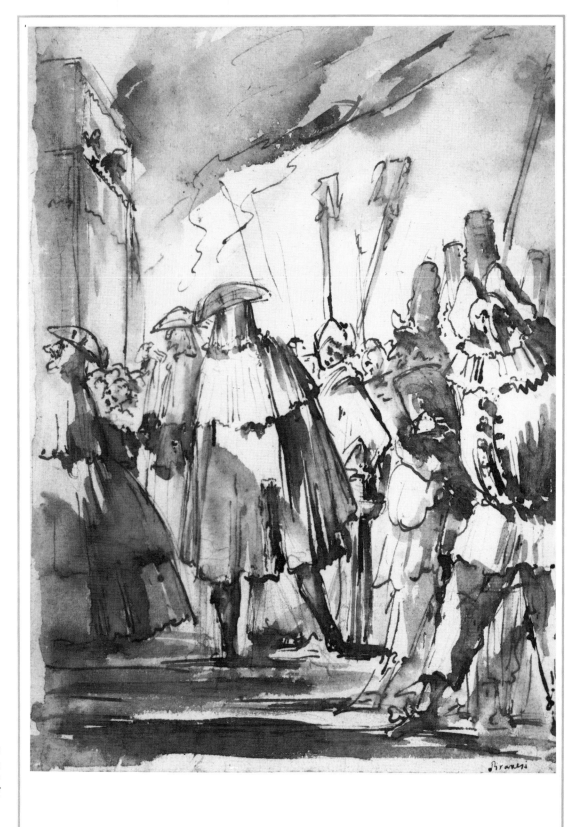

133 Group of masked Venetians

Pen and wash on pencil sketch
258 × 183
Signed, bottom left: *Piranesi*

Hamburg, Kunsthalle (1915/638)

See the remarks for the previous
number. Bettagno regards this
drawing as 'the most obviously
Venetian of the group, by virtue of
the scene that it represents'.

Ref.: Cini 1978 No. 15

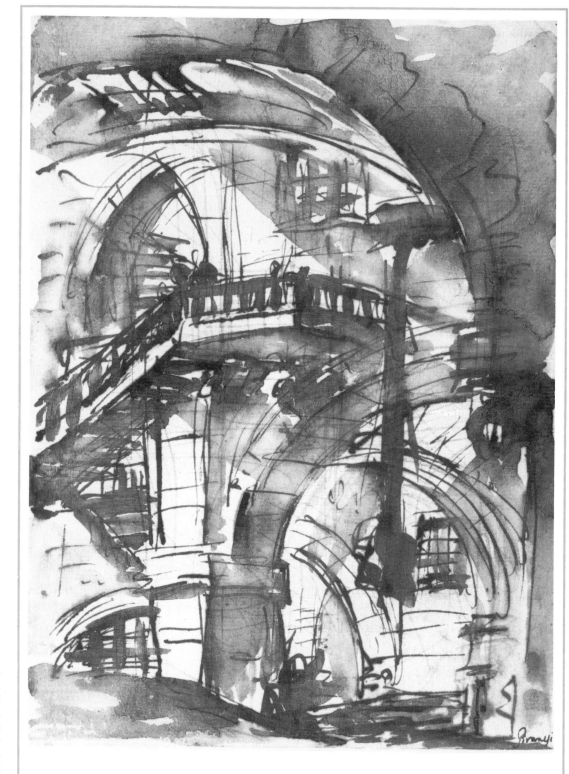

134 Prison

Pen and wash on pencil sketch.
256 × 189
Signed in the bottom right-hand cor-
ner: *Piranesi*

Hamburg, Kunsthalle (1915/578)

While working on the first edition
of his famous *Carceri* (1744-5),
Piranesi made many studies, some
more or less directly connected
with the engravings, but others
not. According to Bettagno, they
all 'breathed the same atmosphere
of *chiaroscuro,* incredible spatial
tension, dramatic contrasts and
translucent clarity'.

Ref.: Cini 1978 No. 15

135 Prison

Pen and wash on sanguine 155 × 216

Hamburg, Kunsthalle (1915/648)

Unlike P.M. Sekler, Bettagno sees no connection between the walkways in this drawing and that in Plate
VII of the *Carceri*. He situates it in the 'creative phase of the Carceri', without linking it to any specific
engraving.

Ref.: P.M. Sekler 1962, p. 346; Cini 1978 No. 20

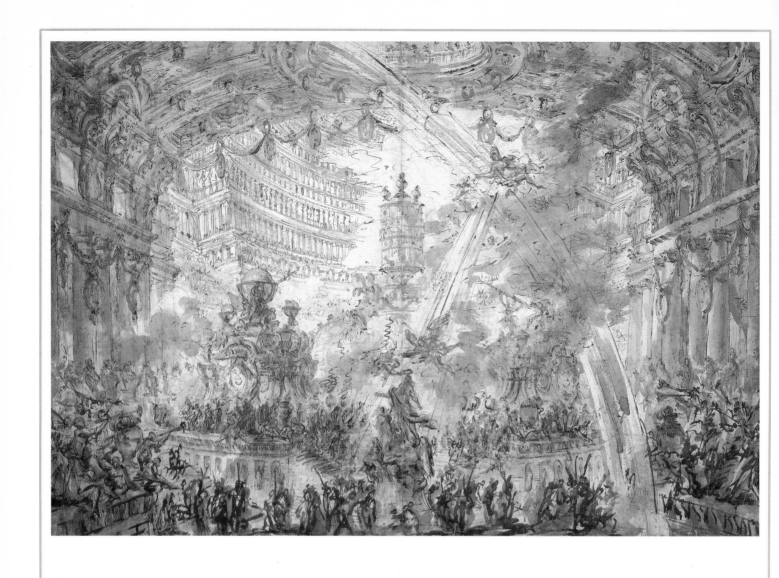

136-7 Palace interior

Pen and brown ink, brown wash on sketch in sanguine 512 × 765
Inscription: *Piranesi*

Paris, Musée du Louvre, Cabinet des Dessins

In the catalogue of the Paris exhibition 'Venice in the Eighteenth Century' (1971) in which this drawing, acquired in February 1983 by the Louvre, was shown for the first time, R. Bacou noted the 'visible influence of the theatre and the architectural creations of the Bibienas', and stressed the 'unusual dimensions of this drawing, in which visionary inventiveness reaches a fascinating paroxysm'. She dated it to about 1745.

Ref.: Paris 1971 No. 143

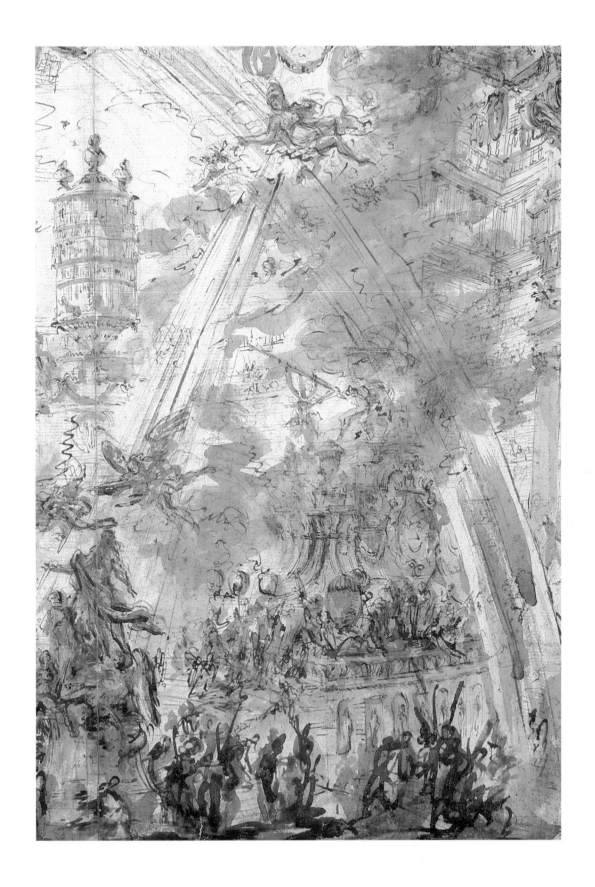

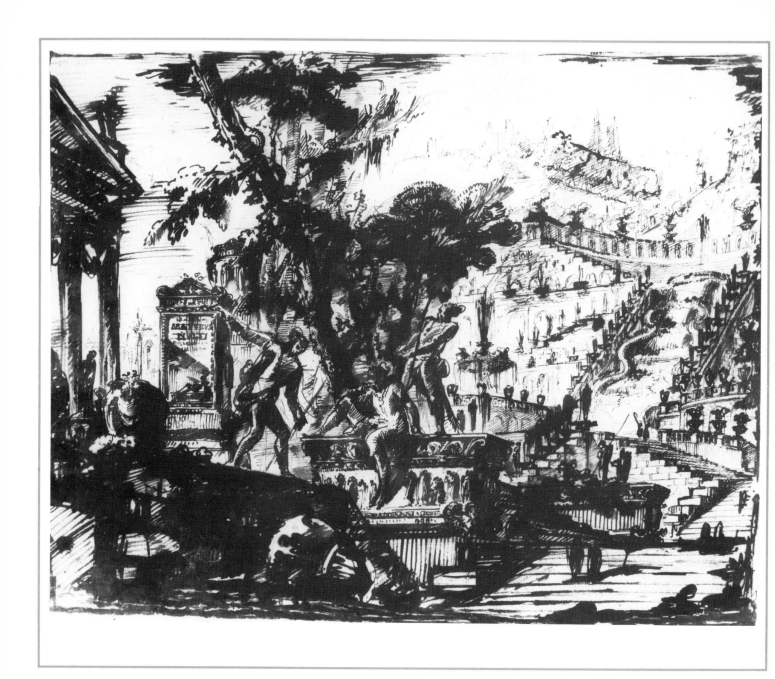

138 Fantastic garden with the tomb of Matthew Nulty

Pen 508 × 660

Private collection

Another example of Piranesi's creative vitality, in which he situates the tomb of the English painter
Matthew Nulty, who died in Rome in 1778, in this fantastic garden. According to Rieder, Nulty formed a
link between Piranesi and Edward Walter.

Ref.: Rieder 1975; Cini 1978 No. 68
See No. 150

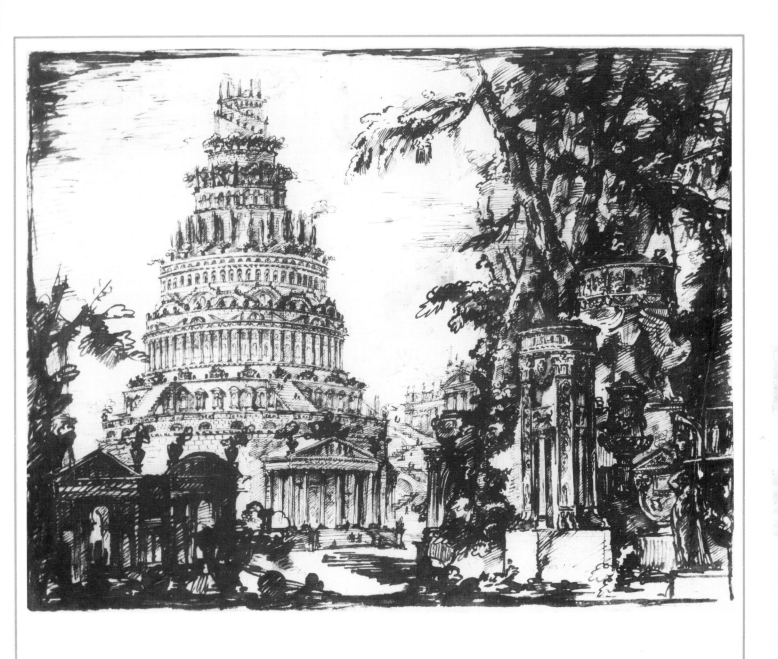

139 Magnificent mausoleum

Pen 508 × 660

Private collection

An extraordinary drawing, the product of Piranesi's overflowing and inexhaustible imagination, coupled
with a deep knowledge of the ancient world.
See the previous number.

Ref.: Cini 1978 No. 66

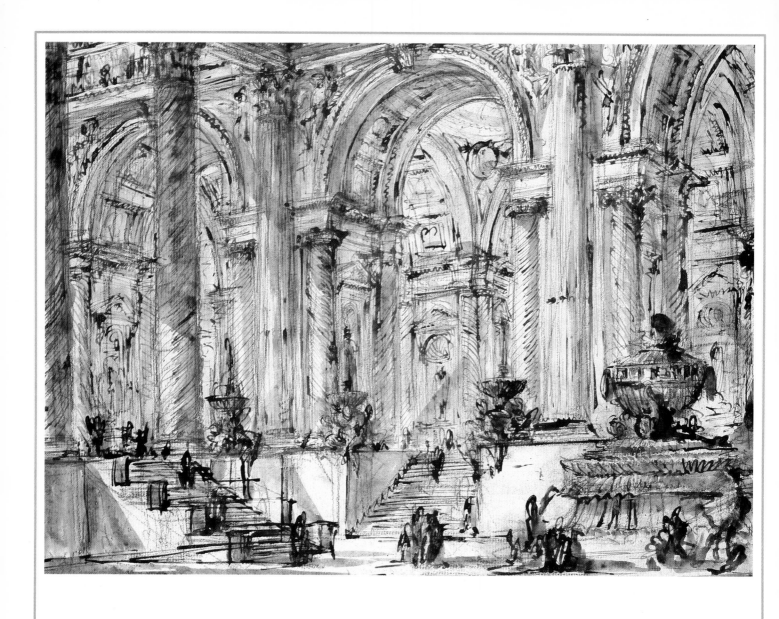

140-1 Architectural fantasy

Pen and wash with brown ink on sketch in sanguine 365 × 505
Signed on the last step of the staircase on the right: *Piranesi*

Oxford, The Visitors of the Ashmolean Museum (1039)

This exceptionally inventive drawing, executed with great freedom, belongs to a group of similar works
(see Nos 136-7) that specialists have dated to the 1750s, when Piranesi was producing his most mature
work.

Ref.: Parker 1956 No. 1039; Cini 1978 No. 33

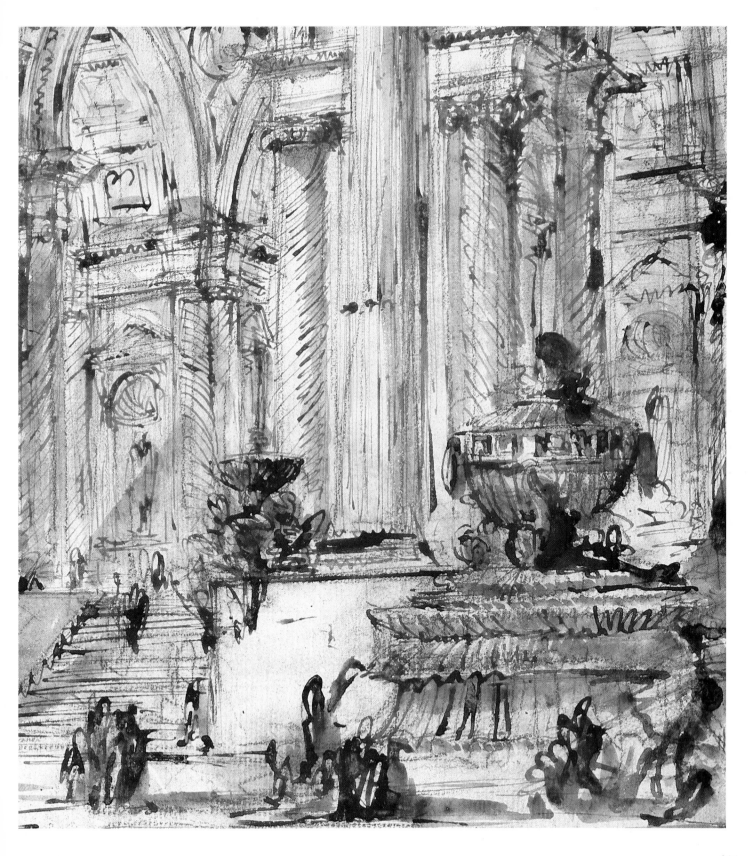

142 The Villa Pamphili

Pencil 508 × 660

Florence, Gabinetto Disegni e Stampe degli Uffizi (96009)

Bettagno believes this large drawing to be a first general sketch, followed by other studies, for the engraving known as Focillon No. 840 (Hind 124). This drawing provides us with a glimpse into Piranesi's methods of working. He seems to have made many such studies for his *Vedute*, although most are now lost.

Ref.: H. Thomas 1954 No. 54; Cini 1978 No. 76

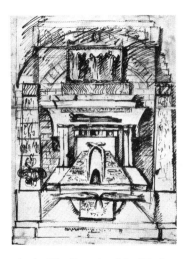

143-4 The Temple of the Sibyl at Tivoli

Sanguine on two joined pieces of paper 657 × 485

Inscription: *Altra veduta del tempio della Sibilla in Tivoli. 1. Sustruzione dell'aja del tempio dalla parte della cascata del Teverone. 2. Parte del tempio supposto d'Albunea*

Verso: Pen study of a monumental building

Paris, Bibliothèque Nationale (B 11 res., fol. 8)
144 (143 verso)

Preparatory study for the engraving Focillon 766, which appeared in 1761 in the first volume of the *Vedute di Roma*.

Ref.: Cini 1978 No. 72

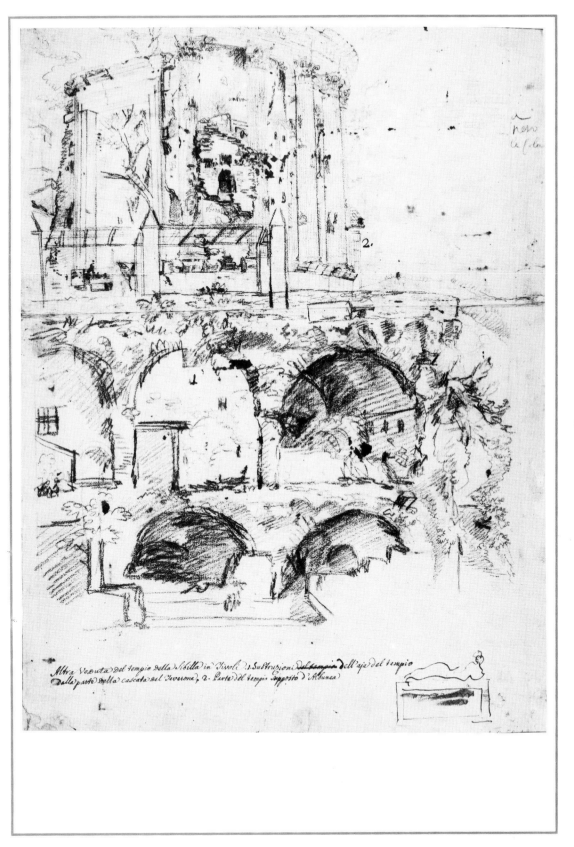

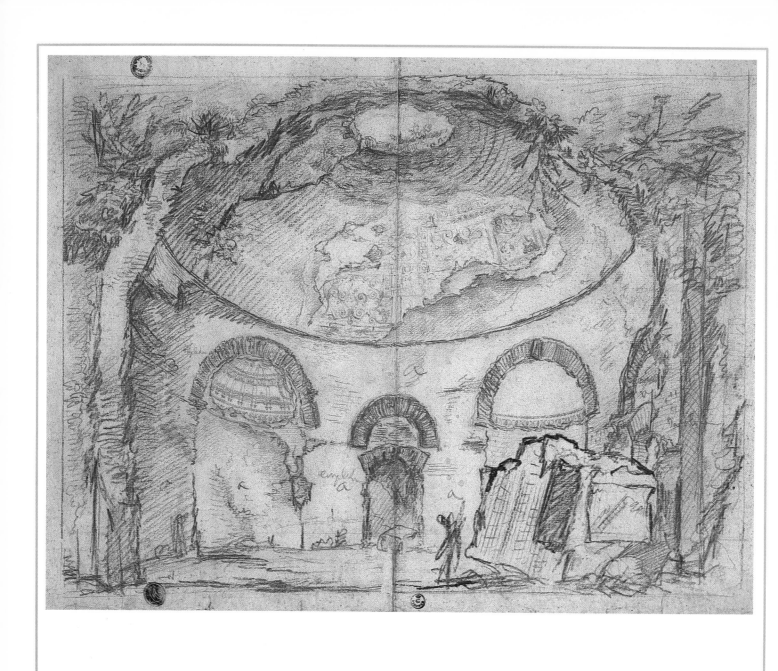

145 The temple of Canopus, Villa Adriana at Tivoli

Florence, Gabinetto Disegne e Stampe degli Uffizi

Ref.: H. Thomas 1954 No. 53

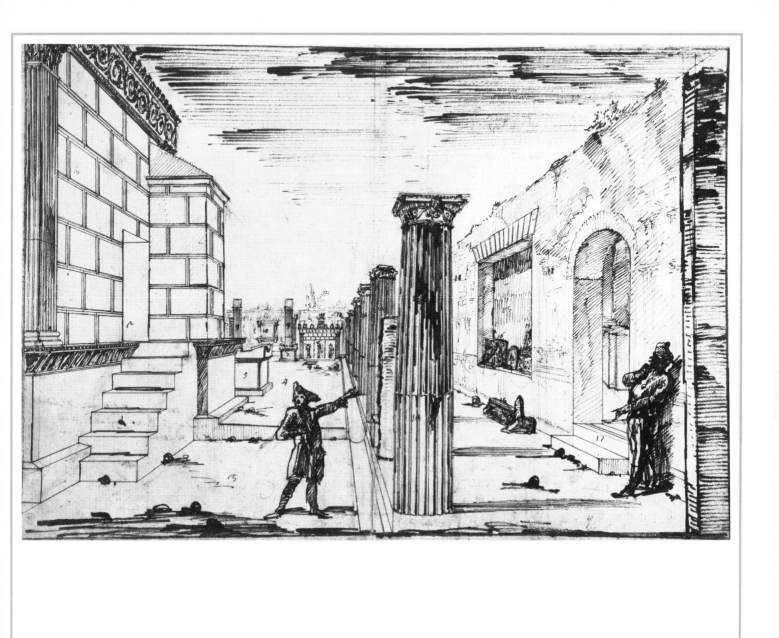

146 Side view of the temple of Isis at Pompeii

Charcoal and pen with brown ink 511 × 773

Berlin, Kunstbibliothek (Hdz 4470)

One of the studies, now scattered among various collections, which Piranesi prepared of the ruins of
Pompeii and Herculaneum and from which his son Francesco engraved the plates for the three-volume
work *Antiquités de la Grande Grèce* (1805).

Ref.: Sabine Jacob 1975

147 Study for a table

Pen with bistre ink on pencil sketch
200 × 146

London, Victoria and Albert
Museum (1092.1963)

Piranesi was also interested in the
decorative arts, that allowed him
to express his vigorous imagination
while imposing on it a degree of
discipline inherent in the new neo-
classicism. Many of his designs for
furniture, fireplaces, vases and so
on are known.

Ref.: Cini 1978 No. 40

148 Two trees

Pen and brown wash
480 × 445 (unevenly trimmed)

Paris, Ecole Nationale Supérieure
des Beaux-Arts (263)

This impressive study was un-
doubtedly drawn from life. As no
other drawing of this kind is
known, it is difficult to date preci-
sely, but since in certain respects it
resembles relatively late engravings
of landscapes, there is general
agreement that it was produced
between 1765 and 1775.

Ref.: Paris 1971 No. 156; Cini 1978
No. 54

149 Three figures of men

Pen and bistre wash 198 × 397 (unevenly trimmed)
Verso: sketch in sanguine of part of the engraving 'Ponte Molle sul Tevere' (Focillon 767), dated to 1762.

Paris, Ecole Nationale Supérieure des Beaux-Arts (267)

It is not easy to date drawings of this kind precisely, as they are not directly connected with a particular engraving. In this case, however, a sketch on the back is related to an engraving dated 1762, which may be an indication of the date of this drawing. It is, according to Bettagno, 'one of the master's most brilliant and famous drawings'.

Ref.: H. Thomas 1954 No. 74; Paris 1971 No. 150; Cini 1978 No. 58

150 Figure

Pen 200 × 146
Autograph inscription: *Il Cavaliere Gio. Bata. Piranesi fecit*, probably added at its transfer (by gift or sale) to Edward Walter

Private collection

This drawing – one of the most fascinating and even mysterious figure studies of its kind, is, like Nos 138-9, one of a group of seven pages discovered only a few years ago. Together they form the most important contribution made recently to our knowledge of the drawings of Piranesi. It is possible to trace their origins to an Englishman, Edward Walter, who was staying with his wife and his daughter Harriet in Rome (1769-71), and who must have been in direct contact with the artist. An ancestor of the present owner married Harriet Walter in 1774, thus coming into possession of Piranesi's works, still preserved in the home of his descendant. In addition to the seven drawings, the collection contains eight vases and two marble fireplaces executed after designs by Piranesi.

Ref.: Rieder 1975; Cini 1978 Nos 63 and 69.

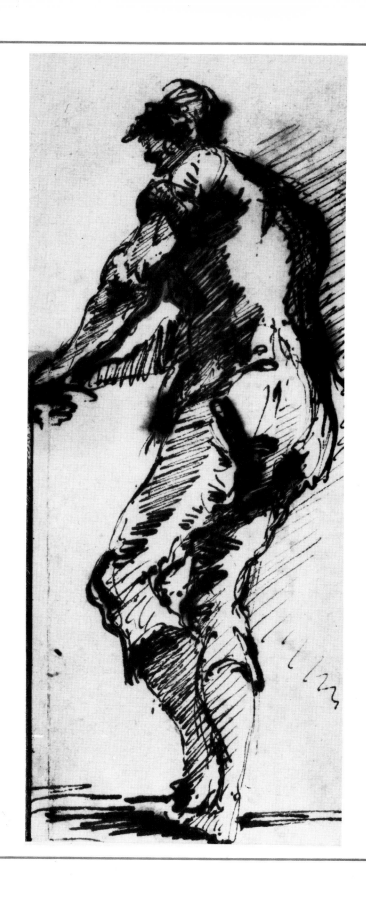

151 Figure study

Pen with brown ink
215 × 90

Switzerland, Private collection

Ref.: *Master Drawings* (Stein); Bury
Street Gallery, London 1981

152-6 Five figure studies

Black chalk
The five drawings are mounted on a passe-partout frame; centre: 130 × 91; top left and right: *c.* 52 × 34; bottom left
and right: *c.* 61 × 41

Private collection

Piranesi must have intended these and a number of other similar sketches (see the following numbers) as
models for the figures that he habitually included in his *vedute* and other engravings.

Ref.: The Matthiesen Gallery 1963 No. 48 (ill.); Sotheby's sale 25 March 1982 No. 59

157-69 Thirteen little sketches
mounted together

Black chalk or sanguine

Switzerland, Private collection

Sources of the illustrations

Jörg P. Anders, Berlin: pp. 59, 105, 119, 120, 121, 151, 152, 155, 182, 191 —
Archivo fotografico del Museo Correr, Venice: pp. 6-18, 21, 72, 94 (top),
113, 117, 118, 122-130, 132, 133, 159, 164, 175, 178, 179, 185 — The Art
Institute of Chicago: pp. 94, 96 — Ashmolean Museum, Oxford: pp. 47, 88,
144, 161, 170, 192, 200, 201 — Bozzetto, Cartigliano: pp. 22, 163 — British
Museum, London: pp. 134, 160, 188, 190 — Bulloz, Paris: p. 103 — The
Cleveland Museum of Art, Cleveland: p. 95 — Courtauld Institute of Art,
London: p. 100 — Ph. Degobert, Brussels: pp. 42, 97, 153 — Ferruzzi,
Venice: pp. 93 (top), 95 — The Fitzwilliam Museum, Cambridge: pp. 56,
58, 103, 166 — Fréquin, Voorburg: pp. 57, 83 — Stefano Giraldi, Florence:
pp. 32, 33, 62, 81, 202 — Giraudon, Paris: p. 74 (3) — Graphische Samm-
lung Staatsgalerie Stuttgart: pp. 28, 30, 38, 39, 50, 51, 52, 77, 80, 90 —
Musées Nationaux, Paris: pp. 107, 196, 197 — Museo Civico di Storia ed
Arte, Trieste: pp. 27 (10), 37, 53, 54, 55, 60, 61, 67, 70, 78 — National
Museet, Stockholm: p. 116 — Rijksmuseum, Amsterdam: pp. 63, 142, 184
— Royal Library Windsor: pp. 98, 99, 101, 104, 139, 141, 143, 146/147, 148,
149, 150 — Schweizer Institut für Kunstwissenschaft Zürich: p. 154.